Frontiers of i
Grenzen des Romischen Reiches
Frontières de l´Empire Romain

David J. Breeze & Sonja Jilek

The African Frontiers
Die Grenzen in Afrika
Les frontières africaines

David Mattingly, Alan Rushworth, Martin Sterry & Victoria Leitch

Edinburgh 2013

TO THE MEMORY OF CHARLES DANIELS AND BARRI JONES

The authors/Die Autoren/Les auteurs

Professor David J. Breeze has published several books on Roman frontiers and the Roman army/
Professor David J. Breeze hat mehrere Bücher über die römischen Grenzen und die römische Armee veröffentlicht/
Le Professeur David J. Breeze a publié plusieurs livres sur les frontières romaines et l'armée romaine

Dr Sonja Jilek is the communication officer and the transnational archaeological co-ordinator of the international
Southeast Europe Project "Danube Limes Brand" /Dr. Sonja Jilek ist für die Kommunikation und die transnationale
archäologische Koordination des internationalen Süd-Ost Europa Projektes „Danube Limes Brand" zuständig/Sonja
Jilek, docteur, est la responsable de la communication et l'archéologue chargée de la communication sur le projet
international de l´Europe «Danube Limes Brand» Sud-Est

Professor David Mattingly is Professor of Roman Archaeology at the University of Leicester and director of the
European Research Council funded Trans-Sahara Project/Professor David Mattingly ist Professor für Römische
Archäologie an der Universität Leicester und Direktor des vom Europäischen Forschungsrat unterstützten Trans-Sahara
Projekts/David Mattingly est professeur d'archéologie romaine à l'Université de Leicester (Angleterre) et directeur du
projet trans-Sahara financé par le Conseil européen de la recherche

Dr Alan Rushworth is a director of The Archaeological Practice Ltd in Newcastle upon Tyne/Dr. Alan Rushworth ist
Direktor des Unternehmens The Archaeological Practice Ltd. in Newcastle upon Tyne/Alan Rushworth, docteur, est l'un
des dirigeants de la société The Archaeological Practice Ltd dont le siège est à Newcastle upon Tyne (Angleterre)

Dr Martin Sterry is a research associate and GIS specialist at the University of Leicester on the European Research
Council funded Trans-Sahara Project/Dr. Martin Sterry ist wissenschaftlicher Mitarbeiter und GIS-Spezialist an der
Universität Leicester für das vom Europäischen Forschungsrat unterstützte Trans-Sahara Projekt/Martin Sterry, docteur,
est ingénieur de recherche et spécialiste SIG à l'Université de Leicester pour le Projet trans-Sahara financé par le
Conseil européen de la recherche

Dr Victoria Leitch is a research associate and ceramics specialist at the University of Leicester on the European
Research Council funded Trans-Sahara Project/Dr. Victoria Leitch ist wissenschaftliche Mitarbeiterin und
Keramikspezialistin an der Universität Leicester für das vom Europäischen Forschungsrat unterstützte Trans-Sahara
Projekt/Victoria Leitch, docteur, est ingénieur de recherche et spécialiste de la céramique à l'Université de Leicester
pour le Projet trans-Sahara financé par le Conseil européen de la recherche

Translation by Christine Pavesicz (Frontiers of the Roman Empire, German), Martin Lemke (The African Frontiers, German),
Gabrielle Kremer (Frontiers of the Roman Empire, French), Christopher Sutcliffe and Michel Reddé (The African Frontiers, French)
Designed by Anna Adamczyk

Printed by Hussar Books www.hussarbooks.pl

Edinburgh 2013
ISBN 978-1-900971-16-4

CONTENTS INHALTSVERZEICHNIS SOMMAIRE

FRONTIERS OF THE ROMAN EMPIRE / GRENZEN DES RÖMISCHEN REICHES / FRONTIÈRES DE L´EMPIRE ROMAIN

THE AFRICAN FRONTIERS / DIE GRENZEN IN AFRIKA / LES FRONTIÈRES AFRICAINES

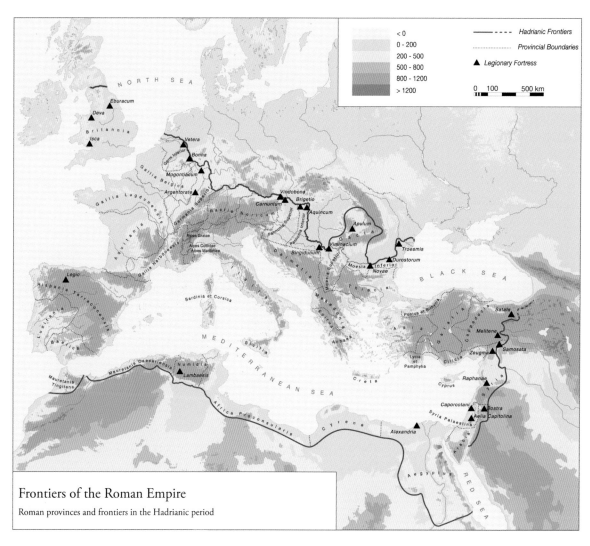

Legend:
- < 0
- 0 - 200
- 200 - 500
- 500 - 800
- 800 - 1200
- > 1200

——— – – – Hadrianic Frontiers
················· Provincial Boundaries
▲ Legionary Fortress

0 100 500 km

Frontiers of the Roman Empire

Roman provinces and frontiers in the Hadrianic period

1. Map of the Roman empire under the Emperor Hadrian (AD 117–138)
Karte des Römischen Reiches unter Kaiser Hadrian (117–138 n. Chr.)
Carte de l'empire romain sous l'empereur Hadrien (117–138 ap. J.-C.)

FOREWORD

The frontiers of the Roman empire together form the largest surviving monument of one of the world´s greatest states. They stretch for some 7,500 km through 20 countries which encircle the Mediterranean Sea. The remains of these frontiers have been studied by visitors and later by archaeologists for several centuries. Many of the inscriptions and sculpture, weapons, pottery and artefacts created and used by the soldiers and civilians who lived on the frontier can be seen in museums. Equally evocative of the lost might of Rome are the physical remains of the frontiers themselves. The aim of this series of booklets is not only to inform the interested visitor about the history of the frontiers but to act as a guidebook as well.

The Roman military remains in North Africa are remarkable in their variety and in their state of preservation: they deserve to be better known. They include towers and forts, stretches of defensive lines of stone and earth with ditches broken by gates, and roads, sitting in the most amazing scenery. I hope each reader of this book will enjoy learning more about North Africa's remarkable Roman inheritance.

VORWORT

Die Grenzen des Römischen Reiches bilden zusammen das am großflächigsten erhaltene Monument eines der großartigsten Weltreiche. Sie erstrecken sich auf mehr als 7500 km über 20 Länder rund um das Mittelmeer. Schon seit einigen Jahrhunderten werden die Überreste dieser Grenzanlagen von Besuchern, und später auch von Archäologen, untersucht. Viele der Inschriften und Skulpturen, Waffen, Keramik und andere Gebrauchsgegenstände, die von den in der Grenzzone lebenden Soldaten und Zivilisten hergestellt und benutzt wurden, können heute in Museen besichtigt werden. Ebenso erinnern auch die physischen Überreste der Grenzanlagen an die einstige Macht Roms. Der Zweck dieser Buchserie ist es, den interessierten Besucher über die Geschichte der Grenzen zu informieren aber gleichzeitig auch als Führer zu dienen.

Die militärischen Überreste Roms in Nordafrika sind beachtlich in ihrer Vielfalt und ihrem Erhaltungszustand: sie verdienen es, besser bekannt zu sein. Diese Altertümer umfassen Türme und Kastelle, Abschnitte von Verteidigungslinien aus Stein und Erde mit Gräben, die von Toren unterbrochen werden und Straßen in einer umwerfenden Landschaft. Ich hoffe, dass jeder Leser dieses Buchs mit Vergnügen mehr über das bemerkenswerte Erbe Roms in Nordafrika erfährt.

AVANT-PROPOS

Prises ensemble, les frontières de l'Empire romain constituent le monument le plus important qui nous reste de ce qui fut l'un des plus grands Etats du monde. Elles s'étendent sur environ 7.500 km à travers une vingtaine de pays ceinturant la mer Méditerranée. Depuis plusieurs siècles, les vestiges de ces frontières ont fait l'objet d'études par des curieux puis plus tardivement par des archéologues. Bon nombre des inscriptions, sculptures, armes, poteries et autres objets créés et utilisés par les militaires et les civils qui peuplaient ces frontières sont visibles dans les musées. Mais les vestiges physiques de ses frontières sont tout aussi évocateurs de la puissance que fut Rome. La présente séries d'opuscules est conçue non seulement pour informer le visiteur curieux de l'histoire des frontières mais également pour servir de guide sur le terrain.

Les vestiges militaires romains en Afrique du Nord sont remarquables tant par leur diversité que par leur état de conservation : ils méritent d'être mieux connus. On y dénombre des tours et des forts, des tronçons de barrières défensives faites de pierre et de terre bordées de fossés et interrompues par des portes, ainsi que des routes, traversant des paysages tout à fait distinctifs. J'espère que le lecteur prendra plaisir à en apprendre davantage sur l'étonnant héritage romain en Afrique du Nord.

David J. Breeze
Chairman, International Congress of Roman Frontier Studies

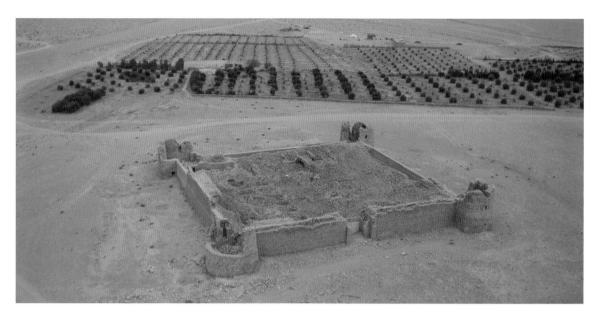

2. The military fortification at Hân al-Manqoûra (Syria), probably dating to the middle of the 2nd century AD

Die Befestigungsanlage von Hân al-Manqoûra (Syrien), die wahrscheinlich auf die Mitte des zweiten Jahrhunderts n. Chr. zurückgeht

La fortification militaire de Han al-Manqoûra (Syrie), datant probablement du milieu du IIe siècle après J.-C.

3. Marcus Aurelius (Alec Guinness) addressing the soldiers in Anthony Mann's "The Fall of the Roman Empire" (1964)

Marcus Aurelius (Alec Guinness) spricht zu den Soldaten in Anthony Manns „The Fall of the Roman Empire" (1964)

Marc Aurèle (Alec Guinness), prononcant une allocution devant les soldats dans « La Chute de l'Empire romain » d'Anthony Mann (1964)

FRONTIERS OF THE ROMAN EMPIRE

Common cultural heritage of the Roman empire

Roman frontiers are part of a common heritage of the countries circling the Mediterranean Sea. Successive generations have built on that heritage and modified it thus helping to create our modern world. Today, our world appears to be diverse, divided by language, religion and traditions. Yet, our heritage is more common and interconnected than we sometimes appreciate. Much knowledge of the ancient world has come to us through the Arab world, the real inheritors of the late Roman empire.

How the Romans managed to rule their enormous empire with a relatively small professional army is a spectacular statement of power and a constant fascination. The Romans were not only experts in the use of power – and force – but also in portraying a strong image about themselves. Indeed, that image was so strong that it still excites our imagination today. Great literature and fantastic films demonstrate our continuing fascination with that image.

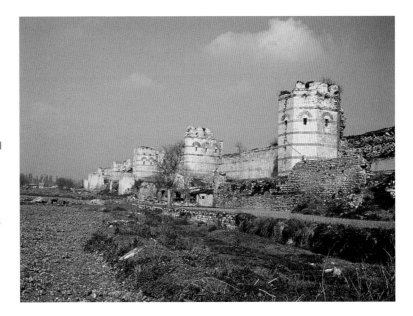

4. The walls of Constantinople (Turkey). It was in 1453 that they fell to the Turks and the Roman empire came to an end

Die Mauern von Konstantinopel (Türkei). Als die Stadt im Jahr 1453 an die Türken fiel, bedeutete das das Ende des Römischen Reiches

Les murs de Constantinople (Turquie). En 1453 ils furent pris par les Turcs et c'était la fin de l'empire romain

GRENZEN DES RÖMISCHEN REICHES

Das gemeinsame kulturelle Erbe des Römischen Reiches

Die Grenzen des Römischen Reiches sind ein Teil des gemeinsamen Erbes der Mittelmeerländer. Nachfolgende Generationen haben auf diesem Erbe aufgebaut, es modifiziert und somit dazu beigetragen, unsere moderne Welt zu schaffen. Dieses Erbe eint uns mehr, als wir im Allgemeinen denken. Viel von unserem Wissen über die Antike wurde uns von den Arabern überliefert, den wahren Erben des spätrömischen Reiches.

Wie die Römer es bewerkstelligten, ihr riesiges Reich mit einem relativ kleinen Berufsheer zu beherrschen, zeigt auf spektakuläre Art ihre Macht und fasziniert uns noch heute. Die Römer waren nicht nur Experten im Gebrauch von Macht und Gewalt, sondern waren auch imstande, sich selbst auf beeindruckende Weise darzustellen. Das Bild, das sie schufen, war so stark, daß es noch heute unsere Phantasie beflügelt. Große Literatur und phantastische Filme zeigen, wie sehr es uns noch immer fasziniert.

FRONTIÈRES DE L´EMPIRE ROMAIN

Le Patrimoine culturel commun de l'empire romain

Les frontières romaines font partie d'un patrimoine commun aux pays qui entourent la Méditerranée. Des générations successives ont construit sur ce patrimoine et l'ont modifié tout en contribuant ainsi à créer notre monde moderne. Aujourd'hui notre monde apparaît diversifié, partagé entre différentes langues, religions et traditions. Pourtant notre patrimoine est davantage un bien collectif que nous ne l'estimons parfois. Une grande partie de ce que nous savons du monde antique nous a été transmis par l'intermédiaire du monde arabe, le vrai héritier de l'empire romain tardif.

Que les Romains aient réussi à dominer leur empire énorme avec une armée de métier relativement petite, nous démontre d'une façon spectaculaire leur pouvoir et nous fascine toujours. Les Romains n'étaient non seulement experts en exerçant le pouvoir – et la force – mais aussi en se créant une réputation de puissance. En fait, cette réputation était tellement forte qu'elle excite notre imagination jusqu'à nos jours. La fascination continuelle de cette vision est démontrée par la grande littérature et par des films passionnants.

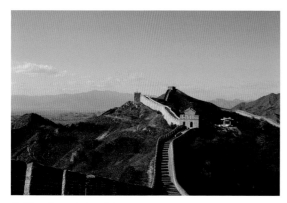

5. The Great Wall of China, World Heritage Site since 1987

Die Chinesische Mauer, Weltkulturerbestätte seit 1987

La grande Muraille de Chine, site du patrimoine mondial depuis 1987

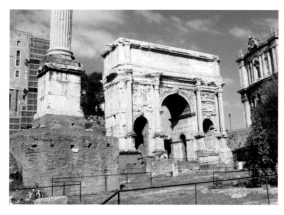

6. The Arch of Severus in the Forum Romanum in Rome (Italy)

Der Serverusbogen auf dem Forum Romanum in Rom (Italien)

L'arc de Septime Sévère sur le Forum Romanum à Rome (Italie)

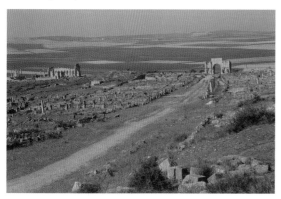

7. The Roman city of *Volubilis* (Morocco)

Die römische Stadt *Volubilis* (Marokko)

La ville romaine de *Volubilis* (Maroc)

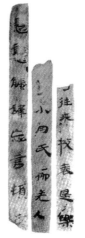

8. Military documents of the Han period, 200 BC – AD 220 (China)

Militärdokumente aus der Han-Zeit, 200 v. – 220 n. Chr. (China)

Documents militaires de la période Han, 200 av. – 220 ap. J.-C. (Chine)

The Roman empire

The Roman state, in one form or another, survived for over 2000 years. Its empire was one of the greatest states which the world has seen, close only to China in its size and longevity. Indeed, our knowledge of the administrative arrangements of the Chinese empire, which have survived in better condition and more detail than those for the Roman empire, aids our understanding of the workings of Roman frontiers.

Many great monuments of the Roman empire are World Heritage Sites, including Rome itself, but also many of its important cities such as Mérida and Lugo (Spain), Orange and Arles (France), Split (Croatia), Istanbul (Turkey), Petra (Jordan), *Lepcis Magna* (Libya) and *Volubilis* (Morocco). Yet these most developed parts of the Roman world were protected and at the same time defined by frontiers. It was as if these frontiers were, as Aelius Aristides remarked in the 2nd century AD, "enclosing the civilised world in a ring". The frontiers did define the Roman empire and were essential for the stability and therefore economic growth of the interior: they allowed the cities of the empire to flourish. An essential part of the Roman genius was its ability to win the support of the people it conquered. It respected local traditions and ethnic characteristics, so long as the superior status of Rome was not challenged.

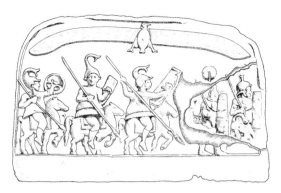

9. Relief with soldiers wearing elephant helmets, Tell el-Herr (Egypt)

Relief mit Darstellung von Soldaten mit Elefantenhelm, Tell el-Herr (Ägypten)

Relief avec soldats coiffés de casques d'éléphants Tell el-Herr (Égypte)

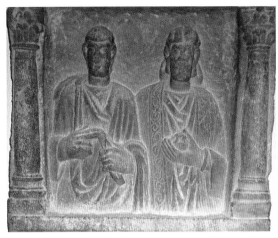

10. Tombstone of civilians from *Aquincum* (Hungary) wearing the local Pannonian dress

Grabstein von Zivilpersonen aus *Aquincum* (Ungarn) in der typischen pannonischen Tracht

Pierre tombale de civils *d'Aquincum* (Hongrie), vêtus du costume local de Pannonie

Das Römische Reich

Der römische Staat überdauerte in der einen oder anderen Form 2000 Jahre. Das Römische Reich war einer der größten Staaten, den die Welt je gesehen hat, und kam in bezug auf seine Größe und Langlebigkeit nur an das Chinesische Reich heran. Und unser Wissen über die Verwaltung des Chinesischen Reiches, dessen Quellen besser erhalten und detaillierter überliefert sind als diejenigen über das Römische Reich, hilft uns, zu verstehen, wie die römischen Grenzen funktioniert haben.

Viele große Denkmäler, wie die Stadt Rom selbst, aber auch zahlreiche wichtige Städte des Römischen Reiches, wie Mérida und Lugo (Spanien), Orange und Arles (Frankreich), Split (Kroatien), Istanbul (Türkei), Petra (Jordanien), *Lepcis Magna* (Libyen) und *Volubilis* (Marokko) sind Teil des Welterbes. Diese entwickelten Teile der römischen Welt wurden durch Grenzen einerseits geschützt andererseits aber auch genau definiert, als ob diese Grenzen, wie es Aelius Aristides im 2. Jahrhundert n. Chr. ausdrückte, „die zivilisierte Welt gleichsam wie ein Ring umschließen". Tatsächlich machten Grenzen das Römische Reich aus und waren für die Stabilität und daher auch für das Wirtschaftswachstum im Inneren unersetzlich: sie gewährleisteten, daß die Städte des Reiches florierten.

L'empire romain

L'Etat romain, dans une forme ou dans une autre, a survécu plus de 2000 ans. Son empire était un des Etats les plus grands que le monde ait connu, semblable uniquement à la Chine en ce qui concerne l'étendue et la longévité. Effectivement, notre connaissance des arrangements administratifs de l'empire Chinois, qui ont survécu dans une condition meilleure et de façon plus détaillée que ceux de l'empire romain, nous fait mieux comprendre la manière dont les frontières romaines fonctionnaient. Un grand nombre de monuments de l'empire romain sont des sites du patrimoine mondial, y compris Rome elle-même, mais aussi un grand nombre de ses villes importantes, comme Mérida et Lugo (Espagne), Orange et Arles (France), Split (Croatie), Istanbul (Turquie), Petra (Jordanie), *Lepcis Magna* (Libye) et *Volubilis* (Maroc). Mais ces parties les plus développées du monde romain étaient protégées et en même temps définies par des frontières. C'était comme si ces frontières « encerclaient le monde civilisé », comme l'a remarqué Aelius Aristides au IIe siècle ap. J.-C. Les frontières délimitaient effectivement l'empire romain et étaient essentielles pour la stabilité et par là l'évolution économique à l'intérieur: elles faisaient que les villes de l'empire florissaient.

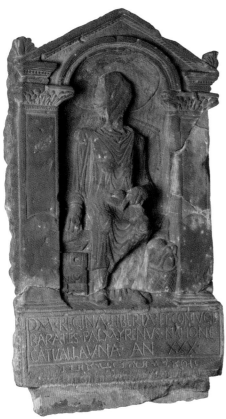

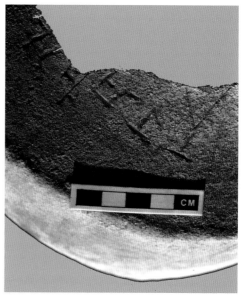

13. A graffito in Tamil-Brahmi on a Roman Dressel 2–4 amphora. The text mentions a man named Korra, a south Indian chieftain, from the mid-first century AD (*Berenice*, Egypt)

Eine Ritzung in Tamil-Brahmi auf einer römischen Dressel 2–4 Amphore. Der Text erwähnt einen Mann namens Korra, einen südindischen Anführer Mitte des 1. Jahrhunderts n. Chr. (*Berenice*, Ägypten)

Graffito à Tamil-Brahmi sur une amphore romaine Dressel 2–4. Le texte mentionne un homme nommé Korra, un chef de l'Inde du Sud du milieu du Ier siècle ap. J.-C. (Bérénice, Égypte)

11. The tombstone of Regina, wife of Barathes of *Palmyra*, from South Shields (UK). The inscription reads in Palmyrene: "Regina, the freedwoman of Barathes, alas"

Grabstein der Regina, Frau des Barathes von *Palmyra* aus South Shields (Großbritannien). Die Inschrift in palmyrenischer Sprache bedeutet: „Regina, die Freigelassene des Barathes, o Unglück!"

Pierre tombale de Regina, épouse de Barathes de Palmyre, provenant de South Shields (Royaume-Uni), avec l'inscription en dialecte palmyrénien « Regina, affranchie de Barathes, hélas »

12. Artefacts from *Berenice* (Egypt): obverse and reverse of a silver coin of the Western Indian monarch Rudrasena III (AD 362)

Funde aus *Berenice* (Ägypten): Avers und Revers einer Silbermünze des westindischen Herrschers Rudrasena III (362 n. Chr.)

Objets provenant de Bérénice (Égypte) : avers et revers d'une monnaie en argent du monarque de l'Inde occidentale Rudrasena III (362 ap. J.-C.)

It encouraged local self-government, merely placing on top the relatively small imperial administration. This imperial administration helped to hold the whole fabric of the empire together. Members of the aristocracy criss-crossed the empire from one appointment to another. The army brought a touch of Rome to the furthermost corners of the empire. More than that, it was a catalyst, helping to create a new frontier society.

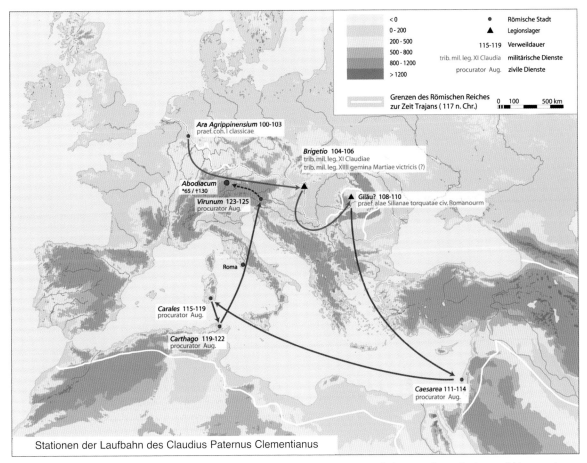

Stationen der Laufbahn des Claudius Paternus Clementianus

14. Career-map of Claudius Paternus Clementianus, a senior officer, who made his way from the lower Rhine, to the Danube, to the Middle East, to Sardinia, Tunisia and finally Austria

Karte mit den verschiedenen Stationen der Karriere von Claudius Paternus Clementianus einem hohen Offizier, der am Niederrhein, an der Donau, im Nahen Osten, in Sardinien, Tunesien und schließlich in Österreich diente

Cursus honorum de Claudius Paternus Clementianus, officier de rang élevé, qui poursuivait sa carrière du Bas-Rhin, vers le Danube, la Palestine, la Sardaigne, la Tunisie et jusqu'en Autriche

Das besondere Talent der Römer bestand darin, sich die Unterstützung der Völker zu sichern, die sie eroberten. Sie respektierten die Traditionen und ethnischen Eigenheiten der Einheimischen, solange die Herrschaft Roms nicht in Frage gestellt wurde. Die Römer unterstützten die Selbstverwaltung und setzten darüber nur eine relativ kleine kaiserliche Verwaltung, durch die das ganze Reich erst zusammengehalten wurde. Mitglieder der Aristokratie durchquerten das gesamte Reich kreuz und quer von einem Posten zum anderen. Durch das Heer kamen die entlegensten Winkel des Reiches in Kontakt mit Rom. Darüber hinaus war das Heer ein Katalysator, der die Entstehung einer neuen Gesellschaft an der Grenze ermöglichte.

Une partie essentielle du génie romain consistait en sa capacité de gagner le support de ceux qu'il soumettait. Il respectait les traditions locales et les caractéristiques ethniques, aussi longtemps que le statut supérieur de Rome n'était pas défié. Il encourageait l'autonomie locale, en mettant en place uniquement une administration impériale relativement peu nombreuse. Cette administration impériale aidait à tenir ensemble l'organisme de l'empire tout entier. Les membres de l'aristocratie remplissaient leurs charges en traversant l'empire d'un bout à l'autre. L'armée apportait une notion de Rome aux quatre coins de l'empire. En plus, elle était un catalyseur, aidant à créer une nouvelle couche sociale le long des frontières.

15. Fragment of Chinese silk from *Palmyra* (Syria) with an inscription in Chinese characters

Fragment chinesischer Seide aus *Palmyra* (Syrien) mit Inschrift in chinesischen Schriftzeichen

Fragment de soie chinoise de Palmyre (Syrie) avec inscription en caractères chinois

16. Finger ring with the depiction of a female bust from *Aquileia* (Italy) made of amber from the Baltic Sea region

Fingerring mit der Darstellung einer weiblichen Büste aus *Aquileia* (Italien) aus Bernstein aus dem Baltikum

Bague avec buste féminin provenant d'Aquilée (Italie), fabriqué en ambre jaune de la région de la Mer Baltique

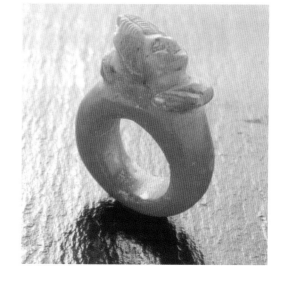

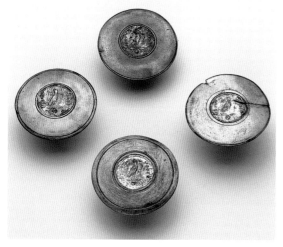

17. Bandoleers with the depiction of eagles from the war booty sacrifice at Vimose (Funen, Denmark)

Abzeichen mit der Darstellung von Adlern aus dem Beuteschatz von Vimose (Fünen, Dänemark)

Insignes avec représentation d'aigles, faisant partie du sacrifice d'un butin à Vimose (Funen, Danemark)

Frontiers and trade

Frontiers were the membrane through which Roman ideas as well as artefacts percolated into the outside world. Roman trade extended eastwards to India and beyond, southwards into the Sahara Desert and northwards to the shores of the Baltic Sea, and, in return, brought a vast range of goods and products into the empire. The museums of many countries beyond the empire contain Roman artefacts and hint at the extent of Roman influence.

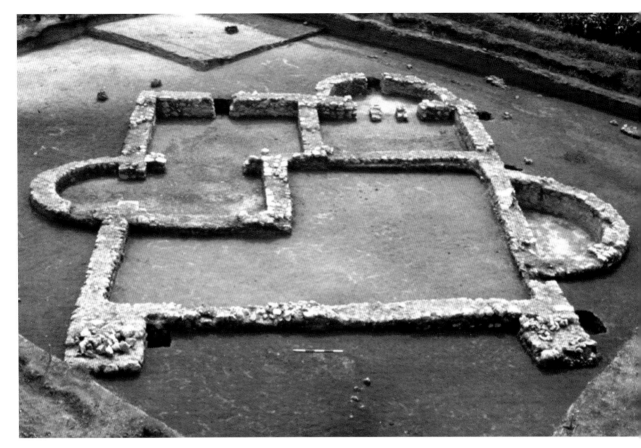

18. Stone masonry in Bratislava-Dúbravka (Slovakia), beyond the empire, built in the Roman manner, is just one of the buildings beyond the frontier which imitated Roman styles

Steinbau in Bratislava-Dúbravka (Slowakei), einem Ort außerhalb des Römischen Reiches, nach römischem Vorbild gebaut. Diese Villa ist nur eines von vielen Gebäuden jenseits der Grenze, das den römischen Stil imitiert

Maçonnerie à Bratislava-Dúbravka (Slovaquie), à l'extérieur de l'empire, construite à la manière romaine, formant un des bâtiments au-delà de la frontière qui imitaient le style romain

Grenzen und Handel

Die Grenzen waren die Membran, durch die römisches Gedankengut und römische Alltagsgegenstände in die Welt jenseits dieser Grenzen drangen. Der Handel der Römer erstreckte sich im Osten bis nach Indien und darüber hinaus, im Süden bis zur Sahara und im Norden bis zur Ostsee und brachte ein riesiges Spektrum an Waren in das Reich. In den Museen vieler Länder außerhalb des Römischen Reiches sind römische Gegenstände zu sehen – ein Hinweis darauf, wie groß der römische Einfluß war.

Frontières et commerce

Les frontières étaient aussi la membrane à travers laquelle les idées romaines aussi bien que les objets artisanaux s'infiltraient dans le monde extérieur. Le commerce romain était avancé à l'est jusqu'en Inde et au-delà, au sud jusqu'au Sahara et au nord jusqu'aux bords de la mer Baltique. Il apportait en revanche à l'empire une offre considérable de marchandises et de produits. Les musées de maints pays au-delà de l'empire possèdent des objets de fabrication romaine et nous indiquent l'étendue de l'influence romaine.

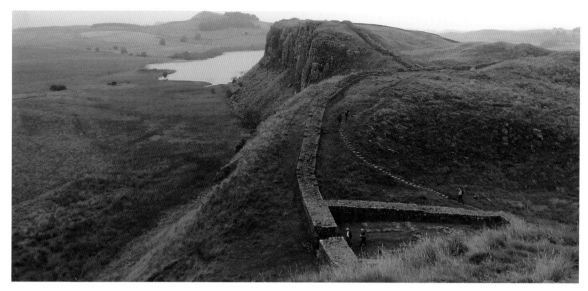

19. Hadrian's Wall at Highshield Crags near Housesteads (UK)
Highshield Crags am Hadrianswall bei Housesteads (Großbritannien)
Mur d'Hadrien à Highshield Crags près de Housesteads (Royaume-Uni)

20. Roman archaeologists discussing international co-operation at Ilok (Croatia) during the Congress of Roman Frontier Studies 2003

Archäologen diskutieren beim Limes-Kongreß in Ilok (Kroatien) im Jahr 2003 über internationale Zusammenarbeit

Spécialistes de l'époque romaine discutant d'une coopération internationale à Ilok (Croatie) à l'occasion du Congrès International d'Études sur les Frontières Romaines 2003

The "Frontiers of the Roman Empire" World Heritage Site

In 1987 Hadrian's Wall (UK) was added to the list of World Heritage Sites. In 2005 the German frontier between the rivers Rhine and Danube, known locally as the Obergermanisch-Raetische Limes, achieved the same accolade. By this act a new, transnational World Heritage Site, Frontiers of the Roman Empire, was created. This, it is hoped, is the first step of many towards the creation of a truly transnational World Heritage Site encompassing countries in Europe, the Middle East and North Africa. In 2008, the Antonine Wall in Scotland was added to the World Heritage Site. To date, the three main artificial frontiers of the Roman empire have been included in the World Heritage Site. Now, the focal point for new nominations concentrates on river frontiers along the Lower Rhine and the eight Danube countries.

This project is a truly challenging concept with no real precedent. It involves the co-operation of archaeologists and cultural resource managers in many countries – and in international agencies. Certain rules have to be accepted and standards met. Yet, each country has its own traditions of undertaking its archaeology, protecting and managing its sites, and presenting and interpreting its monu-

21. The wood-covered frontier in the Taunus mountains (Germany)
Die bewaldete Grenze im Taunus (Deutschland)
La frontière couverte de forêts dans le Taunus (Allemagne)

Das Welterbe „Grenzen des Römischen Reiches"

Im Jahre 1987 wurde der Hadrianswall (Großbritannien) zum Welterbe erklärt. Im Jahre 2005 erhielt auch der römische Grenzabschnitt zwischen den Flüssen Rhein und Donau, besser bekannt als der Obergermanisch-Raetische Limes, diese Auszeichnung. Mit diese Ernennung wurde ein neues, transnationales Welterbe, die Grenzen des Römischen Reiches, geschaffen. Das, so ist zu hoffen, wäre der erste Schritt von vielen zur Schaffung eines wirklichen transnationalen Welterbes, das Länder in Europa, dem Nahen Osten und Nordafrika einschließt. Im Jahr 2008 erreichte der Antoninuswall in Schottland den Welterbestatus. Bist jetzt sind drei künstliche Grenzabschnitte des Römisches Reiches Teil des Welterbes. Im Moment liegt der Fokus für neue Nominierungen auf den Flussgrenzen am Niederrhein und den insgesamt acht Donauländern.

Dieses Projekt stellt ein völlig neues, beispielloses Konzept dar, an dem Archäologen und Denkmalschützer aus vielen Ländern und vielen internationalen Gremien mitarbeiten. Bestimmte Regeln und Standards müssen eingehalten werden. Doch jedes Land hat seine eigenen Traditionen in bezug auf seine Archäologie, den Schutz und die Hand-

Le site du patrimoine mondial des « Frontières de l'Empire Romain »

C'est en 1987 que le mur d'Hadrien (Royaume-Uni) a été inscrit sur la liste des sites du patrimoine mondial. En 2005 la frontière de Germanie entre le Rhin et le Danube, le "limes de Germanie supérieure-Rétie", a reçu la même distinction. Cet acte a donné naissance à un nouveau site multinational, "Les frontières de l'Empire romain". Ce n'est, espérons-le, que le premier pas vers la création d'un véritable site international englobant les pays européens, le proche et le Moyen-Orient, l'Afrique du Nord. En 2008, le mur d'Antonin en Écosse a été ajouté sur la liste du patrimoine culturel mondial. À ce jour les trois principales frontières artificielles de l'Empire romain ont donc été inscrites sur cette liste. Actuellement, l'axe pour les nouvelles nominations concerne les frontières fluviales sur le Rhin inférieur et les huit pays riverains du Danube.

Ce projet constitue un défi conceptuel sans précédent. Il exige la coopération des archéologues et des gestionnaires de la culture dans un certain nombre de pays – et dans des institutions internationales. Certaines règles doivent être observées et certains standards doivent être assurés. Pourtant, chaque pays a ses propres traditions quant

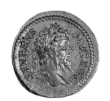

23. Coin depicting the Emperor Septimius Severus (193–211), who campaigned on many frontiers and expanded the empire to the east, south and north

Münze mit dem Bild des Kaiser Septimius Severus (193–211), der an vielen Grenzabschnitten kämpfte und das Reich nach Osten, Süden und Norden ausdehnte

Monnaie montrant l'empereur Septime Sévère (193–211), qui luttait sur de nombreuses frontières et élargissait l'empire vers l'est, le sud et le nord

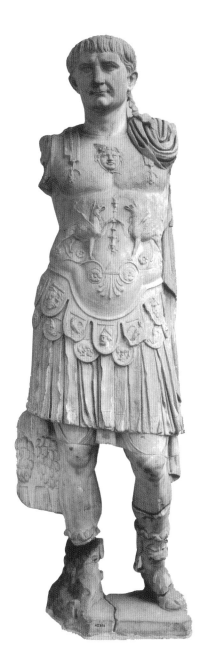

22. Statue of the Emperor Trajan (AD 98–117), who conquered *Dacia* (Romania) and *Parthia* (Iraq and Iran), Rijksmuseum Leiden (Netherlands)

Statue des Kaisers Trajan (98–117 n. Chr.), der Dakien (Rumänien) und das Partherreich (Irak und Iran) eroberte, Rijksmuseum Leiden (Niederlande)

Statue de l'empereur Trajan (98–117 ap. J.-C.), qui conquit la Dacie (Roumanie) et la Parthie (Iraq et Iran), Rijksmuseum Leiden (Pays-Bas)

ments to the public. There is no intention to force each country to change its traditions. Rather, archaeologists and administrators are working together to create over-arching frameworks within which each country can adapt and enhance its own ways of working.

The definition of a World Heritage Site

To that end, the co-ordinators of those countries which have already declared their intention to nominate their stretches of the Roman frontier as a World Heritage Site have formed themselves into a group. Named the Bratislava Group after the location of their first meeting in March 2003, it contains delegates from Austria, Bulgaria, Croatia, Germany, Hungary, the Netherlands, Romania, Serbia, Slovakia, and the UK.

The Bratislava Group acts as an adviser on archaeological and scientific aspects of the frontier. It has proposed the following definition for the Frontiers of the Roman Empire World Heritage Site:

"*The Frontiers of the Roman Empire World Heritage Site should consist of the line(s) of the frontier at the height of the empire from Trajan to Septimius Severus (about AD 100 to 200), and military installations of different periods which are on that line. The installations include fortresses, forts, towers, the limes road, artificial barriers and immediately associated civil structures*".

This definition excludes outpost and hinterland forts. But it has the main advantage that it is relatively simple, an important element when seeking to

24. The east-gate of the Roman fort at Traismauer on the Danube (Austria) dates to the 4th century but qualifies for nomination under the proposed definition

Das Ost-Tor des römischen Kastells in Traismauer an der Donau (Österreich) wurde erst im 4. Jahrhundert gebaut, erfüllt aber die Voraussetzungen für eine Nominierung unter der vorgeschlagenen Definition

Bien que la porte est du fort romain à Traismauer près du Danube (Autriche) date du IVᵉ siècle ap. J.-C., elle est qualifiée pour la liste de nomination selon la définition proposée

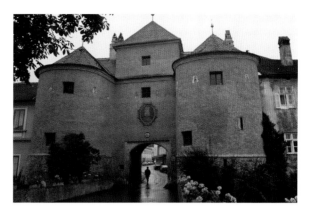

habung seiner Fundstätten und die Präsentation und Interpretation seiner Funde in der Öffentlichkeit. Die Intention ist daher nicht, Länder dazu zu bringen, Traditionen zu ändern; vielmehr arbeiten Archäologen und Verwaltungsgremien zusammen, um ein Rahmenwerk zu schaffen, innerhalb dessen jedes Land seine eigenen Arbeitsweisen optimieren kann.

Die Definition des Welterbes

Mittlerweile schlossen sich Koordinatoren derjenigen Länder, die bereits ihre Absicht erklärt haben, ihren Grenzabschnitt als Welterbe zu nominieren, zur Bratislava-Gruppe zusammen, die sich nach dem Ort ihres ersten Treffens im März 2003 benannt hat. In dieser Gruppe sind Delegierte aus Bulgarien, Deutschland, Großbritannien, Kroatien, Niederlande, Österreich, Rumänien, Serbien, der Slowakei und Ungarn vertreten.

Die Bratislava-Gruppe agiert als ein Beratungsinstrument für archäologische und wissenschaftliche Belange zu den Grenzen. Sie hat die folgende Definition des Welterbes „Die Grenzen des Römischen Reiches" vorgeschlagen:

„Das Welterbe ‚Die Grenzen des Römischen Reiches' umfaßt die Grenzlinie(n) am Höhepunkt des Reiches unter Trajan bis Septimius Severus (ca. 100 bis 200 n. Chr.) und Militäreinrichtungen anderer Perioden, die an dieser Linie bestanden. Zu den Einrichtungen gehören Legionslager, Kastelle, Türme, die Limesstraße, künstliche Barrieren und unmittelbar angeschlossene zivile Einrichtungen".

Diese Definition schließt sowohl Vorposten- als auch Kastelle im Hinterland aus. Doch ihr wesentlicher

à l'archéologie, la protection et la gestion de ses sites, et aussi quant à l'interprétation et à la présentation au public de ses monuments. L'intention n'est pas de forcer les différents pays de changer leurs traditions. Les archéologues et les administrateurs contribuent plutôt à la création de dispositions de base, suivant lesquelles chaque pays peut adapter et intensifier ses propres modes de travail.

Définition d'un site du patrimoine mondial culturel

C'est en poursuivant ce but que les coordinateurs des pays qui ont déjà declaré leur intention de nominer leurs secteurs de la frontière romaine pour la liste des sites de patrimoine mondial ont formé un groupe. Ce groupe est nommé Groupe de Bratislava, selon le lieu de la première rencontre en mars 2003, et comprend des délégués de l'Autriche, la Bulgarie, la Croatie, l'Allemagne, la Hongrie, des Pays-Bas, de la Roumanie, la Serbie, la Slovaquie et du Royaume-Uni.

Le Groupe de Bratislava donne des conseils concernant les aspects archéologiques et scientifiques de la frontière. Il a proposé la définition suivante du « site du patrimoine mondial des Frontières de l'Empire Romain »:

« Le site du patrimoine mondial des Frontières de l'Empire Romain' devrait comprendre la (les) ligne(s) de la frontière de l'empire au sommet de son extension entre les empereurs Trajan et Septime Sévère (de 100 à 200 ap. J.-C. environ), ainsi que des dispositifs militaires de périodes différentes se trouvant sur ces lignes. Ces dispositifs incluent des forteresses, des forts, des tours défensives, la voie frontalière, des barrières artificielles et des structures civiles s'y rapportant immédiatement ».

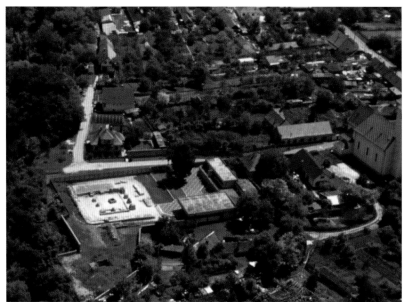

25. The Roman fort at *Gerulata* lies in the outskirts of Bratislava (Slovakia)

Das römische Kastell in *Gerulata* befindet sich am Stadtrand von Bratislava (Slowakei)

Le fort romain à *Gerulata* est situé dans la périphérie de Bratislava (Slovaquie)

```
IM P·CAES·M·AV R·COMMODVS·ANTONINVS
AVG·PIVS·SARM·GER·BRI·PON·MAX·TRIB·POT·
VI·IMP·IIII·COS·IIII·PP·RIPAM·OMNEM·BVRC·IS
A·SOLO·EXTRVCTIS·ITEM·PRAESIDIS·PER·LO
CA·OPPORTVNA·AD·CLANDESTINOS·LATRVNCV
LORVM·TRANSITVS·OPPOSITIS·MVNIVIT·
PER·D·CORNELIVM·     FELICEM·
PLOTIANVM·     LEG·   PR·PR·
```

26. This inscription from *Intercisa* (Hungary) is one of several recording the erection of watch-towers to protect the empire from the illicit incursions of bandits during the reign of the Emperor Commodus (161–180)

Diese Inschrift aus *Intercisa* (Ungarn) ist eine von mehreren, die den Bau von Wachtürmen zum Schutz des Reiches gegen Überfälle von Banditen unter der Herrschaft des Kaisers Commodus (161–180) beschreibt

La construction de tours de guets, protégeant l'empire contre les incursions illicites de bandits pendant le règne de Commode (161–180), est entre autres documentée par cette inscription d'*Intercisa* (Hongrie)

undertake an entirely new concept. Roman military installations stretch across many kilometres of the Roman empire and to seek to include all within this single World Heritage Site would involve enormous tasks of definition, too complex to undertake at this most early stage in the process. It would, of course, be possible to amend the proposed definition in due course.

The task ahead

The present task is daunting enough. Agriculture, and later industrialisation and the growth of towns and cities, has dealt harshly with some sections of the frontier. Many sectors are now no longer visible to the naked eye, yet they remain in the ground as an important archaeological resource. Their preservation is imperative for they hold the key to understanding frontiers better through controlled scientific research. The Frontiers of the Roman Empire are therefore well suited to convey the message that the protection of archaeological sites whether visible or invisible is vital for the preservation of the collective memory of mankind. The best way to protect the remains of the frontier in urban contexts has yet to be determined. This is all the more important because modern excavation has demonstrated that archaeological deposits often better survive in towns than in the countryside.

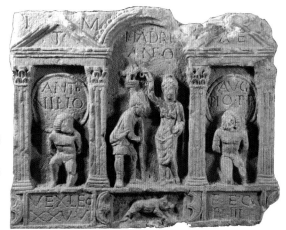

27. An inscription from the Antonine Wall (Scotland, UK) recording the construction of a section of the frontier

Eine Inschrift vom Antoninuswall (Schottland, Großbritannien) dokumentiert den Bau eines Teils der Grenze

Inscription du mur d'Antonin (Écosse, Royaume-Uni) rappelant la construction d'un secteur de la frontière

Vorteil liegt in ihrer Einfachheit, was bei der Suche nach einem völlig neuen Konzept wichtig ist. Römische Militäreinrichtungen erstrecken sich über viele Kilometer im Römischen Reich, und sie alle in dieses einzige Welterbe aufnehmen zu wollen, würde eine überaus schwierige Definitionsaufgabe darstellen; in diesem sehr frühen Stadium sicherlich ein zu komplexes Unterfangen. Die jetzt vorgeschlagene Definition wäre natürlich zu gegebener Zeit zu ergänzen.

Die zukünftige Aufgabe

Die anstehende Aufgabe ist schwierig genug. Die Landwirtschaft und später die Industrialisierung und das Wachstum von Dörfern und Städten sind mit einigen Abschnitten der Grenze hart umgegangen. Viele davon sind heute mit bloßem Auge nicht mehr zu erkennen, befinden sich jedoch als wichtige Quelle für die Archäologen unter der Erde. Sie müssen erhalten werden, denn sie sind der Schlüssel zum besseren Verständnis der Grenzen durch kontrollierte wissenschaftliche Forschung. Die Grenzen des Römischen Reiches eignen sich daher sehr gut dazu, die Botschaft zu übermitteln, daß der Schutz archäologischer Stätten – ob sichtbar oder nicht sichtbar – für den Erhalt des kollektiven Gedächtnisses der Menschheit unerläßlich ist. Wie man die Überreste der Grenze in städtischen Arealen am besten schützt, muß erst festgestellt werden. Dies ist umso

Cette définition exclut aussi bien les forts au-delà des frontières que ceux de l'arrière-pays. Mais son avantage principal est sa simplicité relative, un élément important quand il s'agit de réaliser une idée entièrement nouvelle. Les dispositifs militaires romains s'étendent sur une très longue distance et tenter de les inclure tous dans un seul site du patrimoine mondial nécessiterait des efforts énormes de définition, trop complexes pour cette phase précoce du procédé. Mais naturellement, il serait possible de compléter la définition proposée au bon moment.

La mission à remplir

La mission présente est quelque peu intimidante. L'agriculture, et plus tard l'industrialisation ainsi que l'expansion des villes et des métropoles ont gravement affecté certaines sections de la frontière. Aujourd'hui, beaucoup de secteurs ne sont plus visibles à l'œil nu, mais tout en étant enterrés ils sont une ressource archéologique importante. Leur préservation est absolument nécessaire, car ils sont la clé pour une meilleure compréhension des frontières résultant de recherches scientifiques contrôlées. Pour cette raison, les frontières de l'empire romain sont aptes à transmettre le message que la protection des sites archéologiques, visibles ou non, est vital pour la préservation de la mémoire collective de l'humanité. La meilleure manière de protéger les vestiges de la frontière dans des contextes urbains n'a toujours pas été déterminée. Ceci est d'autant plus

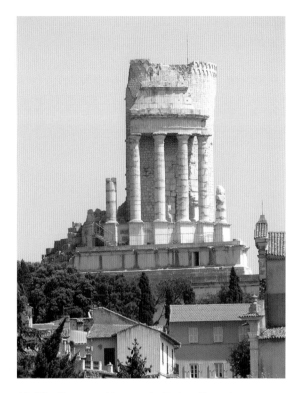

28. The *Tropaeum Alpium* at La Turbie (France) commemorates the conquest of the Alps by the Emperor Augustus

Das *Tropaeum Alpium* in La Turbie (Frankreich) erinnert an die Eroberung der Alpen durch Kaiser Augustus

Le *Tropaeum Alpium* à La Turbie (France) commémore la conquête des Alpes par l'empereur Auguste

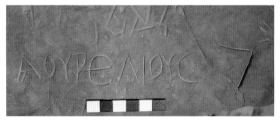

29. A Roman centurion named Aurelios carved his name on the rock at the Garamantian hill-fort of Zinkekra deep in the Sahara Desert (Libya)

Ein römischer Zenturio namens Aurelios meißelte in der garamantischen Hauptstadt Zinkekra tief in der Wüste Sahara (Libyen) seinen Namen in den Felsen

Un centurion romain nommé Aurelios a gravé son nom sur les rochers de l'oppidum garamante de à Zinkekra, au cœur du Sahara (Libye)

A further problem stems from the way that we protect our heritage. Museums cannot be World Heritage Sites. Yet parts of Roman frontiers – inscriptions, sculpture, pottery, artefacts, in short all the material which aids our understanding of life on the frontier – are displayed and stored in museums. Inscriptions are vital to our understanding of frontiers. They inform us when they were built, why and by whom, and what the constituent parts were called. Cramp holes demonstrate that they were once fixed to frontier buildings. In some manner, a way has to be found to associate them with the World Heritage Site itself.

History and extent of frontiers

The Roman perspective was that they had subjected the entire *orbis terrarum* to the rule of Roman people – as far as they had knowledge about it or considered it worth conquering. This philosophy did not encompass the idea of boundaries at all except the idea that "barbarians" should stay outside the Roman concept of the civilised world. However, Rome's boundaries rarely remained stable. Constant political crises, major warfare and even border skirmishes created situations to which Rome had to react. In time, firm lines came into existence.

The man who did most to define the edges of the Roman state was its first emperor, Augustus (27 BC–AD 14). Towards the turn of the Era he completed the conquest of the Alps and Spain, defined the eastern boundary by treaty with the Parthians, sent expeditions up the Nile and into the Sahara Desert, and brought Roman arms to the Danube and the Elbe. He famously gave advice to keep the empire within its present boundaries; advice conspicuously ignored by many of his successors, though their achievements were much less than his.

wichtiger, als moderne Ausgrabungen gezeigt haben, daß archäologische Stätten in urbanen Gebieten oft wesentlich besser überdauern als in ländlichen.

Ein weiteres Problem beruht in der Art und Weise, wie wir unser historisches Erbe schützen. Museen können keine Welterbestätten sein. Doch Bestandteile der römischen Grenzen – Inschriften, Skulpturen, Töpferwaren, Artefakte, kurz, all jenes Material, das uns das Leben an der Grenze erfahrbar macht – wird in Museen ausgestellt und aufbewahrt. Inschriften sind für das Verständnis von Grenzen unverzichtbar. Sie teilen uns mit, wann, warum und von wem sie gebaut und wie die einzelnen Bestandteile genannt wurden. Klammerlöcher sagen uns, daß sie einmal an Grenzgebäuden befestigt waren. Es muß ein Weg gefunden werden, sie mit dem Welterbe selbst in Verbindung zu bringen.

Geschichte und Ausdehnung der Grenzen

Aus römischer Sicht war der gesamte *orbis terrarum* der Herrschaft des römischen Volkes unterworfen – soweit man davon wußte oder ihn als eroberungswürdig befand. Diese Philosophie schloß keineswegs die Vorstellung von Grenzen aus – abgesehen davon, daß die „Barbaren" außerhalb der zivilisierten Welt, wie die Römer sie sahen, gehalten werden sollten. Doch die römischen Grenzen blieben selten stabil. Ständige politische Krisen, große Kriege und selbst Grenzscharmützel schufen Situationen, auf die Rom reagieren mußte. Mit der Zeit entstanden dadurch feste Grenzlinien.

Der Mann, der am meisten für die Festlegung der Grenzen des römischen Staates getan hat, war der erste Kaiser, Augustus (27 v.–14 n. Chr.). Um die Zeitenwende schloß er die Eroberung der Alpen und Spaniens ab, bestimmte in einem Vertrag mit den Parthern die Ostgrenze, sandte Expeditionen auf den Nil und in die Sahara und brachte römische Heere an die Donau und die Elbe. Er ist berühmt für seinen letzten Rat, das Reich innerhalb der damaligen Grenzen zu halten; einen Rat, den viele seiner Nachfolger offenkundig ignorierten, obwohl ihre Leistungen viel geringer waren als seine.

important que des fouilles actuelles ont démontré que les vestiges archéologiques survivent souvent mieux dans les villes qu'en campagne.

Un autre problème provient de la manière dont nous protégeons notre patrimoine. Les musées ne peuvent pas être des sites de patrimoine mondial. Pourtant, certaines parties des frontières romaines inscriptions, sculptures, poteries, produits artisanaux, bref, tous ces objets qui nous aident à comprendre la vie autour des frontières – sont exposées et conservées dans des musées. Les inscriptions sont essentielles pour la compréhension des frontières. Elles nous disent quand les frontières ont été érigées, pourquoi et par qui, et quelle était la désignation des parties constituantes. Des trous de fixage nous démontrent qu'elles étaient jadis fixées sur les bâtiments longeant la frontière. D'une manière ou d'une autre, il faut trouver comment ces inscriptions peuvent être mises en relation avec le site du patrimoine mondial lui-même.

Histoire et étendue des frontières

Le point de vue des Romains était qu'ils avaient soumis au peuple romain *l'orbis terrarum* tout entier – dans la mesure où ils en avaient une notion ou le considéraient valoir la conquête. Cette philosophie ne contenait pas l'idée de limitations du tout, sauf l'idée que les « barbares » devraient rester en dehors du concept romain du monde civilisé. Pourtant, les frontières romaines restaient rarement stables. Des crises politiques constantes, des guerres véritables et même des escarmouches frontalières créaient des situations auxquelles Rome devait réagir. Avec le temps, des lignes stables naissaient.

L'homme qui avait contribué le plus à définir les points d'angle de l'Etat romain était le premier empereur, Auguste (27 av. J.-C.–14 ap. J.-C.). Vers le début de notre ère, il acheva la conquête des Alpes et de l'Espagne, fixa par un traité la frontière est avec les Parthes, envoya des expéditions le long du Nil et au Sahara, et apporta les armes romaines au Danube et à l'Elbe. Il donna le conseil célèbre de s'en tenir aux frontières existantes de l'empire, conseil ignoré de manière frappante par bon nombre de ses successeurs, bien que leurs performances aient été moindres que les siennes.

30. Recent archaeological investigations have led to the discovery of towers erected beside the Rhine in the Netherlands under Claudius

Neue archäologische Untersuchungen haben zur Entdeckung von Türmen geführt, die unter Claudius in den Niederlanden entlang des Rheins errichtet worden waren

Des investigations archéologiques récentes ont mené à la découverte de tours erigées près du Rhin aux Pays-Bas sous le règne de Claude

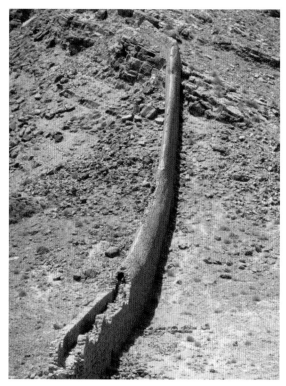

32. A wall at Bir Oum Ali in Tunisia controlled access through a mountain pass along a wadi

Ein Wall bei Bir Oum Ali in Tunesien, der den Zugang entlang eines Wadi kontrollierte

Le mur de Bir Oum Ali en Tunisie permettait de contrôler le passage en barrant un wadi

31. Towers, such as this one in Turkey, aided communication along the frontier roads

Türme, wie dieser in der Türkei, dienten der Kommunikation entlang der Grenzstraßen

Des tours, comme celle-ci en Turquie, facilitaient la communication le long des routes frontalières

Rome´s foreign policy

Yet, Rome's expansion was slowing down and her main aim became the maintenance of imperial security. In doing so Rome's foreign policy used a wide range of different instruments and strategies to maintain her superior status. Her army did not rely only on force but also on the image of Rome itself as a policy instrument. As Adrian Goldsworthy states, "the Roman genius was to combine the practical with the visually spectacular so that the army's actions were often designed to overawe the enemy with a display of massive power before they actually reached him". Thousands of military buildings and installations erected along the borders of the empire, many of which have survived until today, represent this two-fold demonstration of Roman power and influence, at once both architectural and imaginative.

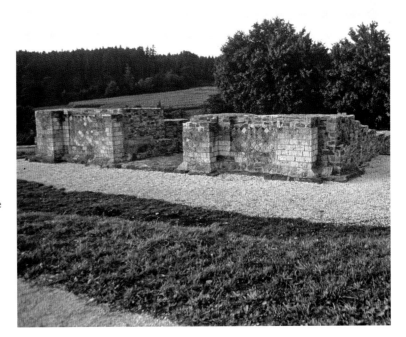

33. The limes-gate of Dalkingen (Germany). It has been argued that this special façade was created to mark the visit of the Emperor Caracalla in 213

Das Limestor von Dalkingen (Deutschland). Möglicherweise wurde diese ganz besondere Fassade anläßlich des Besuchs von Kaiser Caracalla im Jahr 213 gestaltet

La porte frontalière de Dalkingen (Allemagne). On a soutenu la thèse que cette façade spéciale avait été érigée afin de marquer la visite de l'empereur Caracalla en 213

Roms Außenpolitik

Doch die Expansion des Römischen Reiches verlangsamte sich, und der Erhalt der imperialen Sicherheit wurde das Hauptziel. Die römische Außenpolitik wandte ein breites Spektrum an Werkzeugen und Strategien an, um den überlegenen Status des Reiches zu erhalten. Das Heer verließ sich nicht nur auf seine Stärke, sondern auch auf das Bild von Rom selbst als politischem Instrument. Wie Adrian Goldsworthy sagt, bestand „das Genie der Römer" darin, „das Praktische mit dem sichtbar Spektakulären zu verbinden, so daß die Aktionen des Heeres häufig den Feind mit einer Zurschaustellung enormer Stärke einschüchtern sollten, bevor sie tatsächlich zu ihm vordrangen". Tausende militärische Gebäude und Anlagen, die entlang der Reichsgrenzen errichtet wurden, und von denen viele bis zum heutigen Tag überdauert haben, sind Zeugnisse der zweifachen Demonstration von Macht und Einfluß des Römischen Reiches, sowohl in architektonischer als auch in imaginativer Hinsicht.

La politique étrangère de Rome

Mais l'expansion de Rome ralentissait et son but principal devenait la préservation de la sécurité impériale. Ainsi, la politique extérieure romaine se servait d'une grande palette d'instruments et de stratégies différents pour maintenir son statut supérieur. Son armée ne comptait pas seulement sur la force, mais aussi sur l'effet de Rome elle-même en tant qu'instrument politique. Comme l'a dit Adrian Goldsworthy, « le génie romain était de combiner la mise en scène pratique avec la mise en scène visuelle, de manière que les actions de l'armée devaient souvent intimider l'ennemi avec une démonstration de force massive avant même de l'atteindre ». Des milliers de bâtiments et de dispositifs militaires érigés le long des frontières de l'empire, dont un grand nombre a survécu jusqu'à nos jours, représentent cette double démonstration de puissance et d'influence romaine, en même temps architecturale et imaginaire.

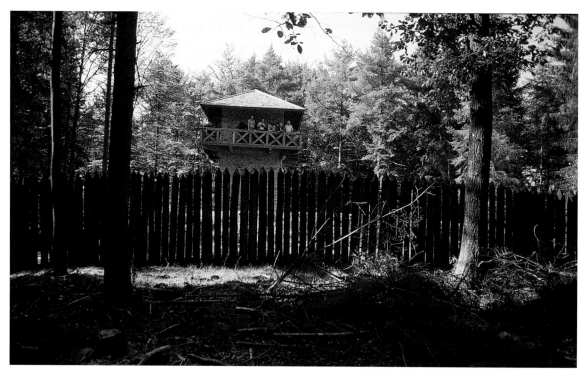

34. A reconstruction of a section of the palisade and a tower in Germany

Eine Rekonstruktion eines Teilstücks der Palisade und eines Turms in Deutschland

Reconstitution d'une section de la palissade et d'une tour en Allemagne

35. The northern fringes of the Carpathian mountains (Romania)

Der Nordrand der Karpathen (Rumänien)

Contreforts nord des Carpates (Roumanie)

The location of frontiers

The Roman empire encircles the Mediterranean Sea – *Mare Nostrum*, Our Sea, as they called it – and beyond that lay its frontiers. These, in time, stretched from the Atlantic Ocean, across Europe to the Black Sea, through the deserts and oases of the Middle East to the Red Sea, and thence across North Africa, skirting the edge of the Sahara Desert, to the Atlantic coast of Morocco.

In the UK the frontier became established on the line of Hadrian's Wall, though for a time even that was abandoned in favour of a more northern frontier, the Antonine Wall. Through much of Europe the frontier lay initially along the rivers Rhine and Danube. In the later 1st century AD, the first steps were taken to shorten the line between the headwaters of the rivers. Under Antoninus this was formalised through the construction of a palisade for about 500 km. In contrast to the usual practice for purely defensive installations, its course is often mathematically straight, completely

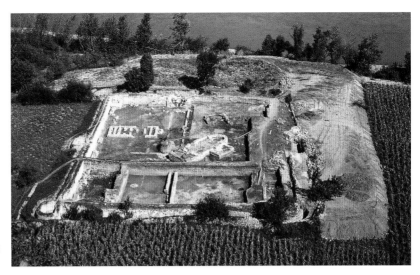

36. The fortlet of Boljetin (Serbia) on the bank of the Danube was excavated in 1969 and flooded after the construction of the dam across the river

Das Kleinkastell bei Boljetin (Serbien) an der Donau wurde 1969 ergraben und beim Bau des Staudammes überflutet

Le fortin de Boljetin (Serbie) sur la rive du Danube a été fouillé en 1969 et inondé après la construction d'une digue de retenue d'eau

Der Verlauf der Grenzen

Das Römische Reich umschloß das Mittelmeer – *Mare Nostrum*, unser Meer, wie sie es nannten –, und jenseits dieses Meeres lagen seine Grenzen. Diese erstreckten sich mit der Zeit vom Atlantischen Ozean durch Europa bis zum Schwarzen Meer, durch die Wüsten und Oasen des Nahen Ostens bis zum Roten Meer, und von dort quer durch Nordafrika, entlang der Wüste Sahara bis zur Atlantikküste von Marokko. In Großbritannien wurde die Grenze am Hadrianswall gezogen, obwohl diese eine Zeitlang zugunsten einer noch nördlicheren Grenze, dem Antoninuswall, aufgegeben wurde. Ursprünglich verlief die Grenze durch einen Großteil von Europa entlang des Rheins und der Donau. Im späteren ersten Jahrhundert n. Chr. unternahm man erste Schritte, um die Strecke zwischen den Oberläufen zu verkürzen. Unter Antoninus geschah das durch die Errichtung einer etwa 500 km langen Palisade. Im Gegensatz zu reinen Verteidigungsanlagen, ist ihr Verlauf oft schnurgerade und ignoriert komplett die topographischen Vorgaben der Landschaft. Das Land, das jetzt zum Reich dazukam, entwickelte sich zu einem reichen landwirtschaftlichen Gebiet, das viele Villen und Bauernhöfe ernährte.

Von Bayern (Deutschland) bis zum Schwarzen Meer (Rumänien) verlief die Grenze entlang der Donau, mit Ausnahme von Dakien (heute Transsylvanien in Rumänien), das im Jahr 106 von Kaiser Trajan erobert wurde. Hier verschob sich die Grenze vom

L'étendue des frontières

L'empire romain encercle la Méditerranée – *Mare Nostra*, Notre Mer, comme les Romains l'appelaient – et ses frontières se trouvent au-delà. Celles-ci, avec le temps, s'étendaient de l'Atlantique à travers l'Europe jusqu'à la Mer Noire, à travers les déserts et oasis du Proche-Orient jusqu'à la Mer Rouge, et de là à travers l'Afrique du Nord, suivant les bords du Sahara, jusqu'à la côte atlantique du Maroc.

Au Royaume-Uni, la frontière était établie sur la ligne du mur d'Hadrien, bien que celle-ci ait été abandonnée pour un certain temps en faveur d'une frontière plus au nord, le mur d'Antonin. Pour une grande partie de l'Europe, la frontière coïncidait d'abord avec le Rhin et le Danube. Au cours du Ier siècle ap. J.-C., les premiers pas étaient faits pour raccourcir la ligne entre les cours supérieurs de ces deux fleuves. Sous l'empereur Antonin, cette idée prit forme avec la construction d'une palissade d'environ 500 km de longueur. Contrairement à la technique de construction courante des dispositifs de défense purs, elle est souvent tracée en ligne absolument droite et ignore la topographie du terrain. Le terrain ainsi incorporé à l'empire commençait à devenir une région agricole riche qui nourissait un grand nombre de villas et de fermes.

De la Bavière (Allemagne) à la Mer Noire (Roumanie), la frontière suivait le Danube . Une exception était la Dacie (la Transilvanie actuelle en Roumanie), qui fut conquise par l'empereur Trajan en 106.

37. The legionary fortress at *Satala* (Turkey) on the Euphrates River was carefully placed to control a potential invasion route

Das Legionslager in *Satala* (Türkei) am Euphrat wurde mit Bedacht an einer Stelle errichtet, wo eine potentielle Einfallsroute kontrolliert werden konnte

Le camp légionnaire à *Satala* (Turquie) sur la rive de l'Euphrate était placé soigneusement afin de contrôler une route d'invasion potentielle

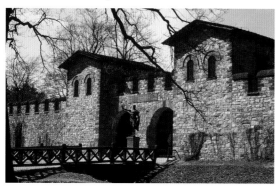

38. One of the earliest archaeological parks was that at the Saalburg (Germany)

Einer der ersten archäologischen Parks war jener auf der Saalburg (Deutschland)

Un des premiers parcs archéologiques a été celui de la Saalburg (Allemagne)

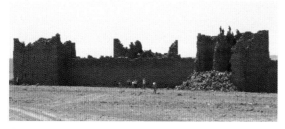

39. Gasr Bshir (Jordan) is typical of the forts in the desert, yet unique in its state of survival

Gasr Bshir (Jordanien) ist ein typisches Beispiel für die Kastelle in der Wüste, jedoch einmalig im Hinblick auf seine heutige Erhaltung

Gasr Bshir (Jordanie) est un fort typique dans le désert, qui se trouve pourtant dans un état de conservation unique

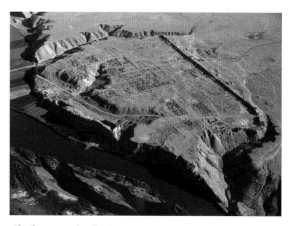

40. *Dura* on the Euphrates River (Syria). As in many cities along the Eastern frontier, it contained a regiment of the Roman army

Dura am Euphrat (Syrien). Wie in vielen Städten entlang der Ostgrenze war auch in dieser Stadt ein römisches Regiment stationiert

Dura sur la rive de l'Euphrate (Syrie). Comme dans de nombreuses villes le long de la frontière orientale, un régiment de l'armée romaine y était stationné

ignoring the topography of the land. The territory now brought into the empire developed into a rich agricultural area supporting many villas and farms.

From Bavaria (Germany) to the Black Sea (Romania) the frontier ran along the river Danube. An exception to this was Dacia (modern Transylvania in Romania) which was conquered by the Emperor Trajan in 106. The frontier now moved from the river to the more difficult terrain of the Carpathian Mountains.

In the East, the Romans faced two enemies, the powerful kingdom of the Parthians and the desert. Together, these defined Rome's Eastern frontier. No running barrier was erected, unnecessary in the desert, though a major river, the Euphrates, was used. A significant feature of this frontier were the roads running for hundreds of kilometres along the edge of the desert and to all intents and purposes defining the frontier itself.

The Sahara Desert defined most of the frontier in North Africa. The rich cities of Egypt and the Mediterranean coast were protected by a relatively light screen of forts. Where necessary, as in modern Algeria, barriers controlled the movement of the transhumance farmers.

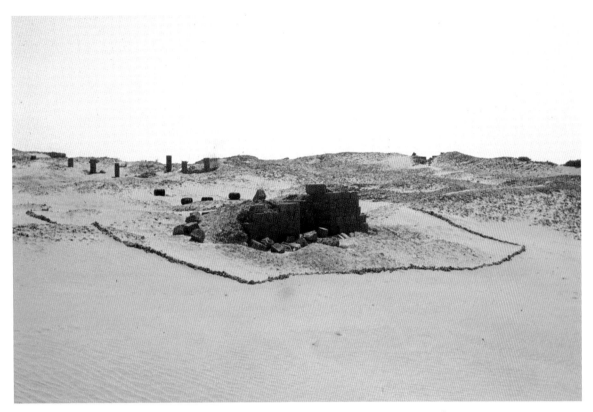

41. The north gate of the fort at Bu Njem (Libya) in 1967 before the present campaign of excavation

Das Nord-Tor des Kastells in Bu Njem (Libyen) im Jahr 1967 vor Beginn der Ausgrabungen, die zur Zeit im Gange sind

Porte nord du fort à Bu Njem (Libye) en 1967, avant la campagne de fouilles

Fluß zum schwierigeren Gelände in den Karpathen. Im Osten trafen die Römer auf zwei Feinde: auf das mächtige Königreich der Parther und auf die Wüste. Gemeinsam definierten sie die Ostgrenze des Römischen Reiches. Hier wurde keine künstliche Barriere errichtet, denn diese war in der Wüste unnötig, doch man wählte einen großen Fluß, den Euphrat, als Grenzfluß. Ein wichtiges Merkmal dieser Grenze waren die Straßen, die hunderte Kilometer entlang der Wüste verliefen und praktisch die Grenze selbst bildeten.

Die Wüste Sahara bildete den Großteil der nordafrikanischen Grenze. Die reichen Städte in Ägypten und an der Mittelmeerküste wurden von relativ wenigen Kastellen geschützt. Wo es erforderlich war, wie im heutigen Algerien, kontrollierten künstliche Barrieren die Bewegungen der nomadisierenden Bauern.

La frontière fut maintenant déplacée du fleuve vers le terrain plus difficile des Carpates.

A l'est, les Romains étaient confrontés à deux ennemis, le royaume puissant des Parthes et le désert. Les deux ensemble définissaient la frontière est de Rome. Aucune barrière continue ne fut érigée, inutile dans le désert, mais un grand fleuve, l'Euphrate, faisait frontière. Une caractéristique de cette frontière étaient les voies accompagnant les bords du désert sur des centaines de kilomètres et définissant la frontière elle-même à différents égards.

Le Sahara déterminait la majeure partie de la frontière en Afrique du Nord. Les villes riches de l'Égypte et de la côte méditerranéenne étaient protégées par une série de forts relativement éparse. Suivant les besoins, comme en Algérie actuelle, des barrières réglaient les mouvements des paysans en transhumance.

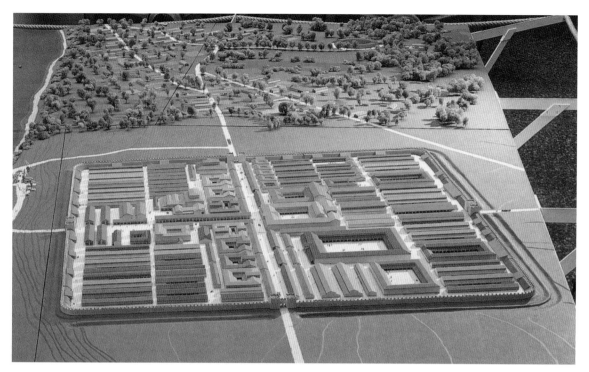

42. Model of the legionary fortress of Bonn (Germany) with the harbour and the civil settlement in the background
Modell des Legionslagers Bonn (Deutschland) mit Hafen und der anschließenden Lagervorstadt im Hintergrund
Modèle du camp légionnaire de Bonn (Allemagne) avec le port et les canabae de la légion en arrière-plan

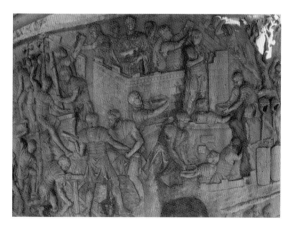

43. Trajan's Column in Rome (Italy) shows soldiers building a fort
Auf der Trajanssäule in Rom (Italien) sind Soldaten dargestellt, die ein Kastell bauen
Sur la colonne de Trajan à Rome (Italie) sont représentés des soldats qui érigent un fort

The army and frontiers

Rome always reacted to the local situation and developed individual solutions to its different problems. The military installations on every frontier were connected by a road, often forming a major highway. Indeed, it appears that the very name of a frontier – *limes* – derives from the Roman name for a frontier road.

The Roman army used local materials to construct its forts and frontiers. Stone, turf, clay, mud-brick, timber, tile, slate, thatch, mortar and plaster were amongst those used. Nor were these plain, unadorned or make-shift structures. Walls, whether of stone or timber, were often plastered and even painted. Painted wall-plaster has even been found in barrack-blocks.

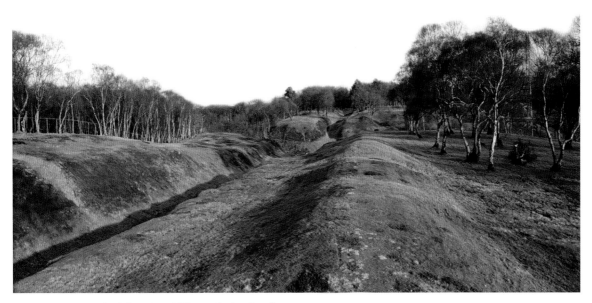

44. The Antonine Wall (Scotland, UK) was built of turf
Der Antoninuswall (Schottland, Großbritannien) wurde aus Rasensoden gebaut
Le mur d'Antonin (Écosse, Royaume-Uni) construit en gazon

Das Heer und die Grenzen

Rom hat stets auf die lokale Situation reagiert und für die unterschiedlichen Probleme individuelle Lösungen gefunden. An jeder Grenze waren die Militäranlagen durch Straßen verbunden, häufig eine wichtige Hauptstraße. Offenbar stammt sogar das Wort für Grenze – limes – vom lateinischen Namen für eine Grenzstraße.

Das römische Heer benutzte Materialien für den Bau seiner Kastelle und Grenzbefestigungen, die sie vor Ort vorfanden, darunter Stein, Rasensoden, Lehm, Lehmziegel, Holz, Ziegel, Schiefer, Schilf, Mörtel und Gips. Es waren auch keine schlichten, schmucklosen oder behelfsmäßigen Gebäude. Die Wände, ob sie nun aus Stein oder aus Holz waren, wurden oft verputzt und sogar bemalt. Selbst in Kasernen fand man Wandmalereien.

L'armée et les frontières

Rome réagissait toujours aux situations locales et développait des solutions individuelles aux différents problèmes. Les dispositifs militaires de chaque frontière étaient liés par une voie, qui souvent constituait une route principale. En effet, il paraît que même la désignation de la frontière – limes – dérive du terme romain pour une route frontalière.

L'armée romaine se servait de matériaux de provenance locale pour construire ses forts et ses frontières, comme pierres, gazon, torchis, briques d'adobe, bois, dalles, ardoises, paille, mortier, plâtre. Mais ce n'étaient pas des constructions simples, dépouillées ou provisoires. Les murs, ou en pierres ou en bois, étaient souvent crépis et même peints. Un enduit de mur peint s'est trouvé même dans des blocs de casernes.

45. Roman military equipment from Augst (Switzerland)

Römische Militärausrüstung aus Augst (Schweiz)

Équipement militaire provenant d'Augst (Suisse)

46. A terracotta model of a fort gate, found at *Intercisa* (Hungary)

Ein Terracottamodell eines Kastelltores, das in *Intercisa* (Ungarn) gefunden wurde

Maquette d'une porte d'un fort en terre cuite trouvée à *Intercisa* (Hongrie)

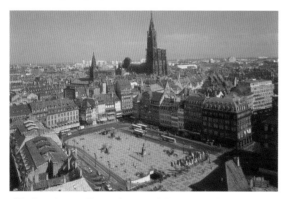

47. Strasbourg (France), one of the seats of the European Parliament, has at its core the fortress of the Eighth Legion Augusta

Unter dem Zentrum von Straßburg (Frankreich), einem der Sitze des Europäischen Parlaments, befindet sich das Legionslager der 8. Legion Augusta

Strasbourg (France), un des sièges du Parlement européen, renferme dans son centre le camp légionnaire de la VIIIᵉ Légion Auguste

48. Tile stamp of the First Legion Italica from *Novae* (Bulgaria) depicting a boat

Stempel der 1. Italischen Legion auf einem Ziegel aus *Novae* (Bulgarien), der ein Schiff zeigt

Brique estampillée de la Iᵉʳᵉ Légion Italique de *Novae* (Bulgarie) montrant un bâteau

The purpose of frontiers

Although bristling with military structures of every kind, and the base of armies whose main purpose was to defend the empire, the primary function of the frontiers themselves was the control of movement into and out of the empire. The buildings – walls, fortlets and towers – were supplemented by scouts whose duties were to maintain watch on land, and fleets whose sailors maintained surveillance over the river and sea boundaries of the empire.

The core of the provincial armies was formed by the legions. Only about 30 of these existed at any one time and they were strung out along the frontiers of the empire, sometimes on the actual line, elsewhere some distance to the rear. The main body of the provincial army was formed by auxiliary units – literally support troops – and these occupied much smaller forts than the legions. In the disturbed times following the fall of the Roman empire, fort walls provided protection. Many of today's major cities have at their centre a legionary fortress.

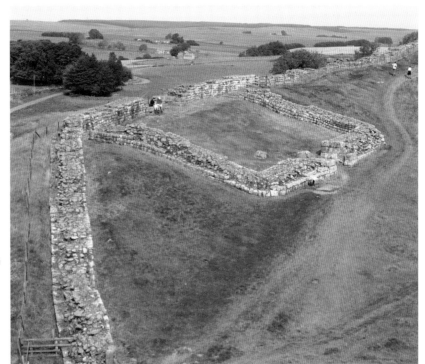

49. Milecastle 42 (Cawfields) on Hadrian's Wall (UK). Gates such as this allowed passage through the frontier

Meilenkastell 42 (Cawfields) am Hadrianswall (Großbritannien). Tore wie dieses erlaubten das Passieren der Grenze

Fortin 42 (Cawfields) au Mur d'Hadrien (Royaume-Uni). De telles portes permettaient le passage à travers la frontière

Zur Funktion der Grenzen

Obwohl es an den Grenzen eine Vielzahl militärischer Gebäude gab, die als Militärbasis dienten, deren Zweck die Verteidigung des Reiches war, bestand die vorrangige Funktion der Grenzen selbst darin, die Bewegungen in das Reich und aus dem Reich hinaus zu kontrollieren. Zusätzlich zu den Gebäuden – Mauern, Kleinkastellen und Türmen – gab es Kundschafter, deren Aufgabe es war, das Land zu überwachen, und Flotten, deren Besatzung die Grenzflüsse und –meere kontrollieren sollten.

Das Kernstück des Provinzheeres waren die Legionen. Es gab niemals mehr als nur etwa 30 Legionen, und sie waren entlang der Grenzen des Reiches verteilt, manchmal direkt an der Grenzlinie, anderswo in einiger Entfernung. Den Großteil des Provinzheeres bildeten – im wahrsten Sinne des Wortes – Hilfstruppen, die in viel kleineren Kastellen als die Legionen untergebracht waren. In den unruhigen Zeiten nach dem Zerfall des Römischen Reiches boten die Mauern der Lager Schutz. Im Zentrum vieler großer Städte befand sich ehemals ein Legionslager.

La fonction des frontières

Tout en regorgeant de structures militaires de toutes sortes et servant de base aux armées qui devaient avant tout défendre l'empire, la fonction primaire des frontières elles-mêmes était le contrôle des mouvements vers l'intérieur et vers l'extérieur de l'empire. Les bâtiments – murs, fortins et tours – étaient complétés par des éclaireurs qui avaient la tâche d'observer le territoire et par des flottes dont les marins surveillaient les frontières fluviales et maritimes de l'empire. Le noyau de l'armée des provinces était constitué par les légions. Il n'en existait jamais plus d'une trentaine et elles étaient réparties le long des frontières, soit sur la ligne actuelle, soit plus à l'arrière-plan. La partie principale de l'armée des provinces était formée par des unités auxiliaires – des troupes de renforcement proprement dites – et elles occupaient des forts beaucoup plus petits que les légions. Pendant les temps troublés qui suivaient la chute de l'empire romain, les murs des forts assuraient une certaine protection. Beaucoup de métropoles actuelles renferment dans leur centre un ancien camp légionnaire.

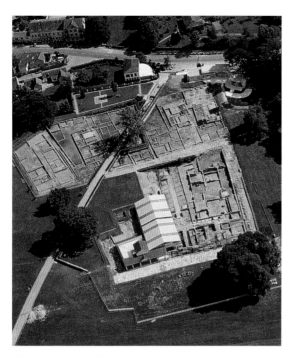

50. Aerial view of the town outside the legionary fortress of *Carnuntum* (Austria)

Luftaufnahme der Zivilstadt neben dem Legionslager von *Carnuntum* (Österreich)

Vue aérienne de la ville à l'extérieur du camp légionnaire de *Carnuntum* (Autriche)

51. This writing tablet found at *Vindolanda* by Hadrian's Wall (UK) is a list of food

Eine Schreibtafel, die in *Vindolanda* am Hadrianswall (Großbritannien) gefunden wurde, enthält eine Lebensmittelliste

Cette tablette à écrire, trouvée à *Vindolanda* près du mur d'Hadrien (Royaume-Uni), représente une liste de ravitaillement

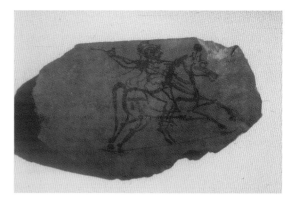

52. An *ostracon*, a drawing on a pottery sherd from *Mons Claudianus*, showing an auxiliary cavalryman such as we know from the documentation was involved with communication and control along the desert roads (Egypt)

Ein *ostracon*, eine Zeichnung auf einer Tonscherbe vom *Mons Claudianus*, zeigt einen Auxiliarreiter. Diese waren für die Kommunikation und Kontrolle entlang der Wüstenstraßen zuständig (Ägypten)

Un *ostracon*, un dessin sur un tesson du *Mons Claudianus*, montrant un des cavaliers auxiliaires qui, selon la documentation, étaient chargés d'assurer la communication et le contrôle sur les routes du désert (Égypte)

Soldiers and civilians

Nearly every fort in the empire attracted civilians to cater for the needs of the soldiers. Civilian settlements sprang up along the frontier. The military installations together with these civilian settlements created a significant economic power, which can only be compared to the great cities of the interior of the empire. This market sucked in goods and attracted trade from both its hinterland as well as from the people beyond the frontier.

Military administration

Both soldiers and civilians required management. The Roman army was excessively bureaucratic, even to our eyes – a receipt in quadruplicate, for example, survives. Every soldier had his own file, and even every horse. Each regiment created a day report. Strength returns were regularly made to Rome. A tiny sample of such documents survive from frontier forts, but they cast strong light on the workings of the Roman army.

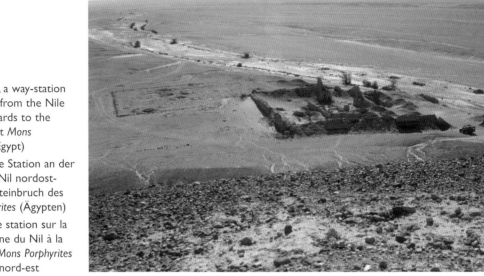

53. Al-Heita, a way-station on the road from the Nile north-eastwards to the quarry site at *Mons Porphyrites* (Egypt)

Al-Heita, eine Station an der Straße vom Nil nordost-wärts zum Steinbruch des *Mons Porphyrites* (Ägypten)

Al-Heita, une station sur la routequi mène du Nil à la carrière du *Mons Porphyrites* (Égypte), au nord-est

Soldaten und Zivilisten

Beinahe jedes Kastell im Reich lockte Zivilisten an, die die Soldaten mit allem versorgten, was sie brauchten, und die sich entlang der Grenze ansiedelten. Gemeinsam bildeten die Militäranlagen und diese zivilen Siedlungen eine Wirtschaftskraft, die nur mit den großen Städten im Inneren des Römischen Reiches verglichen werden kann. Dieser große Markt zog Waren an und war für den Handel aus dem Hinterland und für Menschen jenseits der Grenze interessant.

Die Militärverwaltung

Soldaten und Zivilbevölkerung – beide mußten verwaltet werden. Das römische Heer war extrem bürokratisch, selbst für unsere Begriffe – man fand zum Beispiel eine Empfangsbestätigung in vierfacher Ausfertigung. Jeder Soldat und sogar jedes Pferd hatte seinen eigenen Akt. Jedes Regiment mußte einen Tagesbericht abliefern. Es wurden regelmäßige Stärkemeldungen nach Rom geschickt. In den Kastellen an den Grenzen fand man nur wenige derartige Dokumente, doch sie werfen ein deutliches Licht auf die Verwaltung des römischen Heeres.

Soldats et population civile

Presque chaque fort de l'empire attirait des civils qui répondaient aux besoins des soldats. Des agglomérations civiles naissaient le long de la frontière. Ensemble, les dispositifs militaires et ces agglomérations civiles formaient une puissance économique considérable, comparable uniquement aux grandes villes à l'intérieur de l'empire. Ce marché aspirait les marchandises et attirait le commerce aussi bien de l'arrière-pays que de la population au-delà de la frontière.

Administration militaire

Les soldats ainsi que les civils nécessitaient une gestion. L'armée romaine était excessivement bureaucratique, même à nos yeux – un récépissé par exemple existe en quatre copies. Chaque soldat avait son propre fichier, et même chaque cheval. Chaque régiment rédigeait un rapport journalier. Des rapports d'effectif étaient régulièrement envoyés à Rome. Des échantillons minimes de tels documents ont survécu dans des forts sur la frontière, mais ils contiennent des informations précieuses sur le fonctionnement de l'armée romaine.

54. After 25 years of service the auxiliary soldiers were awarded with the Roman citizenship, which was confirmed and certified by a military *diploma*

Die römischen Soldaten der Hilfstruppen erhielten nach 25 Dienstjahren die römische Staatsbürgerschaft, die mit einem Militärdiplom bestätigt wurde

Après 25 années de service militaire, la citoyenneté romaine était accordée aux soldats auxiliaires, confirmée et certifiée par un diplôme militaire

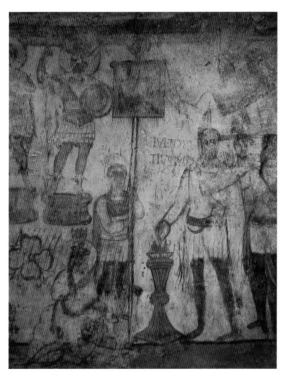

55. Soldiers, including the flag-bearer (*vexillarius*), painted on the wall of a room in *Dura* (Syria)

Wandgemälde auf der Wand eines Zimmers in *Dura* (Syrien) das Soldaten, darunter einen Standartenträger (*vexillarius*) zeigt

Peinture murale dans une pièce de *Dura* (Syrie) montrant des soldats et le porte-drapeau (*vexillarius*)

Research on Roman frontiers

Roman literature and other ancient sources have long provided a valuable source of information about frontier installations. These sources include several military treatises describing the Roman army and its structures, though, alas, generally not frontiers. They also include specific documents such as the report of the governor Arrian on the forts along the eastern shore of the Black Sea.

Inscriptions and documents

Literary sources are supplemented by thousands of inscriptions from every frontier describing the construction and purpose of military structures as well as providing details of the careers and movements of the officers and soldiers of the Roman army. More recently, documents on papyrus, parchment and wood have been discovered through excavation and provide another valuable source of information. Scholars started describing and planning Roman remains in the 16th century. Their records are especially valuable today in view of the great changes in the landscape and the damage to the archaeological remains inflicted during the following centuries. They also collected inscriptions and sculpture, and these frequently form an important element of great national and regional collections.

Survey and excavation

Although excavations were undertaken in the earlier 19th century, it was the 1890s which saw the beginning of the modern era of scientific archaeological investigations. This work did not just encompass excavation; an important element was the surveying and recording of existing remains. This work was often undertaken by institutions such as the Reichs-Limeskommission in Germany, founded in 1892 by the great German historian and winner of the Nobel Prize Theodor Mommsen.

Die Erforschung der römischen Grenzen

Die römische Literatur und andere Quellen der Antike sind seit langem eine wichtige Informationsquelle in bezug auf Grenzanlagen. Darunter sind einige militärische Abhandlungen, in denen das römische Heer und seine Strukturen beschrieben werden, wenngleich leider nicht die Grenzen. Außerdem gibt es spezielle Dokumente wie zum Beispiel den Bericht des Statthalters Arrian, der für die Kastelle entlang der Ostküste des Schwarzen Meeres zuständig war.

Inschriften und Dokumente

Die literarischen Quellen werden ergänzt durch tausende Inschriften von jeder Grenze, in denen Errichtung und Zweck militärischer Gebäude beschrieben sind und die uns auch Details über die Karrieren und Reisen der Offiziere und Soldaten des römischen Heeres liefern. In jüngerer Zeit wurden bei Ausgrabungen Unterlagen auf Papyrus, Pergament und Holz entdeckt, eine weitere wertvolle Informationsquelle.

Bereits im 16. Jahrhundert begannen die Wissenschaftler die römischen Überreste zu beschreiben und zu skizzieren. Im Hinblick auf die großen Veränderungen der Landschaft in den darauffolgenden Jahrhunderten sind ihre Berichte heute von besonders großem Wert. Sie sammelten auch Inschriften und Skulpturen, die häufig einen wichtigen Teil großer nationaler und regionaler Sammlungen bilden.

Prospektion und Ausgrabungen

Obwohl schon im frühen 19. Jahrhundert Ausgrabungen stattfanden, begann die moderne Epoche wissenschaftlicher archäologischer Untersuchungen in den neunziger Jahren des 19. Jahrhunderts. Diese Arbeit umfaßte nicht nur Ausgrabungen: ein wichtiges Element war die Prospektion und Beschreibung der vorhandenen Überreste. Sie wurde oft von Institutionen wie der Reichs-Limeskommission in Deutschland durchgeführt, die 1892 von dem deutschen Historiker und Nobelpreisträger Theodor Mommsen gegründet wurde.

La recherche sur les frontières romaines

La littérature romaine et d'autres sources antiques fournissent des informations précieuses sur les dispositifs militaires le long de la frontière. Parmi ces sources se trouvent plusieurs traîtés militaires qui décrivent l'armée romaine et ses structures, mais qui, hélas, ne mentionnent généralement pas les frontières. Ils comprennent aussi des documents spécifiques comme le rapport du gouverneur Arrian sur les forts de la côte est de la Mer Noire.

Inscriptions et documents

Les sources littéraires sont complétées par des milliers d'inscriptions provenant des frontières, décrivant la construction et la destination des structures militaires et fournissant des détails sur les carrières et les mouvements des officiers et des soldats de l'armée romaine. Plus récemment, des documents sur papyrus, parchemin ou bois ont été découverts lors des fouilles et représentent maintenant une autre source d'informations précieuse.

Au XVIe siècle, les scientifiques ont commencé à décrire et à cartographier les vestiges romains. Leurs documentations sont aujourd'hui particulièrement précieuses à cause des grands bouleversements qui ont affecté les paysages et les vestiges dans les siècles suivants. Ils collectionnaient aussi des inscriptions et des sculptures, et ceux-là constituent maintenant souvent un élement important des grandes collections nationales et régionales.

Prospection et fouilles

Malgré les fouilles du début du XIXe siècle, la période moderne des investigations archéologiques scientifiques ne commençait que dans les années 1890. Cette tâche ne comprenait pas seulement des fouilles, mais un autre élément important était l'observation et la documentation des vestiges existants. Elle était souvent accomplie par des institutions comme la Reichs-Limeskommission en Allemagne, fondée en 1892 par le grand historien allemand et lauréat du Prix Nobel Theodor Mommsen.

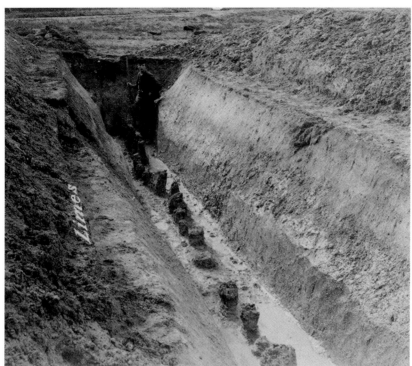

56. The timber palisade in Germany, excavated in 1894

Die Holzpalisade in Deutschland, 1894 ausgegraben

Palissade en bois en Allemagne, dégagée en 1894

Research in the 20th century was dominated by excavation. Early work focussed on uncovering structural remains often neglecting the more detailed history of each site. Whole forts might be laid open. Yet at the same time, members of the Reichs-Limeskommission in Germany were able to confirm that the frontier had indeed a timber palisade, while in Scotland it was revealed that the Antonine Wall was built of turf as described in the *Historia Augusta*. Techniques soon improved. Better use was made of dating evidence such as coins and pottery and, in time, weapons and other small finds. The advantages of stratigraphy in helping understand the history of sites was also appreciated.

Aerial survey

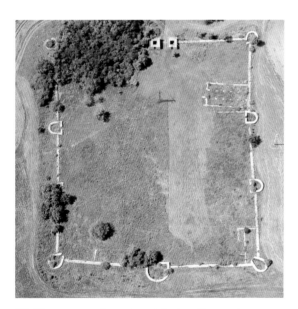

57. The preserved remains of the late Roman fort at Tokod are situated a few kilometres south of the river Danube (Hungary)

Die erhaltenen Ruinen des spätrömischen Kastells Tokod liegen einige Kilometer südlich des Donaulaufes (Ungarn)

Les vestiges conservés du fort Tokod, datés de l'antiquité tardive sont situés à quelques kilomètres au sud du Danube (Hongrie)

Aerial photography provided another valuable tool. Aristide Poidebard's great survey of Roman military sites in Syria, undertaken in the 1920s, and Sir Aurel Stein's survey of Jordan remain major sources for the study of the Eastern frontier. Jean Baradez's *Fossatum Africae*, published in 1949, is based upon his aerial reconnaissance of North Africa and remains a major source for any study of this area.

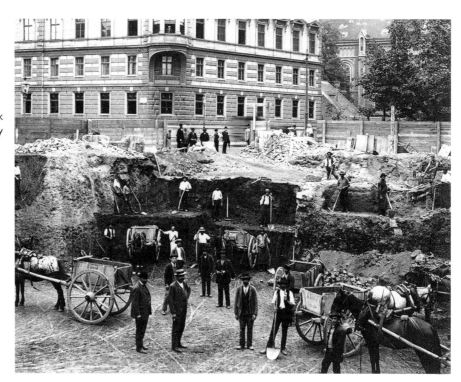

58. Excavations started in Vienna during the major construction work removing the former city defences in the second half of the 19th century

Vor mehr als 100 Jahren begannen die Ausgrabungen in Wien während der massiven Umbauten bei der Entfernung der alten Stadtbefestigungen

Les fouilles ont commencé à Vienne dans la seconde moitié du 19ème siècle, pendant les travaux de démolition des remparts antérieurs de la ville

Im 20. Jahrhundert bestand die Forschung in erster Linie aus Ausgrabungen. Die frühen Arbeiten konzentrierten sich darauf, bauliche Überreste freizulegen, wobei die Einzelheiten zur Baugeschichte jedes Fundortes häufig vernachlässigt wurden. Ganze Kastellplätze wurden ausgegraben. Doch gleichzeitig konnten Mitglieder der Reichs-Limeskommission in Deutschland bestätigen, daß die Grenze tatsächlich eine Holzpalisade hatte, während man entdeckte, daß der Antoninuswall in Schottland tatsächlich aus Rasensoden gebaut ist, beides Details, die in der *Historia Augusta* beschrieben sind.

Luftbildarchäologie

Die Luftbildarchäologie war ein weiteres wertvolles Instrument. Aristide Poidebards großartige Beschreibung römischer Militärstützpunkte in Syrien in den zwanziger Jahren des 20. Jahrhunderts und Sir Aurel Steins Beschreibung von Jordanien bleiben bis heute eine wichtige Quelle für das Studium der Ostgrenze. Jean Baradez' 1949 veröffentlichtes Buch zum *Fossatum Africae* basiert auf seinen Aufklärungsflügen über Nordafrika und ist und bleibt der Ausgangspunkt für das Studium dieses Gebietes.

Les recherches au vingtième siècle étaient dominées par les fouilles. Au début, on se concentrait sur le dégagement de structures, tout en négligeant souvent les détails du passé historique du site en question. Des forts entiers étaient dégagés. Pourtant, à cette même époque, la Reichs-Limeskommission en Allemagne était capable de confirmer qu'il y avait effectivement une palissade le long de la frontière, pendant qu'en Écosse on avait découvert que le mur d'Antonin était fait en gazon, comme il est décrit dans la *Historia Augusta*.

Photographie aérienne

La photographie aérienne a fourni un autre instrument utile. L'importante prospection des sites militaires en Syrie d'Aristide Poidebard, entreprise dans les années 1920, et la prospection de la Jordanie de Sir Aurel Stein sont toujours des sources d'information importantes pour l'étude de la frontière est. Le *Fossatum Africae* de Jean Baradez, publié en 1949, est basé sur son exploration aérienne de l'Afrique du Nord et reste le point de départ pour toute étude de cette région.

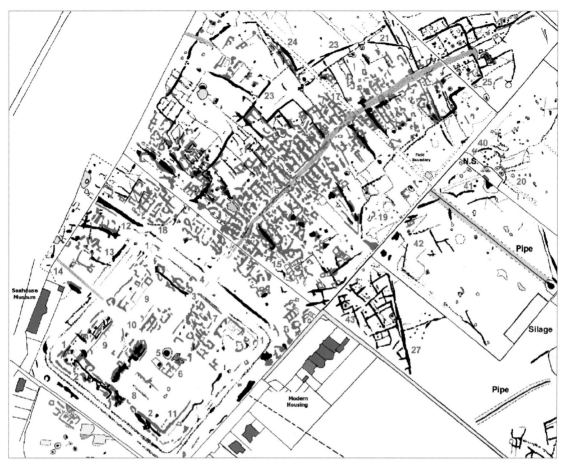

59. Geophysical survey of the fort and civil settlement at Maryport (UK)

Geophysikalische Untersuchung des Kastells und der Zivilsiedlung in Maryport (Großbritannien)

Prospection géophysique du camp et de l'agglomération civile à Maryport (Royaume-Uni)

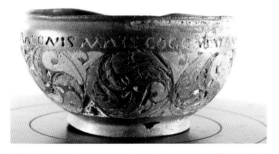

60. Tourism is not a modern phenomenon. This bowl was probably made as a souvenir of Hadrian's Wall (UK) in the 2nd century

Der Tourismus ist kein modernes Phänomen. Diese Schüssel wurde wahrscheinlich im 2. Jahrhundert als Souvenir vom Hadrianswall (Großbritannien) hergestellt

Le tourisme n'est pas un phénomène moderne. Ce bol est probablement un souvenir du mur d'Hadrien (Royaume-Uni) du IIe siècle

Today, terrestrial and aerial survey is supplemented by remote sensing, in particular geophysical survey. So much of this work is facilitated by advances in computer technology in helping documenting and mapping. This will be a great advantage in international co-operation in the study of Roman frontiers.

International co-operation in work on Roman frontiers began in the 19th century. In 1949 the Congress of Roman Frontier Studies was founded and has met regularly since in various countries. Today, research on the Frontiers of the Roman Empire brings together scientists from all over the world: the 22nd Congress in Ruse in Bulgaria was attended by 300 scholars from 30 countries in all 5 continents. Many universities are specialised in the study of Roman history and of the sites along the edge of the Roman Empire.

61. *Aquincum* museum in Budapest (Hungary) founded in 1894

Das *Aquincum*-Museum in Budapest (Ungarn), gegründet 1894

Le Musée d'*Aquincum* à Budapest (Hongrie), fondé en 1894

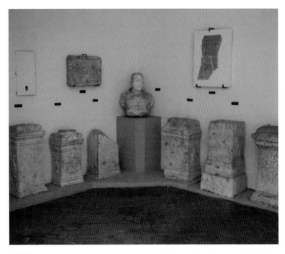

62. Roman stone monuments and inscriptions in Osijek Museum (Croatia)

Römische Steindenkmäler und Inschriften im Museum Osijek (Kroatien)

Monuments Romains en pierre et inscriptions dans le Musée d'Osijek (Croatie)

Die Methoden wurden rasch verbessert. Fundstücke wie Münzen und Töpferwaren, und im Lauf der Zeit auch Waffen und andere Kleinfunde, konnten besser datiert werden. Die Vorteile stratigraphischer Grabungsmethoden trugen weiter zum besseren Verständnis der Geschichte der Fundorte bei.

Heute wird die Luftbildprospektion auf der Erde durch geophysikalische Meßmethoden ergänzt. Fortschritte in der Computertechnologie sind eine wesentliche Hilfe bei der Dokumentation und Kartographie, ein großer Vorteil bei der internationalen Zusammenarbeit beim Studium der römischen Grenzen.

Die internationale Zusammenarbeit entlang der Grenzen des Römischen Reiches begann bereits im 19. Jahrhundert. Im Jahr 1949 wurde der Limes-Kongreß gegründet, der seither in regelmäßigen Abständen in verschiedenen Ländern zusammenkam. Heute bringt die Erforschung der römischen Grenzen Wissenschaftler aus der ganzen Welt zusammen: der 22. Limeskongreß in Ruse in Bulgarien wurde von 300 Wissenschaftlern aus 30 Ländern und allen 5 Kontinenten besucht. Viele Universitäten sind auf das Studium der römischen Grenzen spezialisiert.

Les techniques devaient s'améliorer bientôt. On apprenait à mieux faire valoir les indices de datation comme les monnaies et les poteries et, avec le temps, les armes et d'autres objets. On appréciait aussi les avantages de la stratigraphie quand il s'agissait de mieux comprendre l'histoire des sites.

Aujourd'hui, la prospection terrestre et aérienne est complétée par la télédétection, avant tout par la prospection géophysique. Le progrès de la technique d'informatisation a apporté des facilités énormes pour les travaux de documentation et de cartographie. Les coopérations internationales se consacrant à l'étude des frontières romaines vont en tirer profit.

La coopération internationale portant sur les frontières romaines commença au XIXe siècle. En 1949, le Congrès International d'Études sur les Frontières Romaines fut fondé et se réunit régulièrement depuis dans différents pays. Aujourd'hui, l'exploration des frontières de l'empire romain réunit des scientifiques du monde entier : 300 spécialistes de 30 pays et des cinq continents ont assisté au 22e Congrès à Ruse en Bulgarie. Un grand nombre d'universités sont spécialisées dans les études de l'histoire romaine et des sites aux bords de l'empire romain.

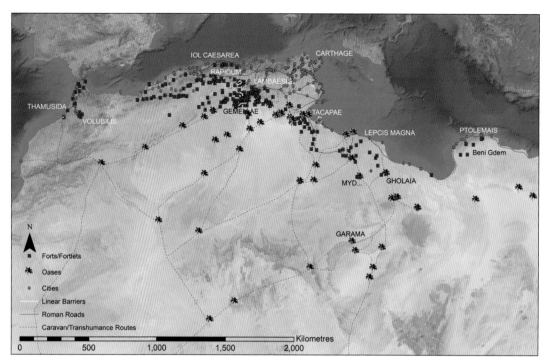

63. Map of the African frontiers, showing the main sites discussed

Karte der afrikanischen Grenzen, mit den wichtigsten besprochenen Standorten

Carte des frontières africaines indiquant les principaux sites mentionnés

THE AFRICAN FRONTIERS

INTRODUCTION

The Roman frontiers in Africa extended from the Atlantic to the borders of Egypt. This vast area included varied landscapes: *Mauretania Tingitana* in the west facing the mountains, *Mauretania Caesariensis* in the high plains and mountains of north-west Algeria, *Numidia* in the high plains and pre-desert zone of south-central Algeria and Tunisia, *Tripolitana* in the desert lands of southern Tunisia and north-west Libya, *Cyrenaica* in the fertile lands of eastern Libya. The processes of conquest and development of this series of provinces varied. The first territory was acquired with the defeat of Carthage in 146 BC, though the main frontier expansion occurred in the late 1st century BC – early 3rd century AD. Some sectors of the frontier were maintained until the 5th century. The challenge here is to encapsulate more than 400 years of the development of frontiers across 3,000 km of varied terrain.

The African frontiers are less well researched than those of other parts of the Roman empire, in part because of the curtailment of fieldwork at Roman military sites in the modern post-colonial era. Nonetheless, the African material has much to contribute to our understanding of Roman frontiers.

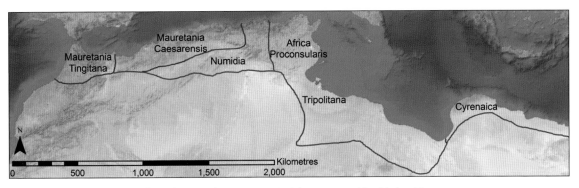

64. Outline map of North Africa showing the main provincial names used in this booklet

Umrisskarte von Afrika mit den Namen der in dieser Broschüre vorkommenden Provinzen

Carte de l'Afrique indiquant les noms des provinces dont il est principalement question dans cet opuscule

DIE GRENZEN IN AFRIKA

EINLEITUNG

Die römischen Grenzen in Afrika erstreckten sich vom Atlantik bis an die Grenze Ägyptens. Dieser weite Raum umfasste unterschiedliche Landschaften: *Mauretania Tingitana* den Bergen gegenüber im Westen, *Mauretania Caesariensis* in den Hochebenen und Bergen des nordwestlichen Algerien, *Numidia* in den Hochebenen und der Vorwüstenzone des südlichen zentralen Algerien und Tunesien, *Tripolitana* in den Wüstengebieten des südlichen Tunesien und nordwestlichen Libyen, *Cyrenaica* in den fruchtbaren Gebieten des östlichen Libyen. Der Verlauf der Eroberung und Entwicklung in diesen Provinzen war unterschiedlich. Das erste Gebiet wurde mit dem Sieg über Karthago im Jahr 146 v. Chr. erworben, obwohl die eigentliche Ausdehnung der Grenze in einem Zeitraum vom späten 1. Jh. v. Chr. bis ins frühe 3. Jh. n. Chr. stattfand. Einige Abschnitte der Grenze wurden bis zum 5. Jahrhundert gehalten

LES FRONTIÈRES AFRICAINES

INTRODUCTION

Les frontières romaines en Afrique s'étendaient de l'Atlantique jusqu'aux confins de l'Egypte, un espace immense aux territoires diversifiés : à l'ouest face à la montagne, la Maurétanie tingitane ; sur les hauts plateaux et dans les montagnes du nord-ouest de l'Algérie, la Maurétanie césarienne ; sur les hautes plaines et dans la zone pré-saharienne de l'Algérie méridionale-centrale et de la Tunisie, la Numidie ; dans le désert du sud tunisien et du nord-ouest de la Libye, la Tripolitaine ; dans les terres fertiles de la Libye orientale, la Cyrénaïque. La conquête et la mise en valeur de ces diverses provinces ont suivi des trajectoires diverses. Si le premier territoire a été acquis par la défaite de Carthage en 146 av. J.-C., l'extension principale des frontières ne s'est produite qu'entre la fin du 1er siècle ap. J.-C. et le début du 3ème siècle ap. J.-C. Certains secteurs de la frontière ont été maintenus

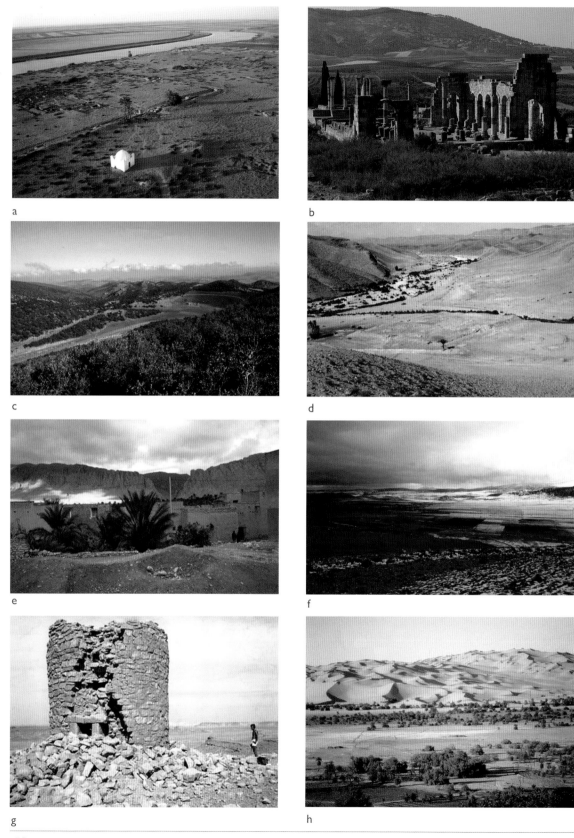

a

b

c

d

e

f

g

h

Die Herausforderung im vorliegenden Band besteht darin, die über 400 Jahre der Grenzentwicklung auf einer Strecke von 3000 km differenzierten Terrains zusammenfassend darzustellen.

Die afrikanischen Grenzen sind weniger gründlich untersucht worden als jene in anderen Teilen des Römischen Reiches, teilweise wegen der beschränkten Grabungsmöglichkeiten an römischen Militäranlagen in der modernen Nachkolonialzeit. Dennoch trägt das afrikanische Material viel zum besseren Verständnis der römischen Grenzen bei.

jusqu'au 5ème siècle L'enjeu ici est de tracer le développement de ces frontières sur plus de 400 ans et à travers quelques 3.000 km d'un territoire aux multiples facettes.

Les frontières africaines sont méconnues par rapport aux autres frontières de l'Empire romain, en partie parce que les travaux de terrain sur les sites militaires romains ont pris fin au cours de la période postcoloniale moderne. Néanmoins, l'Afrique peut contribuer de manière importante à notre compréhension des frontières romaines.

65. Frontier landscapes: a) *Thamusida* on the Wadi Sebou in Morocco; b) *Volubilis* in the foothills of the Atlas mountains (Morocco); c) mountains of eastern *Mauretania Caesariensis* (Algeria); d) Sadouri fort in the Saharan Atlas (Algeria); e) the Algerian desert west of the al-Kantara pass into the Aures mountains; f) location of *Lambaesis* on the Aures high plains (Algeria); g) tower (*burgus*) at Gheriat al-Garbia (Libya); h) Saharan sand sea and oasis (Libya)

Grenzlandschaften: a) *Thamusida* am Wadi Sebou in Marokko; b) *Volubilis* in den Vorbergen des Atlas (Marokko); c) Berge in der östlichen *Mauretania Caesariensis* (Algerien); d) Das Kastell Sadouri im Atlasgebirge der Sahara (Algerien); e) Die algerische Wüste westliche des al-Kantara Passes, der in das Aures Gebirge führt; f) Die Lage von *Lambaesis* auf dem Hochplateau von Aures (Algerien); g) Turm (*burgus*) bei Gheriat al-Garbia (Libyen); h) Sandmeer und Oase in der Sahara (Libyen)

La diversité des paysages de la frontière : a) *Thamusida* sur l'oued Sebou au Maroc ; b) *Volubilis* dans les contreforts de l'Atlas ; c) la montagne de la *Mauretania Caesariensis* (Algérie) ; d) le fort de Sadouri dans l'Atlas saharien (Algérie) ; e) le désert algérien à l'ouest du col d'al-Kantara dans le massif de l'Aurès ; f) l'emplacement de Lambèse sur les hauts-plateaux de l'Aurès ; g) tour (*burgus*) à Gheriat al-Garbia (Libye) ; h) mer de sable et oasis sahariennes (Libye)

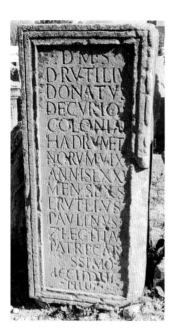

66. Tombstone erected at *Lambaesis* (Algeria) by a soldier of the *legio III Augusta*, for his father

Grabstein, aufgestellt in *Lambaesis* (Algerien) von einem Soldaten der *legio III Augusta*, für seinen Vater

Pierre tombale dressée à Lambèse (Algérie) par un soldat de la légion III Auguste, pour son père

67. Graffito of a Roman fort, from Bu Njem (Libya)

Graffito eines römischen Kastells, aus Bu Njem (Libyen)

Graffiti d'un fort romain provenant de Bu Njem (Libye)

68. Pastoralists in the Algerian High Plains south of the Mauretanian frontier

Hirten in der Algerischen Hochebene südlich der mauretanischen Grenze

Nomades pastoraux des hauts-plateaux d'Algérie au sud de la frontière maurétanienne

The Nature of the Roman Frontiers in Africa

The traditional view of the Roman frontiers (*limites*) in Africa has characterised them as 'open' desert frontiers, protecting the intensive spread of sedentary agriculture within the African provinces from the depredations of nomadic pastoralists. This image requires revision on a number of grounds. Firstly, the geographical context of the African frontiers was much more complicated and many sectors were constructed well to the north of the desert fringe. There was no single frontier entity; geography dictated different frontier systems. Under half of the frontier zone was located in true desert terrain (receiving less than 150 mm of rainfall a year).

Secondly, we rebut the idea of the 'nomad menace'. Relationships between pastoral and sedentary peoples in Africa have often tended to be symbiotic in nature rather than based on conflict, and the frontier works appear better suited to supervision of the movements of transhumant pastoralists than to prevention of such migrations across the frontier. The idea of an 'open' frontier also needs to be reassessed, in that there is evidence for the creation of linear barriers in some sectors.

The History of Research

The pioneers of Roman frontier research in Africa were frequently modern imperial servants, who made researching Roman monuments a hobby alongside their day jobs implementing colonial government in the 19th and early 20th centuries. The French colonial journals are full of reports on antiquities by men like Commandant Donau, Capitaine Boizot, Capitaine Hilaire and so on. Vast numbers of inscriptions relating to the Roman army were discovered and recorded by such men. A large part of the main legionary base in Algeria was excavated at *Lambaesis*, producing one of the richest epigraphic hauls. An influential figure and

Charakteristik der römischen Grenzen in Afrika

Die traditionelle Sichtweise der römischen Grenzen (*limites*) in Afrika stellt diese als „offene" Wüstengrenzen dar, welche die intensive Verbreitung von sesshafter Landwirtschaft innerhalb der afrikanischen Grenzen vor Plünderungen durch nomadische Hirten schützten. Dieses Bild bedarf einer Korrektur in mancherlei Hinsicht. Zunächst war der geographische Kontext der afrikanischen Grenzen wesentlich komplizierter und viele Abschnitte wurden weit nördlich des Wüstensaums gebaut. Es gab keine einzelne Grenze als Gesamtheit, die Geographie diktierte verschiedene Grenzsysteme. Weniger als die Hälfte der Grenzzone befand sich auf tatsächlichem Wüstenboden (mit einem Niederschlag von weniger als 150 mm Regen im Jahr). Zweitens widerlegen wir die Theorie der „Nomadenbedrohung". Die Beziehungen zwischen den pastoralen und sesshaften Völkern in Afrika tendierten vielfach dazu, eher von symbiotischer Art zu sein, denn auf Konflikten basierend, und die Grenzanlagen scheinen besser zur Überwachung der Bewegungen von Hirtennomaden geeignet gewesen zu sein, als zur Verhinderung von solchen Migrationen über die Grenze. Die Idee einer „offenen" Grenze muss ebenfalls überdacht werden, in Anbetracht der Beweise für die Konstruktion von linearen Barrieren in einigen Abschnitten.

Forschungsgeschichte

Bei den Pionieren der Untersuchungen zu den römischen Grenzen in Afrika handelte es sich vielfach um moderne imperiale Staatsdiener, denen die Erforschung von römischen Denkmälern ein Hobby neben ihrer Hauptbeschäftigung in der Kolonialadministration des 19. und frühen 20. Jahrhunderts war. Die französischen Kolonialjournale sind voll von Reporten über Antiquitäten von Personen wie Commandant Donau, Capitaine Boizot, Capitaine Hilaire und so fort. Riesige Mengen die römische Armee betreffender Inschriften wurden entdeckt und von solchen Männern festgehalten. Ein Großteil der Hauptfestung der Legionen Algeriens in

La nature des frontières romaines en Afrique

La représentation traditionnelle des frontières romaines (*limites*) en Afrique est celle de frontières « ouvertes » sur le désert, protégeant la forte expansion de l'agriculture sédentaire au sein des provinces africaines des razzias d'éleveurs nomades. Cette représentation demande à être révisée à plus d'un titre.

Tout d'abord, le contexte géographique des frontières africaines était bien plus complexe, de nombreux secteurs étant construits bien au nord de la frange désertique. La frontière n'était pas une entité unique ; les données géographiques imposaient une diversité de systèmes frontaliers. En fait, moins de la moitié de la zone frontalière se situait dans le désert proprement dit (précipitations annuelles inférieures à 150 mm).

Ensuite, il faut rejeter la notion d'une « menace nomade ». Les relations entre éleveurs et sédentaires en Afrique relèvent plus de la symbiose que du conflit et les aménagements frontaliers semblent mieux adaptés au contrôle des transhumances qu'à la prévention de migrations transfrontalières. D'un autre côté, la notion de frontière « ouverte » doit également être revue, dans la mesure où des traces de création de barrières linéaires existent dans certains secteurs.

L'histoire des recherches

Bien souvent, les pionniers des recherches sur la frontière romaine en Afrique ont été des fonctionnaires coloniaux, qui ont fait de l'étude des monuments romains un passe-temps alors que leur gagne-pain consistait en l'administration des colonies au 19ème et au début du 20ème siècles. Les revues coloniales françaises regorgent de comptes rendus sur les antiquités par des hommes de la trempe du commandant Donau, du capitaine Boizot, du capitaine Hilaire et autres. Ces chercheurs ont découvert en quantité inouïe des inscriptions qui se rapportent à l'armée romaine. Une grande partie de la principale base de légionnaires à Lambèse (*Lambaesis*) en Algérie a été

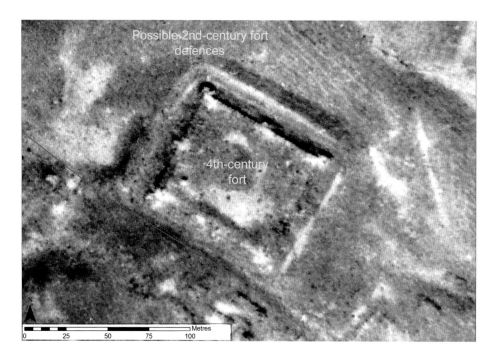

Possible 2nd-century fort defences

4th-century fort

Metres

0 25 50 75 100

69. Baradez air-photo of the late Roman fort at Seba Mgata ('fort parallelogram'), with a hint of the underlying 2nd century fort (Algeria)

Baradez, Luftbild des spätrömischen Kastells bei Seba Mgata ('Parallelogramm-Fort'), mit einer Spur des darunterliegenden Lagers aus dem 2. Jahrhundert (Algerien)

Photo aérienne de Baradez du fort romain tardif à Seba Mgata (« fort parallélogramme ») et indices de la présence d'un fort du 2ème siècle (Algérie)

founding father of Roman frontier studies was Colonel Jean Baradez, who applied his wartime air-photo interpretation skills to mapping the remains of the most famous linear frontier elements, the *fossatum Africae* at *Gemellae* and near *Mesarfelta*.

Unsurprisingly, there has been a problematic legacy from this close association between the study of the Roman frontier and the modern colonial rulers of the Maghreb, which has led to an almost total cessation of fieldwork on the frontiers following independence. Most modern research on the frontiers has involved work on unpublished data from colonial archives or re-analysis of the rich epigraphic record. The African frontier is rightly celebrated as the 'epigraphic frontier' par excellence, yet the lack of fresh field investigation has also ossified understanding.

There are several reasons, however, why the study of Roman frontiers is relevant to the modern nation states of the region. The first is the tourism potential of the frontier monuments, but there is also the potential to gain a better understanding of the nature of African peoples through the study of the Roman infrastructure that was used to regulate their communities, as has proved the case in many European countries.

Lambaesis, wurde ausgegraben, wobei einer der umfangreichsten epigraphischen „Fänge" ans Tageslicht gefördert wurde. Eine einflussreiche Persönlichkeit und ein Begründer der Studien zu den römischen Grenzen war Oberst Jean Baradez, der seine im Krieg erworbenen Fähigkeiten der Interpretation von Luftbildern zur Kartierung der Überreste der bekanntesten linearen Grenzsperre, des *fossatum Africae* bei *Gemellae* und von El Kantara nahe *Mesarfelta* anwandte.

Es überrascht nicht, dass die enge Verbindung zwischen Untersuchungen an der römischen Grenze und den zeitgenössischen Kolonialherren des Maghreb ein problematisches Erbe hinterließ, dass zu einem nahezu vollständigen Abbruch aller Grabungsarbeiten nach Erlangung der Unabhängigkeit führte. Der Großteil moderner Forschungen an den Grenzen beinhaltet Arbeiten an unveröffentlichten Informationen aus Kolonialarchiven oder Aufbereitungen der reichen epigraphischen Dokumentation. Die afrikanische Grenze gilt zu Recht als die „epigraphische Grenze" *par excellence*, aber der Mangel an frischen Forschungsarbeiten im Gelände hat auch das Verständnis verknöchert.

Es gibt jedoch eine Reihe von Gründen, weswegen das Studium der römischen Grenzen für die modernen Staaten der Region relevant ist. Der erste davon ist das touristische Potential der Grenzdenkmäler, aber daneben besteht auch die Möglichkeit, den Charakter der afrikanischen Völker besser zu verstehen, indem man die römische Infrastruktur studiert, die dazu diente, deren Gemeinschaften zu regulieren, so wie es für viele europäische Länder erwiesen ist.

fouillée, livrant l'un des plus importants fonds épigraphiques qui soient. Personnage influent et père fondateur des études sur la frontière romaine, le colonel Jean Baradez a apporté ses compétences acquises en temps de guerre en matière d'interprétation des photographies aériennes à la cartographie des traces des éléments frontaliers linéaires les plus connus, le *fossatum Africae* à *Gemellae* et à proximité de *Mesarfelta*.

L'association étroite entre les études sur la frontière romaine et la présence de la puissance coloniale moderne au Maghreb représente un héritage gênant qui a conduit, sans grande surprise, à la cessation quasi-totale des recherches sur le terrain à la suite des indépendances. La plupart des recherches récentes sur les frontières s'appuient sur des données inédites des archives coloniales ou sur de nouvelles analyses de l'abondant fonds épigraphique. La frontière africaine est connue à juste titre comme la « frontière épigraphique » par excellence ; pourtant l'absence de nouvelles recherches sur le terrain fait que la compréhension de ce domaine s'ankylose.

L'étude des frontières romaines a son importance pour les Etats actuels de la région et ce à plusieurs titres. Tout d'abord, pour le potentiel touristique des monuments frontaliers ; mais aussi pour la possibilité qu'elle offre de mieux comprendre la nature des populations africaines grâce à l'étude des infrastructures romaines qui ont servi à contrôler ces territoires, tout comme cela s'est produit dans de nombreux pays d'Europe.

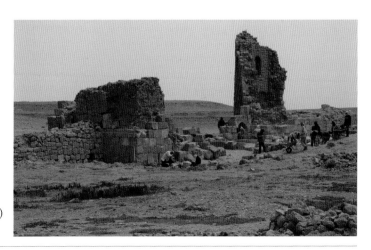

70. Excavation work in progress at Gheriat al-Gharbia (Libya)

Ausgrabungen in Gheriat al-Gharbia (Libyen)

Fouilles à Gheriat al-Gharbia (Libye)

71. Depiction of *Garamantes* in a Roman amphitheatral mosaic from Zliten (Libya)

Mosaikdarstellung der *Garamantes* aus einem römischen Amphitheater aus Zliten (Libyen)

Représentation de *Garamantes* dans une mosaïque provenant d'un amphithéâtre romain à Zliten (Libye)

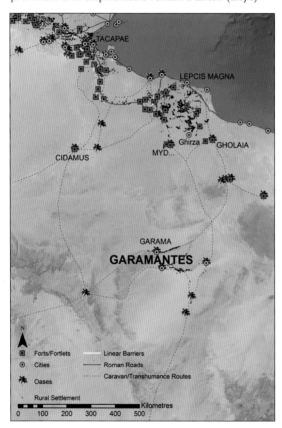

72. Map showing the land of the *Garamantes* (Fazzan) in relation to the Mediterranean

Karte mit den Gebieten der *Garamantes* (Fazzan) in Relation zum Mittelmeergebiet

Carte indiquant la situation de du territoire des *Garamantes* (Fazzan) par rapport à la Méditerrannée

The Peoples of Africa

A key objective is to contextualise Roman frontiers more fully in relation to the archaeology of the indigenous peoples. A major problem is that the Iron Age (or Protohistoric) archaeology of the Maghreb is still very poorly developed. Ancient literary evidence is problematic. Pliny the Elder, for instance, mentioned 516 separate peoples of North Africa. The many ethnic names reflect the segmented nature of traditional African societies, where individuals were commonly associated with several levels of a 'tribal hierarchy', ascending from the household, to clans, sub-tribes, peoples and confederations. Plainly, ancient writers were not explicit (or did not always understand) about the significance of the ethnic names they encountered. Another literary sterotype of all the Roman frontier zones was the schematic imposition of barbaric characteristics on neighbouring peoples. While people close to the Mediterranean seaboard were generally characterised as agricultural and urbanised, those lying further into the interior were uniformly portrayed as pastoralists, living in tents and huts and lacking the trappings of civilisation. With increasing distance people were schematically relegated further down the human evolutionary scale: hunter gatherers; cave-dwellers; people who slept in the open like animals; sub-human apparitions (lacking heads and so on). Such source material is bound up with the Roman colonial discourse and tells us more about Roman prejudices than it does about the African realities. Roman sources have too often been taken at face value, leading some modern scholars to underestimate the potential sophistication of these peoples.

Archaeology has the potential to redress this imbalance, as in the case of the **Garamantes** of southern Libya. Based in the central Saharan region known today as Fazzan, about 1000 km south of the Mediterranean ports of *Sabratha*, *Oea* (Tripoli) and *Lepcis Magna*, the *Garamantes* first appear in the historical account of Herodotus in the 5th century BC and entered Roman consciousness in the later 1st century BC. A celebrated campaign by the Proconsul Cornelius Balbus penetrated to their desert heartlands in 20 BC, with a triumph celebrated in Rome the following year. For much of the next

Die Völker Afrikas

Ein Hauptanliegen ist es, die römischen Grenzen vollständiger in ihrer Relation zur Archäologie der indigenen Völker darzustellen. Ein großes Problem besteht darin, dass die Archäologie der Eisenzeit (bzw. Frühgeschichte) des Maghreb weiterhin schwach entwickelt ist. Antike Schriftquellen sind tückisch. Plinius d. Ältere etwa nennt 516 separate Völker Nordafrikas. Die vielen ethnischen Bezeichnungen spiegeln den segmentierten Charakter der traditionellen afrikanischen Gemeinschaften wider, in denen einzelne Personen gemeinhin mit mehreren Stufen einer „Stammeshierarchie" assoziiert wurden, die vom Haushalt bis zu Klans, Stammesgruppen, Völkern und Konföderationen aufsteigt. Offensichtlich gaben die antiken Autoren die Bedeutung der ethnischen Bezeichnungen mit denen sie sich auseinandersetzten nicht wider (oder verstanden diese nicht immer).

Ein weiteres literarisches Vorurteil in Bezug auf alle römischen Grenzzonen war die Zuweisung von barbarischen Merkmalen an die Nachbarvölker. Während Völker nahe dem Mittelmeer zumeist als landwirtschaftlich und urbanisiert dargestellt werden, charakterisierte man jene weiter im Binnenland uniform als Hirten, die in Zelten und Hütten leben und denen die Eigenschaften der Zivilisation fehlten. Mit zunehmender Entfernung wurden Völker auf schematische Weise auf der Entwicklungsleiter weiter nach unten verschoben: Jäger und Sammler, Höhlenbewohner, Gemeinschaften, die wie Tiere im Freien schlafen, untermenschliche Erscheinungen (ohne Köpfe, und ähnliches mehr). Solch ein Quellenmaterial entstammt dem kolonialrömischen Diskurs und sagt uns mehr über die Vorurteile der Römer als über die afrikanische Wirklichkeit. Römische Quellen wurden allzu häufig im Wert überschätzt, was moderne Forscher dazu verleitete, die mögliche Fortschrittlichkeit dieser Völker zu unterschätzen.

Die Archäologie hat das Potential, dieses Ungleichgewicht zu kompensieren, wie im Fall der ***Garamantes*** des südlichen Libyen. Heimisch in einer Zentralregion der Sahara, die heute als Fazzan bekannt ist, etwa 1000 km südlich der Mittelmeerhäfen *Sabratha*, *Oea* (Tripoli) und *Lepcis Magna*, erscheinen die *Garamantes* zuerst in der

Les peuples d'Afrique

L'un des objectifs clé est de mieux comprendre le contexte des frontières romaines par rapport à l'archéologie des populations autochtones. Un des problèmes majeurs est le faible développement de l'archéologie de l'âge du fer (la protohistoire) au Maghreb. Les témoignages littéraires anciens sont problématiques. Pline l'Ancien, par exemple, fait état de 516 peuples différents en Afrique du Nord. Les nombreux noms d'ethnies sont le reflet de la nature gigogne des société africaines traditionnelles où les individus étaient souvent associés à plusieurs niveaux de la « hiérarchie tribale », depuis le foyer et le clan à la sous-tribu, au peuple et à la confédération. De toute évidence, les auteurs anciens n'ont pas été explicites au sujet de (ou n'ont pas toujours compris) la signification des noms ethniques qu'ils rencontraient.

Un autre stéréotype littéraire de toutes les zones frontalières romaines consistait à attribuer des caractéristiques barbares aux populations voisines. Tandis que les habitants du littoral méditerranéen étaient généralement caractérisés comme cultivateurs et urbanisés, ceux de l'intérieur des terres étaient dépeints comme des éleveurs, vivant dans des tentes ou des huttes et dépourvus des atours de la civilisation. Plus elles étaient éloignées, plus les populations se situaient en bas de l'échelle de l'évolution humaine : chasseurs-cueilleurs, troglodytes, populations couchant à la belle étoile comme des bêtes, apparitions sous-humaines (sans tête ou autres). De telles sources sont liées au discours colonial romain et nous en disent plus long sur les préjugés des Romains que sur les réalités africaines. Les sources romaines ont bien trop souvent été prises à la lettre, ce qui a conduit certains chercheurs modernes à sous-estimer la sophistication potentielle de ces populations.

L'archéologie a la capacité de corriger ce déséquilibre, comme dans le cas des ***Garamantes*** du sud de la Libye. Occupant la région du Sahara central connue aujourd'hui sous le nom de Fezzan, à un millier de kilomètres au sud des ports méditerranéens de *Sabratha*, *Oea* (Tripoli) et de *Lepcis Magna*, les *Garamantes* apparaissent pour la première fois dans le récit historique d'Hérodote au 5ème siècle av. J.-C. et se font connaître des

73. Ashlar construction at the Garamatian capital (Old Jarma), Libya

Bau aus Quadermauerwerk in der Hauptstadt der *Garamantes* (Alt Jarma), Libyen

Construction en pierre de taille de la capitale des *Garamantes* (Jarma), Libye

75. Spoil mounds at the surface of a subterranean Garamantian irrigation canal (foggara), Libya

Ausflussöffnungen an der Oberfläche eines unterirdischen garamantischen Bewässerungskanals (foggara), Libyen

Déblais résultant du creusement d'un canal souterrain d'irrigation garamante (foggara), Libye

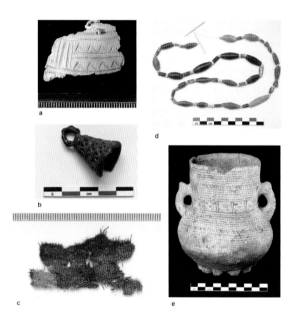

74. Garamantian craftwork: a) engraved gourd; b) copper alloy bell; c) textile; d) beadwork in carnelian and amazonite; e) decorated pottery, Libya

Garamantische Handwerkserzeugnisse: a) gravierte Kalebasse; b) Kupferglocke; c) Textilie; d) Perlschmuck aus Karneol und Amazonit; e) verzierte Keramik, Libyen

Artisanat garamante : a) gourde gravée ; b) cloche en alliage de cuivre ; c) textile ; d) perles en cornaline et amazonite ; e) poterie décorée, Libye

century, the *Garamantes* periodically featured as an enemy of Rome, though from the AD 70s onwards the relationship appears to have been transformed into one of trading partner. The Roman sources portray them as ungovernable nomads and barbarians, interested only in brigandage, but archaeological research provides an important corrective to this view.

The *Garamantes* can now be recognised as a sophisticated early Libyan state. Their heartlands lay in a very arid area where there is negligible rainfall and summer temperatures can approach 50° C. However, despite the climatic adversity, their society was based on agriculture and was essentially sedentary, focused on villages and towns of considerable architectural pretension. Garamantian agriculture was made possible by the construction of a vast network of underground irrigation canals (foggaras) – it is estimated that the construction of this system required about 80,000 man years of work, a clear indication of organisational ability. Huge volumes of Roman goods – amphorae of oil, wine and fish products, fine pottery and glassware – have been recovered from Garamantian burials and settlements, indicating that Trans-Saharan trade reached a significant volume and value in the Roman period. At the height of its power, the Garamantian kingdom controlled a vast Saharan territory of about 250,000 km^2 with an overall population probably in excess of 100,000.

Geschichtsschreibung von Herodot im 5. Jh. v. Chr. und treten im späten 1. Jh. v. Chr. in die römische Wahrnehmung. Ihr Kernland in der Wüste wurde bei einer umjubelten Kampagne des Prokonsuls Cornelius Balbus im Jahr 20 v. Chr. penetriert, und im darauffolgenden Jahr mit einem Triumph in Rom gefeiert. Für den Großteil des nächsten Jahrhunderts traten die *Garamantes* immer wieder als Feind Roms in Erscheinung, obwohl sich die Beziehung ab den 70er Jahren des ersten Jahrhunderts zu einer Handelspartnerschaft gewandelt hatte. Die römischen Quellen sehen die *Garamantes* als unregierbare Nomaden und Barbaren, die nur an Räuberei interessiert waren, aber archäologische Untersuchungen liefern eine wichtige Korrektur dieser Sichtweise.

Die *Garamantes* können heute als ein fortschrittlicher früher libyscher Staat angesehen werden. Ihr Kernland lag in einer sehr kargen Gegend, wo es kaum regnet und die Temperaturen im Sommer 50° C erreichen können. Aber trotz des ungünstigen Klimas, basierte Ihre Gesellschaft auf Landwirtschaft und war insgesamt sesshaft, konzentriert in Dörfern und Städten von beträchtlichem architektonischem Anspruch. Die Landwirtschaft der *Garamantes* wurde durch den Bau eines riesigen Netzwerks von unterirdischen Bewässerungskanälen (foggaras) ermöglicht – man schätzt, dass die Konstruktion dieses Systems etwa 80.000 Menschenjahre an Arbeit erforderte, ein klarer Hinweis auf organisatorische Fähigkeiten. Gewaltige Mengen an römischen Waren – Amphoren mit Öl, Wein und Fischprodukten, Feinkeramik und Glaserzeugnissen – wurden aus garamantischen Gräbern und Siedlungen geborgen, ein Indikator dafür, dass der Transsahara-Handel in der römischen Zeit einen signifikanten Umfang und Stellenwert erreicht hatte. Auf dem Höhepunkt seiner Macht kontrollierte das Königreich der Garamanten ein gigantisches Territorium in der Sahara von etwa 250.000 km², mit einer Gesamtbevölkerung von über 100.000 Menschen.

Romains vers la fin du 1er siècle av. J.-C. Une campagne célèbre du proconsul Cornelius Balbus permet de pénétrer au cœur de leurs terres désertiques vers 20 av. J.-C., donnant lieu à un triomphe à Rome l'année suivante. Pendant une grande partie du siècle qui suit, les *Garamantes* font figure d'ennemis de Rome, encore qu'à compter des années 70 ap. J.-C., la relation semble s'être muée en un partenariat commercial. Les sources romaines font état d'un peuple de nomades et de barbares impossible à gouverner, ne s'intéressant qu'au brigandage, mais les recherches archéologiques corrigent cette vision des choses.

Les *Garamantes* sont reconnus à présent comme un Etat libyen primitif et sophistiqué. Le cœur de leur territoire se situait dans une zone extrêmement aride, sans précipitations notables et soumises à des températures estivales avoisinant les 50 °C. Toutefois, malgré les affres du climat, c'est une société agricole et sédentaire pour l'essentiel, dont les villages et les villes n'étaient pas sans prétention architecturale. L'agriculture garamante était rendue possible grâce à la construction d'un vaste réseau souterrain de canaux d'irrigation (foggaras) – on estime que la construction de ce système a nécessité environ 80.000 ans/homme de travail, indiquant une capacité d'organisation certaine. D'énormes quantités de marchandises romaines – amphores d'huile ou de vin et produits de la pêche, poteries fines et verroterie – ont été récupérées dans les sépultures et l'habitat, indiquant que le commerce trans-saharien à l'époque romaine était significatif tant par son volume que par sa valeur. Au faîte de sa puissance, le royaume garamante contrôlait un vaste territoire saharien de quelques 250.000 km² avec une population totale sans doute supérieure à 100.000 habitants.

76. Italian sigillata bowl (Drag. 29) from a typical late 1st century AD Garamantian grave, Libya

Italische Terra Sigillata Schüssel (Typ Drag. 29) aus einem typischen garamantischen Grab des späten 1. Jahrhunderts n. Chr., Libyen

Bol sigillé italien (Drag. 29) provenant d'une sépulture garamante type de la fin du 1er siècle ap. J.-C., Libye

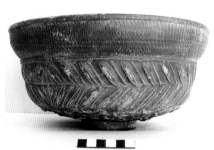

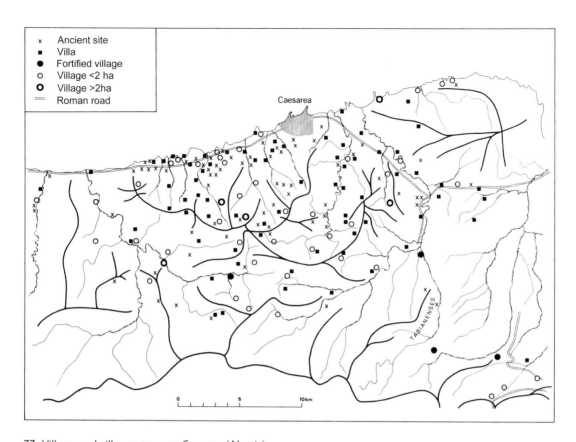

Legend:
- x — Ancient site
- ■ — Villa
- ● — Fortified village
- ○ — Village <2 ha
- **O** — Village >2ha
- = — Roman road

Caesarea

TABIANENSES

0 5 10 km

77. Villages and villa estates near *Caesarea* (Algeria); the solid lines indicate watersheds

Dörfer und Villenanlagen nahe *Caesarea* (Algerien); die durchlaufenden Linien stellen Wasserscheiden dar

Villages et domaines de villa près de *Caesarea* (Algérie) les traits épais représentent les lignes de partage des eaux

Nor were the *Garamantes* uniquely advanced among African societies. In the northern Maghreb, it is clear that by the latter centuries BC, there were advanced urban, agricultural societies coalescing into genuine states (the Numidian and Mauretanian kingdoms). Even in the pre-desert boundary lands it is clear that oasis societies were becoming widespread (as evidence of Roman campaigns against oases at *Capsa* and *Cidamus* indicate). This radically changes our perception of the nature of the Roman frontier interaction in Africa. Far from being faced by 'nomadic brigands', the Romans were confronted by numerous substantial and socially well-evolved oasis farming communities, as well as by transhumant pastoral groups.

There is a need for similar studies elsewhere. The peoples of the Mauretanian mountains and interior steppes, in particular, are poorly understood. The mountains were once thought of as devoid of Roman settlements, home to 'tribes' implacably hostile to Roman rule, a theory which reflected the 19th- and 20th-century colonial situation. Fieldwork can transform this negative picture.

Auch waren die *Garamantes* unter den afrikanischen Gemeinschaften durchaus nicht ungewöhnlich weit fortgeschritten. Es ist sicher, dass im nördlichen Maghreb in den letzten Jahrhunderten v. Chr. entwickelte urbanisierte und Ackerbau betreibende Gemeinschaften existierten, die miteinander verschmolzen und sich in richtige Staaten entwickelten (die Königreiche von Numidien und Mauretanien). Sogar in den Grenzländern der Vorwüste ist es offensichtlich, dass Oasengemeinschaften zunehmend weit verbreitet waren (wofür die römischen Kampagnen gegen die Oasen bei *Capsa* und *Cidamus* ein Beweis sind). Dies verändert unsere Wahrnehmung der Beschaffenheit der Interaktion an der römischen Grenze in Afrika. Weit davon entfernt, es mit „nomadischen Räubern" zu tun zu haben, waren die Römer mit einer Vielzahl von substanziellen und sozial weit entwickelten Gemeinschaften des Oasenackerbaus konfrontiert, wie auch mit nichtsesshaften, pastoralen Gruppen.

Es besteht ein Bedarf für ähnliche Studien anderswo. Insbesondere die Völker der Berge Mauretaniens und der Binnenlandsteppen werden mangelhaft verstanden. Die Berge wurden einst als bar jeder römischen Siedlungen angesehen, als Heimat von „Stämmen", die der römischen Herrschaft mit unerbittlicher Feindseligkeit gegenüberstanden – eine Theorie, welche die Situation der Kolonien im 19. und 20. Jh. widerspiegelt. Ausgrabungen können dazu beitragen, dieses negative Bild zu modifizieren. Bei Oberflächenbegehungen in den 1970er Jahren im Hinterland von *Caesarea* (Cherchel), der Hauptstadt von *Mauretania Caesariensis*, wurden mehrere größere Dörfer (*castella*) identifiziert, welche jenseits der Zone mit Villenbebauung im Umkreis der Stadt lagen. Diese wurden als Siedlungen der autochthonen Gemeinschaften interpretiert, möglicherweise Bestandteile von Splittergruppen wie den *Mazices* oder *Maccui*, die einen schrittweisen Übergriff auf ihr Gebiet von der Stadt aus erlebten.

Inschriften bieten eine bessere Einsicht in die differenzierten Beziehungen zwischen Rom und den mauretanischen Völkerschaften. Bemerkenswert sind die Serien von „Friedensaltären", die an Treffen (*conloqia*) zwischen den Gouvenateuren von *Mauretania Tingitana* und den Statthaltern der *Baquates* erinnern, Zeugnis einer diplomatischen Verbindung mit diesem großen Volk und ähnlichen

La civilisation évoluée des *Garamantes* n'était pas un cas unique parmi les sociétés africaines. Dans le nord du Maghreb, il est patent que, vers les derniers siècles av. J.-C., des sociétés avancées, urbaines et agricoles se regroupaient pour former de véritables Etats (les royaumes de Numidie et de Maurétanie). Même dans les territoires de la ceinture pré-saharienne, il est évident que les sociétés des oasis étaient largement répandues (comme l'indiquent les campagnes romaines contre les oasis à *Capsa* et à *Cidamus*). Tout cela transforme radicalement notre perception de la nature des interactions à la frontière romaine en Afrique. Loin d'être confrontés à des « brigands nomades », les Romains se trouvaient aux prises avec de nombreuses populations de cultivateurs d'oasis dotées d'une organisation sociale bien développée ainsi qu'avec des groupes d'éleveurs transhumants.

Des études semblables dans d'autres régions sont nécessaires. Notamment, les populations du massif maurétanien et des steppes intérieures sont méconnues. On a longtemps pensé que les massifs étaient dénués d'établissements romains et accueillait des « tribus » d'une hostilité implacable à l'administration romaine, théorie qui reflétait la situation coloniale du 19ème et 20ème siècles. Des travaux sur le terrain pourraient faire évoluer cette image négative.

Des prospections entreprises dans les années 1970 dans arrière-pays de *Caesarea* (Cherchel), capitale de la Maurétanie césarienne, ont identifié plusieurs villages (*castella*) situés au-delà de la zone des villas entourant la ville. Ceux-ci ont été interprétés comme des établissements indigènes, peut-être les composants de sous-groupes ethniques comme les *Mazices* ou les *Maccui*, dont les territoires étaient progressivement grignotés par l'agglomération.

Les inscriptions donnent une vision plus nette des relations contrastées entre Rome et les populations maures. La série des « autels de paix » commémorant des rencontres (*conloquia*) entre les gouverneurs de la Maurétanie tingitane et les chefs des *Baquates*, preuves d'une relation diplomatique avec ce peuple nombreux ainsi qu'avec des ensembles similaires comme les *Macennites* ou les *Bavares*. Une grande tablette en bronze provenant de *Banasa* qui atteste de l'octroi de la citoyenneté

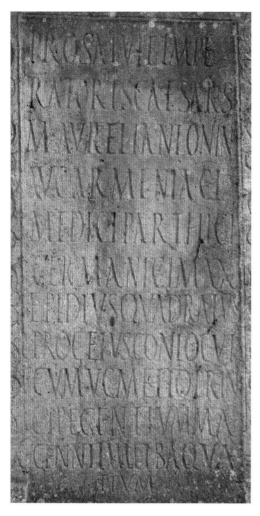

78. Inscription recording the peace conference between Roman governor and Ucmetio, *princeps* of *Baquates* and *Macennites* (Morocco)

Eine Inschrift, welche die Friedensverhandlungen zwischen dem römischen Statthalter und Ucmetio, dem *princeps* der *Baquates* und der *Macennites* festhält (Marokko)

Inscription rappelant une conférence de paix entre le gouverneur romain et Ucmetio, *princeps* des *Baquates* et des *Macennites* (Maroc)

Survey undertaken in the 1970s in the hinterland of *Caesarea* (Cherchel), the capital of *Mauretania Caesariensis*, identified several large villages (*castella*) located beyond the zone of villa estates surrounding the city. These were interpreted as the settlements of indigenous communities, perhaps constituents of segmentary groupings like the *Mazices or Maccui*, experiencing gradual encroachment on their territory from the city.

Inscriptions provide a clearer view of the varied relations between Rome and Moorish communities. Notable are the series of 'altars of peace' commemorating meetings (*conloqia*) between the governors of *Mauretania Tingitana* and the chiefs of the *Baquates*, attesting a diplomatic relationship with this large people and with similar groups like the *Macennites* and *Bavares*. A large bronze tablet from *Banasa* attesting the grant of citizenship to a chief of the *Zegrenses*, which also alludes to their taxation, suggests that some indigenous groups were much more tightly controlled. Such control was often formalised by placing communities under the control of a *praefectus gentis*, as in the case of the *Mazices*, usually the commander of a nearby regiment or a local civic magistrate. By the late empire, however, such prefects were generally members of the indigenous elite, holding the post like a civic magistracy or simply as an honorary title, while some Moorish chieftains also served as military officers. One individual, Gildo, even rose to hold the most senior regional command, with the imposing title *comes et magister utriusque militiae per Africam*, and was a key figure in imperial politics towards the end of the 4th century. Evidently the native elites wanted a share of the benefits provided by membership of the official hierarchy, just like their civic counterparts.

Gruppen wie den *Macennites* und *Bavares*. Ein Bronzetablett aus *Banasa* bezeugt die Zusprechung des römischen Bürgerrechts an einen Stammesführer der *Zegrenses*, was auch auf deren Steuerpflicht hinweist und nahelegt, dass einige indigene Gruppen wesentlich intensiver kontrolliert wurden. Diese Kontrolle wurde oft dadurch formalisiert, dass Gemeinschaften, wie im Fall der *Mazices*, unter die Aufsicht eines *praefectus gentis* gestellt wurden, bei dem es sich um den Kommandanten eines nahen Regiments oder lokalen zivilen Magistrats handelte. Im der späten Kaiserzeit waren diese Präfekten zumeist Mitglieder der indigenen Elite, welche das Amt wie eine zivile Magistratur oder einfach als Ehrentitel innehatten, während einige Anführer der Mauretanier auch als Militäroffiziere dienten. Eine Einzelperson, Gildo, stieg sogar so weit auf, den höchsten regionalen Befehlsrang zu haben, mit dem imposanten Titel *comes et magister utriusque militiae per Africam*, und war eine Schlüsselfigur in der imperialen Politik gegen Ende des 4. Jahrhunderts. Offensichtlich wollten die Eliten der Einheimischen in der Grenzzone einen Anteil an den Vorteilen haben, die eine Zugehörigkeit zur offiziellen Hierarchie bot, ebenso wie ihre Pendants in den Städten.

à un chef des *Zegrenses*, faisant allusion aussi à leur imposition fiscale, donne à penser que certains groupes indigènes étaient soumis à un contrôle bien plus strict. Souvent ce contrôle était formalisé par la mise d'une population sous la tutelle d'un *praefectus gentis*, comme c'était le cas des *Mazices*, souvent en la personne du commandant d'un régiment voisin ou d'un magistrat local. Dès le bas-Empire, cependant, ces préfets étaient généralement des membres de l'élite autochtone, détenant la fonction comme une magistrature ou un simple titre honorifique, alors que certains chefs maures exerçaient également des fonctions militaires. Un dénommé Gildo est même arrivé à l'exercice du haut commandement régional sous le titre imposant de *comes et magister utriusque militiae per Africam*, devenant ainsi un personnage clé de la vie politique impériale vers la fin du 4ème siècle. De toute évidence, les élites indigènes ambitionnaient de bénéficier eux aussi des avantages offerts par l'appartenance à la hiérarchie officielle, au même titre que leurs homologues issus des élites municipales.

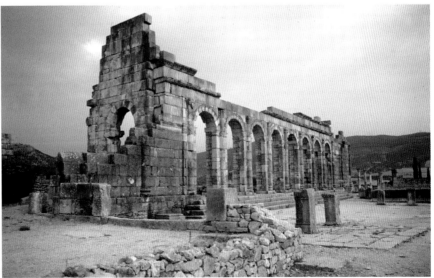

79. The forum basilica in *Volubilis* (Morocco) where peace treaties with the *Baquates* were agreed

Die Basilika des Forums von *Volubilis* (Marokko), wo das Abkommen mit den *Baquates* zustande kam

Le forum de la basilique à Volubilis (Maroc) où furent convenus les traités avec les *Baquates*

80. Coin of Ptolemy, Roman client king of *Mauretania*

Münze des Ptolemäus, von Rom unterstützter Klientelkönig von *Mauretania*

Monnaie de Ptolémée, roi de *Maurétanie*, client de Rome

81. Inscription of the Legate of *Legio III Augusta*, identified as patron of veteran colony at *Thamugadi* (Algeria)

Inschrift eines Legaten der *Legio III Augusta,* als Gründer der Verteranenkolonie von *Thamugadi* angeführt (Algerien)

Inscription du légat de la légion III Auguste, identifié comme le patron d'une colonie de vétérans à *Thamugadi* (Algérie)

82. The command of the duke and governor of *Mauretania Caesariensis* in the *Notitia Dignitatum*

Die Befehlsgewalt des Fürst (*dux*) und Statthalters von *Mauretania Caesariensis* in der *Notitia Dignitatum*

Le commandement du duc et gouverneur de la Maurétanie Césarienne dans la *Notitia Dignitatum*

Historical Background

Africa Proconsularis was founded on Carthage's territory at the end of the 3rd Punic War in 146 BC, augmented in 46 BC by the confiscation by Julius Caesar of the Numidian kingdom, to which was also added *Tripolitania* to the south-east. To the west, Rome recognised a client kingdom of *Mauretania*, until Caligula had its ruler Ptolemy murdered in AD 39. The annexation was strongly resisted and when Roman control was secured under Claudius, the territory was divided into two provinces, *Mauretania Caesariensis* in the east and *Mauretania Tingitana* in the west, with governors appointed directly by the emperor. However, control of the legionary garrison in Africa was passed from a proconsul to an imperial legate in 39 and *Numidia* was recognised as a separate province from the early 3rd century. *Cyrenaica* passed under Roman control in 96 BC with the death of the last recognised client king and in 27 BC was administratively attached to Crete. In the later Roman period there was further subdivision of the provinces and reorganisation of military commands. *Cyrenaica* always remained in the Eastern Dioceses, while *Mauretania Tingitana* was attached to Hispana across the Straits of Gibraltar. The other African territories were subsumed in an African Diocese. The Vandal invasion of North Africa in 429 led to the creation of a kingdom there, though with significant depletion of effective frontier control. The power vacuum in the old frontier sectors was filled by a number of 'berber' kingdoms, in part based on the populations of the old garrison settlements.

The African frontiers were not entirely peaceful, though there has been considerable disagreement about the source and severity of reported outbreaks of warfare and revolt. The threats seem to have come in equal measure from internal communities as external peoples and some sectors such as *Mauretania* seem to have been much more severely affected. Nonetheless, looking at the overall picture, and considering the chronology and geographic scale, it is evident that considerable economies of force were achieved.

Historischer Hintergrund

Africa Proconsularis wurde nach Ende des 3. Punischen Krieges 146 v. Chr. auf karthagischem Gebiet gegründet, und 46 v. Chr. vergrößert, als Julius Caesar das Numidische Königreich konfiszierte. Im Westen wurde von Rom das Klientelkönigreich Mauretania anerkannt, bis Caligula den Herrscher Ptolemäus im Jahr 39 n. Chr. ermorden ließ. Die versuchte Annexion traf auf harten Widerstand und als die römische Kontrolle unter Claudius gesichert war, wurde das Gebiet in zwei Provinzen geteilt, *Mauretania Caesariensis* im Osten und *Mauretania Tingitana* im Westen. Jedoch wurde in *Africa* die Kontrolle über die dort stationierten Legionäre im Jahr 96 v. Chr. vom Prokonsul an einen kaiserlichen Legaten übertragen und *Numidia* seit dem frühen 3. Jahrhundert als eigenständige Provinz angesehen. *Cyrenaica* kam im Jahr 96 v. Chr. unter römische Kontrolle, als der letzte anerkannte Klientelkönig verstarb und wurde dann 27 v. Chr. etwas ungeschickt aus administrativen Gründen mit der Insel Kreta im Norden zusammengefügt. In der späteren Römerzeit wurde eine weitere Unterteilung der Provinzen und eine Reorganisation der Kommandos über das Militär vorgenommen. *Cyrenaica* blieb stets in den östlichen Diözesen, während *Mauretania Tingitana* an *Hispana* jenseits der Straße von Gibraltar angefügt wurde. Die anderen afrikanischen Territorien wurden in einer einzigen Diözese zusammengefasst. Die Invasion der Vandalen in Nordafrika im Jahr 429 resultierte in der Entstehung eines Königreichs dort, wenngleich mit einer signifikanten Schwächung der effektiven Grenzkontrolle. Das Machtvakuum an den alten Grenzabschnitten wurde von einer Anzahl von „Berberkönigreichen" ausgefüllt, die zum Teil auf der Bevölkerung der alten Garnisonssiedlungen basierten. Die afrikanischen Grenzen waren nicht gänzlich friedlich, wenn auch der Ursprung und das Ausmaß der berichteten Ausbrüche von Kriegshandlungen und Revolten umstritten sind. Die Bedrohung scheint in gleichem Maß von den internen Gemeinschaften wie von äußeren Völkern ausgegangen zu sein und einige Sektoren wie etwa *Mauretania* waren offenbar wesentlich stärker betroffen. Insgesamt ist ersichtlich, dass – im Hinblick auf die Chronologie und die geographische Weite – eine beträchtliche Ökonomie in der Kraftverteilung erreicht wurde.

Le contexte historique

L'*Africa Proconsularis* a été fondée dans le territoire pris à Carthage à l'issue de la troisième Guerre punique en 146 av. J.-C., agrandie en 46 av. J.-C. grâce à la confiscation par Jules César du royaume numide, et étendue à la Tripolitaine au sud-est. A l'ouest, Rome reconnaissait un royaume client de Maurétanie, jusqu'à ce Caligula fit assassiner son roi, Ptolémée, en 39 ap. J.-C. L'annexion rencontra une forte résistance et, lorsque le contrôle romain a finalement été imposé sous Claude, le territoire fut divisé en deux provinces, la Césarienne à l'est et la Tingitane à l'ouest, les gouverneurs étant nommés par l'empereur. Toutefois, le contrôle de la garnison de légionnaires en *Africa* s'est vu transféré d'un proconsul à un légat impérial en 39 et la Numidie fut reconnue en tant que province distincte à partir du début du 3ème siècle. La Cyrénaïque passa sous contrôle romain en 96 av. J.-C. lors du décès du dernier roi client reconnu et a été rattachée en 27 av. J.-C. à l'île de Crète. La fin de l'époque romaine vit d'autres découpages des provinces et la réorganisation des commandements militaires. La Cyrénaïque resta toujours dans les évêchés orientaux tandis que la Maurétanie Tingitane fut rattachée à Hispania de l'autre côté du détroit de Gibraltar. Les autres territoires furent englobés dans un évêché africain. L'invasion vandale de l'Afrique du Nord en 429 conduisit à la création d'un royaume, mais non sans une réduction significative du contrôle effectif des frontières. La vacance du pouvoir dans les anciens secteurs frontaliers fut comblée par des royaumes « berbères » s'appuyant en partie sur les populations des anciennes villes de garnison.

Les frontières africaines n'étaient pas totalement pacifiées, encore que les origines et l'intensité des épisodes de guerre et de révolte sont controversées, les menaces provenant tantôt des populations internes tantôt des peuplades externes, certains secteurs comme la Maurétanie étant bien plus touchés que d'autres. Néanmoins, dans l'ensemble, et compte tenu des échelles temporelle et spatiale, il est certain que des « économies de force » importantes ont été réalisées.

83. *Signum* of the *Legio III Augusta* found at *Lambaesis* (Algeria)

Signum der *Legio III Augusta*, gefunden in *Lambaesis* (Algerien)

Signum de la *Legio III Augusta* retrouvé à Lambèse (Algérie)

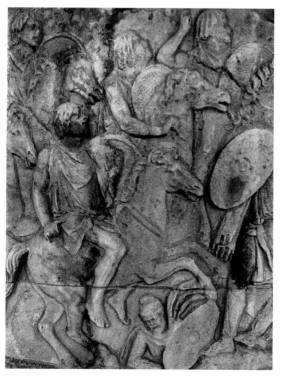

84. Moorish cavalry as depicted on Trajan's Column in Rome (Italy)

Maurenkavallerie, dargestellt auf der Trajanssäule in Rom (Italien)

Cavalerie maure représentée sur la colonne de Trajan à Rome (Italie)

Military Deployment

The Roman garrison in North Africa never appears to have been particularly large in relation to the linear extent of the frontier zones. *Mauretania Tingitana* and *Caesariensis* were normally garrisoned solely by auxiliary units (with a total of about 15,000 troops at maximum), exceptionally reinforced by legionary expeditionary forces from other provinces in moments of particular crisis, as in 140–150. The garrison of *Africa Proconsularis* (with its frontier sectors of *Numidia* and *Tripolitana*) had stabilised by the late 1st century with no more than about 20,000 troops, comprising the *Legio III Augusta* and a small core of auxiliary units. The manpower resources were thinly stretched, as is evident from the substantial outposting of legionary detachments away from their home base at *Lambaesis* from the later 2nd century. This became even more evident when the frontier was pushed further out in the reign of Septimius Severus. From the 2nd century recruitment into the legion was predominantly from within the African provinces, though the auxiliary units included a significant group of Syrians. Many units were cavalry *alae* or mixed infantry/cavalry cohorts – in part reflecting the long communication lines on the African frontiers and in part the fact that the native peoples of Africa were celebrated for their light cavalry.

The disbanding of the *III Augusta* by Gordian III in 238 ushered in a period of further reorganisation of frontier arrangements. The Late Roman army in Africa comprised two distinct classes of troops with separate command structures and different pay and conditions. On the one hand were new style battle units (*comitatenses*, including both infantry and cavalry); on the other were the *limitanei* who were remnants of the old frontier troops, now with a largely policing role, but often still with the same names and in the same bases as the 2nd-century garrison.

Truppenstationierung

Die römische Garnison in Nordafrika scheint angesichts der linearen Dehnung der Grenzzonen nie sehr umfangreich gewesen zu sein. In *Mauretania Tingitana* und *Caesariensis* waren normalerweise ausschließlich Auxiliareinheiten (mit einer maximalen Truppenstärke von 15.000 Mann) stationiert, die in Ausnahmefällen, bei besonderen Krisensituationen, wie etwa in den Jahren 140–150 n. Chr., durch Expeditionsstreitkräfte der Legionen aus anderen Provinzen verstärkt wurden. Die Garnison von *Africa Proconsularis* (mit den ehemaligen Abschnitten *Numidia* und *Tripolitana*) stabilisierte sich zum Ende des 1. Jahrhunderts auf nicht mehr als 20.000 Soldaten, bestehend aus der *legio III Augusta* und einem kleinen Verbund von Auxiliareinheiten. Die Mannschaftsressourcen wurden stark gestreckt, wovon die substanzielle Aussendung von Legionsdetachements weit von ihrem Hauptquartier in *Lambaesis* ab dem späten 2. Jahrhundert zeugt. Dies wurde umso deutlicher, als die Grenze in der Regierungszeit des Septimius Severus weiter nach außen verlegt wurde. Ab dem 2. Jahrhundert kamen die Rekruten der Legion überwiegend aus den afrikanischen Provinzen, wenn auch die Auxiliareinheiten ein signifikantes Kontingent von Syrern umfasste. Viele Einheiten waren berittene *alae* oder gemischte Infanterie/Kavalleriekohorten, was teils die Länge der Kommunikationslinien an den afrikanischen Grenzen zum Ausdruck brachte und teils die Tatsache widerspiegelte, dass die einheimischen Völker Afrikas für ihre leichte Kavallerie berühmt waren.

Die Auflösung der *legio III Augusta* durch Gordian III im Jahr 238 leitete eine Periode weiterer Neuorganisationen der Grenzregulierungen ein. Die spätrömische Armee in Afrika bestand aus zwei grundsätzlichen Truppengattungen mit separaten Kommandostrukturen und unterschiedlicher Besoldung und Bestimmung. Es gab einerseits die Kampfeinheiten neuer Machart (*comitatenses*, die sowohl Infanterie wie auch Kavallerie umfassten) sowie die *limitanei*, welche Überbleibsel der alten Grenztruppen darstellten, nunmehr vorwiegend mit einer Polizeifunktion, aber vielfach mit denselben Namen und Stützpunkten wie die Garnisonen des 2. Jahrhunderts.

Le dispositif militaire

La garnison romaine en Afrique du Nord ne semble, à aucun moment, avoir été très importante par rapport à la longueur des zones frontalières. Les garnisons de la Maurétanie Tingitane et Césarienne n'étaient composées normalement que d'unités auxiliaires (d'un effectif maximum d'environ 15.000 soldats), renforcées exceptionnellement par des forces expéditionnaires de la légion provenant des autres provinces dans les moments de crise, comme ce fut le cas de 140 à 150. Les effectifs de la garnison d'*Africa Proconsularis* (et ses secteurs frontaliers avec la Numidie et la *Tripolitana*) avaient été stabilisés vers la fin du 1er siècle à 20.000 soldats tout au plus, un corps qui comprenait la *legio III Augusta* ainsi qu'un petit noyau d'unités auxiliaires. Les ressources en hommes étaient très dispersées géographiquement, comme le prouve le déploiement important de détachements légionnaires loin de leur base de Lambèse dès la deuxième moitié du 2ème siècle. Ce phénomène s'est accentué lorsque la frontière a été étendue au cours du règne de Septime Sévère. A partir du 2ème siècle, le recrutement de la légion se fit majoritairement dans les provinces africaines, encore que les unités d'auxiliaires comptaient un nombre important de Syriens. De nombreuses unités étaient des *alae* de cavalerie ou des cohortes mixtes d'infanterie et de cavalerie. Cette situation reflétait, d'une part, l'allongement des lignes de communication des frontières africaines et, d'autre part, le fait que les populations indigènes d'Afrique étaient réputées pour leur cavalerie légère. La dissolution de la légion III Auguste par Gordien III en 238 annonça une nouvelle période de réorganisation des dispositifs frontaliers. Sous le Bas-Empire, l'armée romaine d'Afrique comportait deux catégories distinctes de soldats avec leur structure de commandement propre et des différences de salaire et de conditions. D'un côté, les unités combattantes d'un type nouveau (*comitatenses*, composées d'infanterie et de cavalerie) ; de l'autre, les *limitanei*, avatar des anciennes troupes stationnées sur la frontière, affectés désormais à un rôle policier mais bien souvent sans changer de dénomination et occupant les mêmes bases que la garnison du 2ème siècle.

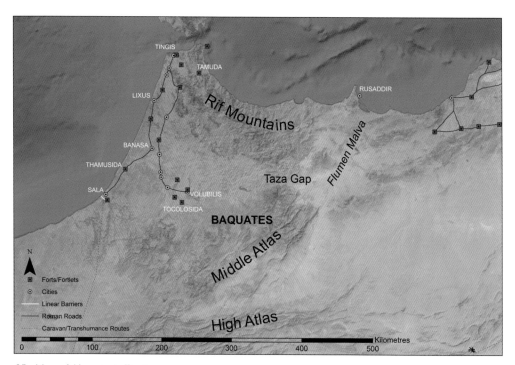

85. Map of *Mauretania Tingitana*
Karte von *Mauretania Tingitana*
Carte de la Maurétanie Tingitane

86. The High Atlas in Morocco
Der Hohe Atlas in Marokko
Le Haut-Atlas du Maroc

Frontier Development

The garrison deployment varied in nature and density. Despite having essentially similar garrison forces, frontier development in the two Mauretanian provinces were strikingly different. **Mauretania Tingitana** comprised a broad expanse of relatively fertile coastal plain enclosed by a series of formidable mountain ranges – the High Atlas and Middle Atlas, plus the Rif further north. The directly administered part of the province, where the army was deployed, was, however, restricted to the northern plainlands, corresponding to north-west Morocco. Here forts were strung out along two main roads leading south from the provincial capital, *Tingi* (Tangiers). One of these roads ran parallel with the Atlantic coast, through the ancient Punic town of *Lixus* and the Augustan *colonia* of *Banasa*, to *Sala* (Rabat), where a short stretch of ditched linear barrier, extending from the coast to the banks of the Oued Bou Regreg, closed off the southern

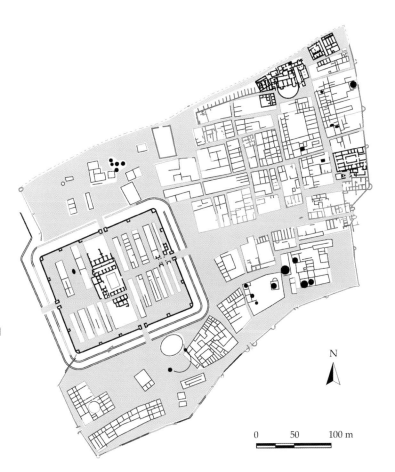

87. The fort at *Thamusida* and associated garrison settlement (Morocco)

Das Kastell *Thamusida* und die damit verbundene Garnisonssiedlung (Marokko)

Le fort de *Thamusida* et la ville (Maroc)

N

0 50 100 m

Grenzentwicklung

Art und Dichte der Stationierung von Garnisonen waren unterschiedlich. Obwohl die beiden maure-tanischen Provinzen in etwa über gleiche Truppen-stärken verfügten, verlief die Entwicklung der Grenze bemerkenswert unterschiedlich. **Mauretania Tingitana** umfasste ein weites Gebiet mit einer rela-tiv fruchtbaren Küstenebene, das von einer Reihe schützender Gebirge eingeschlossen war – dem Hohen und Mittleren Atlas, sowie dem Rif weiter im Norden. Der direkt verwaltete Teil der Provinz jedoch, wo die Armee stationiert war, war auf die nördliche Ebene beschränkt, die dem nordwestlichen Ma-rokko entspricht. Hier waren die Kastelle entlang der beiden Hauptstraßen platziert worden, die von der Provinzhauptstadt *Tingi* (Tangiers) aus nach Süden verliefen. Eine dieser Straßen erstreckte sich parallel zur Atlantikküste, durch die alte punische Stadt *Lixus* und die augusteische Kolonie *Banasa*, bis nach *Sala* (Rabat), wo ein kurzer Abschnitt einer mit

Le développement des frontières

Le déploiement de la garnison a varié dans sa nature et sa densité. Malgré la similitude fonda-mentale des forces de garnison, les différences de développement des frontières dans les deux pro-vinces maurétaniennes sont frappantes. La **Maurétanie Tingitane** comprenait une large plai-ne côtière assez fertile, ceinte par une impression-nante série de chaînes montagneuses – le Haut et le Moyen Atlas ainsi que le Rif plus au nord. La par-tie de la province sous administration directe, là où l'armée était déployée, était réduite aux plaines septentrionales, correspondant au nord-ouest du Maroc. Un chapelet de forts suivait les deux voies principales vers le sud depuis la capitale provincia-le, *Tingi* (Tanger). L'une de ces routes suivait un tracé parallèle à la côte Atlantique, passant par l'ancien-ne ville punique de *Lixus* et la colonie augustéenne de *Banasa*, jusqu'à *Sala* (Rabat), où une courte bar-rière linéaire bordée d'un fossé s'étendait depuis la

88. The linear barrier south of *Sala* (Morocco)
Die lineare Grenzsperre südlich von *Sala* (Marokko)
La barrière linéaire au sud de *Sala* (Maroc)

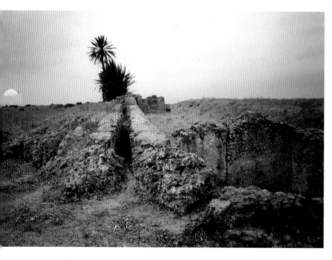

89. The corner of the fort of *Thamusida* (Morocco)
Eine Ecke des Kastells *Thamusida* (Marokko)
L'angle du fort à *Thamusida* (Maroc)

approaches to the town. The second road ran a little further inland and led to the important city of *Volubilis*, which was ringed by a network of small forts, fortlets and watchtowers.

Beyond this limited deployment no bases can be identified in the wide sweep of plainland and low, forested hill country, extending south and south-west as far as Marrakech and Essaouira at the foot of the Atlas mountains. In the north one or two other forts, such as *Tamuda* (near Tetouan), protected the south-eastern approaches to the Straits of Gibraltar, but there is no evidence that there was ever a permanent military presence further east in the Rif Mountains, nor even a formally defined road along the Mediterranean coast. Thus a gap of some 350 km separated the units around *Volubilis* from the westernmost military bases in *Mauretania Caesariensis*. Travel between the two was theoretically possible through the inland corridor known as the Taza gap, but it is unclear to what degree this was used. The Roman geographical sources imply that the province was considered to extend as far as the Atlas mountains and the Wadi Moulouya (*Flumen Malva* or *Mulucha*), the border with *Caesariensis*. Instead of deploying permanent garrisons, authority over these areas was evidently maintained by agreements with the leaders of confederations, such as the *Baquates* and *Macennites*.

Once it had taken its definitive form, this deployment did not significantly alter until the end of the 3rd century when the troops stationed around *Volubilis* were withdrawn and direct control over the southern area relinquished, with the exception of the coastal fort at *Sala*.

The military deployment in **Mauretania Caesariensis** had a different dynamic, again appropriate to the complex, mountainous geography of the province. Two chains of mountain ranges, collectively labelled the Tell Atlas, run parallel with the Mediterranean coast, with the Dahra, the Grande Kabylie, the Petite Kabylie and Babors amongst the ranges forming the coastal chain whilst a second series, further inland, includes the Ouarsenis, Titteri-Biban and Hodna Mountains. Sandwiched between these chains are a series of narrow plains strung out along the main river valleys, such as the Chélif, and sometimes broadening out into higher plateaux, as in the case of the Plains of Setif at the eastern end

Gräben versehenen linearen Grenzanlage, von der Küste bis ans Ufer des Oued Bou Regreg verlaufend, den südlichen Zugang zur Stadt abriegelte. Die zweite Straße verlief etwas weiter im Inland und führte zur wichtigen Stadt *Volubilis*, die mit einem Netz von kleinen Befestigungen, Kleinkastellen und Wachtürmen umgeben war. Über diese beschränkten Stationierungen hinaus wurden keine Truppenbasen im weiten Streifen der Ebene und dem niedrigen, bewaldeten Hügelland ausgemacht, das sich nach Süden und Südwesten bis nach Marrakesch und Essaouira am Fuß des Atlasgebirges erstreckt. Im Norden schützten ein oder zwei weitere Kastelle, wie *Tamuda* (unweit Tetouan), den südöstlichen Zugang zur Straße von Gibraltar, es gibt aber keinen Beweis dafür, dass es jemals eine ständige Militärpräsenz weiter östlich im Rif-Gebirge gab, oder auch nur eine formal definierte Straße an der Mittelmeerküste entlang. So teilte eine Lücke von gut 350 km die Einheiten um *Volubilis* herum von den am weitesten im Westen gelegenen Militärstützpunkten in *Mauretania Caesariensis*. Das Reisen zwischen beiden Orten war theoretisch möglich, durch den Inlandkorridor, der als Taza Pass bekannt ist, es ist aber unklar, inwieweit davon Gebrauch gemacht wurde.

Die geographischen Quellen der Römerzeit implizieren, dass die Provinz als bis ans Atlasgebirge und den Wadi Moulouya (*Flumen Malva* oder *Mulucha*), die Grenze zu *Caesariensis*, reichend angesehen wurde. Anstatt ständige Truppen zu stationieren wurde die Autorität in diesen Gebieten sicherlich durch Abmachungen mit den Anführern von Konföderationen, etwa der *Baquates* oder *Macennites* gewührt. Nachdem das Schema der Truppenverteilung seine endgültige Form angenommen hatte, wurde es nicht mehr maßgeblich verändert, bis gegen Ende des 3. Jahrhunderts die um *Volubilis* stationierten Truppen abgezogen und die direkte Kontrolle über das südliche Gebiet mit Ausnahme des Küstenheereslagers *Sala* aufgegeben wurde.

Die Truppenstationierung in **Mauretania Caesariensis** hatte eine andere Dynamik, die erneut der komplexen, gebirgigen Geographie der Provinz angepasst war. Zwei Gebirgsketten, gemeinsam als Tell Atlas bezeichnet, verlaufen parallel zur Mittelmeerküste, wobei der Dahra, der Grande Kabylie, der Petite Kabylie und der Babors zu den Höhen der

côte jusqu'aux rives de l'Oued Bou Regreg, fermant les approches méridionales de la ville. L'autre route se trouvait un peu plus vers l'intérieur des terres, menant à la ville importante de *Volubilis*, ceinte par un réseau de petits forts, de fortins et de tours de guet.

Au delà de ces limites, aucune base n'est connue dans la plaine et les collines boisées qui s'étendent au sud et au sud-ouest jusqu'à Marrakech et Essaouira au pied de l'Atlas. Au nord, un ou deux forts, comme à *Tamuda* (près de Tétouan), protégeaient les abords sud-est du détroit de Gibraltar, mais il n'y a pas de preuves d'une présence militaire permanente plus à l'est dans le Rif, ni d'une voie formellement définie le long de la côte méditerranéenne. Ainsi il existait un hiatus d'environ 350 km entre les unités autour de *Volubilis* et les bases les plus occidentales de la Maurétanie césarienne. Les déplacements entre les deux étaient possibles par le couloir intérieur de la trouée de Taza, mais on ne sait pas bien à quel point ce tracé était utilisé.

Les sources géographiques romaines donnent à croire que la province s'étendait jusqu'à l'Atlas et à l'oued Moulouya (*Flumen Malva* ou *Mulucha*), la frontière avec la Césarienne. Au lieu d'un dispositif permanent de garnisons, l'autorité sur ces zones était maintenue de toute évidence par des accords avec les chefs des confédérations, comme les *Baquates* ou les *Macennites*.

Une fois sa forme définitive acquise, ce dispositif est resté largement inchangé jusqu'à la fin du 3ème siècle lorsque les soldats stationnés autour de *Volubilis* ont été retirés et le contrôle direct de la zone sud abandonné, à l'exception du fort côtier de *Sala*. Le dispositif militaire en **Maurétanie césarienne** présente une dynamique différente, adaptée ici encore aux complexités géographiques de la province montagneuse. Deux plissements montagneux, dénommées collectivement l'Atlas tellien, se dressent parallèlement à la côte méditerranéenne ; le Dahra, la Grande Kabylie, la Petite Kabylie et les Babor figurent parmi les massifs de la chaîne côtière alors qu'une seconde série de massifs, plus continentale, comprend l'Ouarsenis, les Titteri-Bibans et le Hodna. Prises entre ces massifs, une série de plaines étroites suit les vallées des principaux cours d'eau comme le Chélif, s'élargissant parfois pour former de hauts-plateaux, comme la

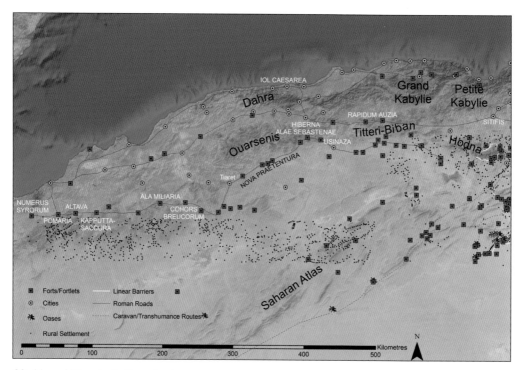

90. Map of *Mauretania Caesariensis*

Karte von *Mauretania Caesariensis*

Carte de la Maurétanie Césarienne

91. The fort platform at Ain al-Hammam in the Saharan Atlas (Algeria)

Die Kastellplattform in Ain al-Hammam im Sahara-Atlas (Algerien)

La plate-forme du fort d'Ain al-Hammam dans l'Atlas saharien (Algérie)

of the province. Only rarely do these plains open directly onto the sea in the eastern and central parts of the province, but the plainland is more extensive in the west, where the coastal ranges become more attenuated and mountains less formidable.

Further south still, beyond the relatively well-watered mountain valleys and plains of the Tell, lies the high arid steppe of the High Plateaux which is fringed along its southern edge by the Saharan Atlas (though Roman garrisoning of this latter area was managed as part of the Numidian frontier, see below). Initially, in the 1st century, it is likely that the army was largely concentrated in the provincial capital, *Iol Caesarea* (Cherchel), with a few units perhaps outposted in some of the other coastal cities. By the early 2nd century the bulk of the army was distributed along a single east-west routeway, extending virtually the length of the province. This is documented most clearly in the Antonine Itinerary which records a system of alternate main forts (*castra*) – the regimental bases – and intervening fortlets (*praesidia*) along the route. The deployment seems to have culminated in the reign of Hadrian with the creation of forts like *Rapidum* (Sour Djouab) and *praesidium Sufative*, but the basic framework was probably established in a more piecemeal fashion

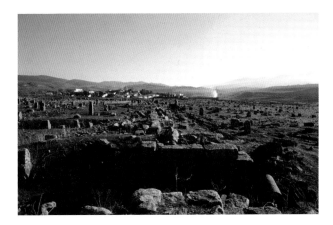

92. The fort and garrison settlement at *Rapidum* (Algeria)

Das Kastell und die Garnisonssiedlung *Rapidum* (Algerien)

Le fort et la ville de garnison à *Rapidum* (Algérie)

Gebirgskette an der Küste gehören, während die zweite Reihe, weiter im Inland, den Ouarsenis, Titteri-Biban und das Hodna-Gebirge umfasst. Zwischen diesen Gebirgsketten gezwängt befinden sich einige schmale Ebenen entlang der größeren Flusstäler, wie am Chélif, und weiten sich mitunter in höhere Plateaus, wie im Fall des Hochlands von Setif am Ostende der Provinz. Im östlichen und zentralen Teil der Provinz öffnen sich diese Ebenen nur selten direkt zum Meer hin, aber im Westen ist das Flachland weiträumiger, wo die Küstengebirge spärlicher und die Berge weniger hinderlich sind.

Weiter im Süden, jenseits der relativ wasserreichen Gebirgstäler und Ebenen des Tell, liegt die hohe, öde Steppe des High Plateaux deren südlicher Rand das Atlasgebirge der Sahara säumt (allerdings wurde die Stationierung römischer Truppen im letzteren Gebiet als Teil der numidischen Grenze verwaltet, siehe unten). Vermutlich war die Armee zunächst im 1. Jahrhundert vorwiegend in der Provinzhauptstadt, *Iol Caesarea* (Cherchel) konzentriert, vielleicht mit einigen Einheiten als Außenposten in verschiedenen anderen Küstenstädten. Bis Anfang des 2. Jahrhunderts war der Großteil der Armee entlang einer einzigen Ost-West Route verteilt, was praktisch die Provinz in die Länge zog. Dies dokumentiert am deutlichsten das *Itinerarium Antonini*, das ein System von alternierenden Hauptlagern (*castra*) – den Regiments-stützpunkten – und Interventionskleinkastellen (*praesidia*) entlang der Strecke beschreibt. Die Truppenstationierung scheint ihren Höhepunkt in der Regierungszeit Hadrians gehabt zu haben, als Lager wie *Rapidum*

plaine de Sétif à l'extrémité orientale de la province. Ce n'est que rarement que ces plaines s'ouvrent directement sur la mer dans les parties orientales et centrales de la province, mais la plaine est plus large à l'ouest, où les chaînes côtières sont plus atténuées et les massifs moins imposants.

Plus au sud encore, au-delà des vallées de montagne et des plaines du Tell relativement bien arrosées, s'étend la steppe aride des Hauts-Plateaux, bordée au sud par l'Atlas saharien (encore que la garnison romaine de ce territoire ait été gérée avec la frontière de Numidie, voir plus loin). Dans un premier temps, au 1er siècle, il est probable que l'armée se soit concentrée dans la capitale provinciale, *Iol Caesarea* (Cherchel), avec quelques unités stationnées dans d'autres villes côtières. Dès le début du 2ème siècle, la plus grande partie de l'armée se trouvait répartie d'est en ouest selon un axe unique, sur presque toute la longueur de la province. C'est l'*Itinéraire antonin* qui le montre le plus clairement, avec un système de forts principaux (*castra*) – les bases régimentaires – alternant avec des fortins (*praesidia*). Le dispositif semble avoir culminé sous le règne d'Hadrien avec la création de forts comme à *Rapidum* (Sour Djouab) ou *praesidium Sufative*, mais la trame en était établie sans doute de manière plus fragmentaire dès Domitien et Trajan à mesure que des unités éloignées les unes des autres établissaient des bases et construisaient des tronçons de route vers l'intérieur. Dans la mesure du possible, la voie suivait le tracé le plus simple en exploitant les vallées des plissements montagneux. Parfois, il était impossible d'éviter des

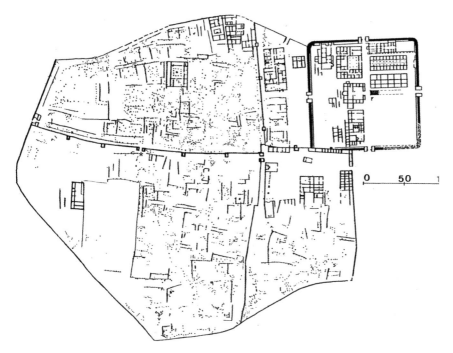

0 50

93. Plan of *Rapidum* (Algeria) and its garrison settlement
Plan von *Rapidum* (Algerien) mit Garnisonssiedlung
Plan de *Rapidum* (Algérie) et de la ville de garnison

earlier, under Domitian and Trajan, as widely sepa-
rated units established bases and constructed
stretches of road into the interior. Wherever possible
this highway followed the easiest course using the
valleys sandwiched between the mountain chains.
More difficult terrain was sometimes unavoidable,
particularly further east at the watershed between
the Chélif and the Isser river systems, the rugged hill
country between *Auzia* (Sour el-Ghozlane) and
Rapidum. The latter is the best known of these early
forts. It is notable also for the development along-
side the fort of a town of veterans and local
migrants from the surrounding countryside (*veterani
et pagani consistentes*) which was provided with
defences by its inhabitants in 166–167.

The elongated shape of *Mauretania Caesariensis*
favoured a more linear distribution of the garrison
along a frontier road. The army could concentrate
its forces to deal with major emergencies by mov-
ing units along this strategic highway. It should be
emphasised that the road did not form a line of
preclusive frontier control. The forts were much too
widely spaced for that to be feasible. Watchtowers
were built along some stretches, notably between
Auzia and *Rapidum*, but it is more likely these towers
were designed to protect communications along
the highway rather than to monitor movement
across the road line.

94. Location of a Roman watchtower between *Auzia* and *Rapidum* (Algeria)

Lage des römischen Wachturms zwischen *Auzia* und *Rapidum* (Algerien)

Emplacement d'une tour de guet romaine entre *Auzia* et *Rapidum* (Algérie)

(Sour Djouab) und *praesidium Sufative* entstanden, aber die grundlegende Rahmenstruktur wurde vermutlich in kleineren Schritten früher etabliert, unter Domitian und Trajan, als weit voneinander entfernte Einheiten Stützpunkte errichteten und Wegabschnitte ins Binnenland bauten. Wo immer es möglich war folgte diese Straße dem einfachsten Verlauf, indem zwischen den Bergketten gelegene Täler genutzt wurden. Schwierigeres Terrain war mitunter unvermeidbar, insbesondere weiter im Osten an der Wasserscheide zwischen dem Einzugsgebiet des Chélif und des Isser, dem zerfurchtem Hügelland zwischen *Auzia* (Sour el-Ghozlane) und *Rapidum*. Letzteres ist das bestbekannte dieser frühen Kastelle. Es ist auch deshalb nennenswert, da zusammen mit dem Lager eine Stadt von Veteranen und lokalen Migranten aus der umliegenden ländlichen Umgebung entstand (*veterani et pagani consistentes*), welche von den Einwohnern in den Jahren 166–167 mit einer Befestigung ausgestattet wurde.

Der längliche Umriss von *Mauretania Caesariensis* kam einer stärker linearen Verteilung der Garnisonen entlang der Grenzstraße entgegen. Die Armee konnte ihre Kräfte konzentrieren, um auf Notfallsituationen zu reagieren, indem sie ihre Einheiten auf dieser strategischen Trasse bewegte. Zu unterstreichen ist, dass die Straße keineswegs eine Linie der antizipierenden Grenzkontrolle darstellte. Die Kastelle waren zu weit voneinander entfernt, um dies zu ermöglichen. An einigen Abschnitten wurden Wachtürme errichtet, insbesondere zwischen *Auzia* und *Rapidum*, es ist aber wahrscheinlich, dass

terrains plus difficiles, notamment à l'est vers la ligne de partage des eaux entre les bassins versants du Chélif et de l'Isser, les massifs escarpés entre *Auzia* (Sour el-Ghozlane) et *Rapidum*. Ce dernier est le plus connu de ces premiers forts. Il est connu également pour le développement à côté du fort d'une ville de vétérans et de migrants locaux issus du pays environnant (*veterani et pagani consistentes*) dont les ouvrages défensifs ont été assurés par ses habitants en 166–167.

La configuration plus allongée de la Maurétanie césarienne favorisait une répartition plus linéaire de la garnison le long d'une voie frontalière. L'armée était à même de concentrer ses forces afin d'intervenir en cas d'urgence en faisant circuler ses unités le long de cet axe stratégique. Il est à souligner que cette voie ne constituait pas une ligne infranchissable de contrôle frontalier. Les forts étaient bien trop espacés. Des tours de guet ont été construites sur certains tronçons, notamment entre *Auzia* et *Rapidum*, mais il est plus probable que celles-ci étaient destinées à protéger les communications le long de l'axe plutôt que de suivre les déplacements à travers celui-ci.

Aux alentours de l'an 200, la masse de l'armée de la Césarienne a été redéployée vers le sud le long d'un nouvel axe stratégique dénommé « *nova praetentura* » sur les bornes jalonnant son secteur occidental. Ce nouveau dispositif revêtait deux formes bien contrastées. Au centre et à l'est, l'avancée vers le sud a conduit les garnisons en dehors des massifs pour s'installer sur le bord septentrional des

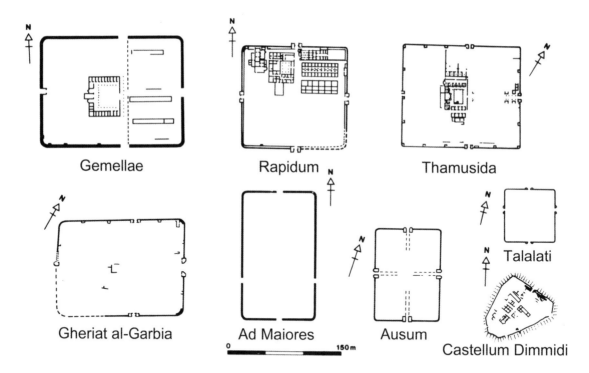

Gemellae

Rapidum

Thamusida

Gheriat al-Garbia

Ad Maiores

Ausum

Talalati

Castellum Dimmidi

0 150 m

95. Comparative plans of 2nd and 3rd century forts

Vergleichende Pläne von Kastellen des 2. und
3. Jahrhunderts

Plans comparés de forts des 2ème et 3ème siècles

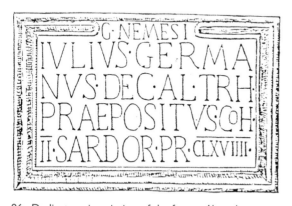

96. Dedicatory inscription of the fort at *Altava* by
Cohors II Sardorum in 208 (Algeria)

Weihinschrift aus dem Kastell *Altava*, im Auftrag der
Cohors II Sardorum aus dem Jahr 208 (Algerien)

Inscription dédicatoire du fort à *Altava* par la *Cohors II
Sardorum* en 208 (Algérie)

Around 200 the bulk of the army of *Caesariensis* was pushed south to deploy along a new strategic highway, which was labelled the *nova praetentura* on milestones lining its western sector. The new deployment took two distinctly contrasting forms. In the centre and the east, the southward advance brought the garrisons out of the mountains on to the northern fringe of the High Plateaux and Hodna Plain or on to the southern flank of the Ouarsenis range, overlooking the steppe. Some of the new bases provided superb vantage points, for example the *Hiberna Alae Sebastenae* (Kherba of the Ouled Hellal), situated at the junction of two passes at the south-east end of the Ouarsenis. Also associated with the deployment along this sector of the frontier was the establishment of new towns (*oppida*), a recently discovered inscription at *Usinaza* (Saneg) suggests at least some of the settlers were drawn from the province of Africa, some 500 km to the east. Further west, however, the military road abandoned the steppe margins and cut back into the mountains south of Tiaret and thence running along the northern edge of the inland Tell Atlas chain. Significant populations in these mountains therefore probably remained outside formal provincial administration.

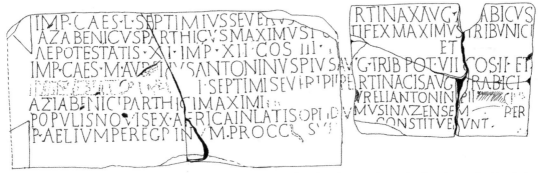

97. Inscription at *Usinaza* (Saneg) recording the resettlement of 'civilians' to reinforce the frontier under Septimius Severus (Algeria)

Inschrift in *Usinaza* (Saneg), die eine Wiederbesiedlung von „Zivilisten" zur Stärkung der Grenze unter Septimius Severus festhält (Algerien)

Inscription d'*Usinaza* (Saneg) rappelant la réinstallation de « civils » afin de renforcer la frontière sous Septime Sévère (Algérie)

diese Türme eher dazu gedacht waren, die Kommunikation entlang der Straße zu sichern, als eine Überwachung der Bewegungen über die Linie des Wegs zu ermöglichen.

Um das Jahr 200 herum wurde der Großteil der Armee von *Caesariensis* nach Süden verschoben, um eine neue strategische Straße in Position zu bringen, die auf Meilensteinen, die ihren westlichen Sektor säumten, als *nova praetentura* bezeichnet wurde. Die Stationierung nahm zwei stark kontrastierende Formen an. Im Zentrum und im Osten brachte der Vorstoß nach Süden die Garnisonen aus den Bergen an den nördlichen Rand des High Plateaux und der Hodna-Ebene oder an die Südflanke des Ouarsenis-Gebirges, das die Steppe überblickt. Einige der neuen Stützpunkte boten hervorragende Aussichtspunkte, etwa die *Hiberna Alae Sebastenae* (Kherba des Ouled Hellal), an der Vereinigung zweier Gebirgspässe am Südostende des Ouarsenis gelegen. Auch die Errichtung neuer Städte (*oppida*) war mit der Stationierung an diesem Sektor der Grenze verbunden, eine kürzlich in *Usinaza* (Saneg) entdeckte Inschrift legt nahe, dass zumindest einige der Siedler aus der Provinz Africa herangezogen wurden, die gut 500 km östlich davon liegt.

Weiter im Westen hingegen verließ die Militärstraße den Saum der Steppe und schnitt wieder in die Berge südlich von Tiaret ein, um von dort den Nordrand der Binnenland-Gebirgskette des Tell Atlas entlang zu verlaufen. Größere Populationen in diesen Bergen wären daher formal außerhalb der Provinzadministration geblieben.

Hauts-Plateaux et la plaine du Hodna ou bien sur le flanc méridional du massif de l'Ouarsenis, surplombant la steppe. Certains des nouveaux établissements offraient des points d'observation superbes, par exemple les *Hiberna Alae Sebastenae* (Kherba de l'Ouled Hellal), situés au croisement de deux défilés à l'extrémité sud-est de l'Ouarsenis. Est associée également au dispositif dans ce secteur de la frontière, la fondation de nouvelles villes (*oppida*) ; une inscription découverte récemment à *Usinaza* (Saneg) suggère que certains des immigrants provenaient de la province d'Afrique, quelques 500 km plus à l'est.

Plus à l'ouest, la voie militaire quittait les marges des steppes pour rejoindre le massif au sud de Tiaret, suivant, à partir de là, le bord septentrional de l'Atlas tellien continental. Ainsi des populations importantes dans ce massif restaient sans doute en dehors de l'administration provinciale proprement dite.

Les unités étaient bien plus espacées que sur les frontières en Grande Bretagne ou en Allemagne. Par exemple, les quatre garnisons entre *Numerus Syrorum* (Lalla Maghnia) et *Kaputtasaccura* était éparpillées sur une distance de 90 km. Les camps de *Pomaria* (Tlemcen), *Altava* (Ouled Mimoun), *Kaputtasaccura/Castra Severiana* (Sidi Ali ben Youb), *Ala Miliaria* (Benian) et *Cohors Breucorum* (Henchir Takhremaret) se situent tous sur des itinéraires relativement faciles à travers les massifs. Leur positionnement était vraisemblablement lié au contrôle d'axes clés, assurant en même temps l'accès pour Rome au cœur des massifs et au-delà de

98. Milestones along the military road established by Nonius Asprenas between the legionary base at *Ammaedara* and *Tacapae* in 14 (Tunisia)

Meilensteine entlang der im Jahr 14 n. Chr. von Nonius Asprenas errichteten Militärstraße zwischen der Legionsbasis *Ammaedara* und *Tacapae* (Tunesien)

Bornes de la route militaire établie par Nonius Asprenas entre le camp de la légion à *Ammaedara* et *Tacapae* en 14 (Tunisie)

99. The Byzantine walls and Roman amphitheatre at Tebessa (Algeria)

Die byzantinischen Mauern und das römische Amphitheater in Tebessa (Algerien)

La muraille byzantine et l'amphithéâtre romain de Tébessa (Algérie)

100. Storm clouds over the legionary fortress at *Lambaesis* (Algeria)

Sturmwolken über dem Legionslager *Lambaesis* (Algerien)

Ciel d'orage au-dessus de la forteresse de la légion à Lambèse (Algérie)

The units were much more widely spaced than on the British and German frontiers – the four garrisons between *Numerus Syrorum* (Lalla Maghnia) and *Kaputtasaccura*, for example, were strung out over a distance of 90 km. The bases at *Pomaria* (Tlemcen), *Altava* (Ouled Mimoun), *Kaputtasaccura/Castra* Severiana (Sidi Ali ben Youb), *Ala Miliaria* (Benian) and *Cohors Breucorum* (Henchir Takhremaret) all straddle relatively easy routes through the mountains. Their positioning may have related to control of key routes, at the same time ensuring Rome's access into and through the mountain ranges to the steppe beyond. The frontier zone remained fully part of the province of *Caesariensis* right up to the end of Roman rule and beyond, with the provincial dating era continuing in use well into the 6th and even 7th century on epitaphs from the frontier settlements

There are hints in colonial survey reports of at least one possible short linear barrier at Kef Irhoud on the southern flank of the Ouarsenis and remote sensing may reveal more examples of such features similar to those found in Tripolitania.

The first deployments in **Africa Proconsularis** that we can trace in any detail relate to the Augustan base of the *Legio III Augusta* at *Ammaedara* (Haidra) and the construction of a road in 14 linking that site with the oasis of *Capsa* (Gafsa) and the coastal site of *Tacapae* (Gabes). This road cut across the lands of the Musulami and other steppe/pre-desert peoples (collectively known as *Gaetuli*), sparking a major revolt from 17–24. The fortress at *Ammaedara*, if it lay directly beneath the heart of the later town, cannot have been a full legionary base, suggesting the likelihood that the legion was split into several vexillations at this date. It is quite likely that other major troop detachments were placed at *Capsa* and *Tacapae*, key topographic locations for the control of groups of oases and transhumant movement in the intervening spaces. In the late 1st century, the fort's deployment advanced further west, with the legion probably now united at *Theveste* (Tebessa) and smaller forts pushed out into the Aures mountains beyond.

Under Trajan and Hadrian there was further transformation towards an organised frontier system, operating around the pivot provided by a new legionary fortress at *Lambaesis* in the Aures mountains, with

Die Einheiten waren wesentlich weiter voneinander entfernt als an den Grenzen in Britannien oder Germanien – die vier Garnisonen zwischen *Numerus Syrorum* (Lalla Maghnia) und *Kaputtasaccura* etwa erstreckten sich auf eine Distanz von 90 km. Die Stützpunkte *Pomaria* (Tlemcen), *Altava* (Ouled Mimoun), *Kaputtasaccura/Castra Severiana* (Sidi Ali ben Youb), *Ala Miliaria* (Benian) und *Cohors Breucorum* (Henchir Takhremaret) bewachten alle relativ günstigen Routen durch die Berge. Die Positionierung kann aus einer Kontrolle von Schlüsseltrassen herrühren, wobei gleichzeitig der Zugang Roms in die Berge und darüber, in die jenseitige Steppe, gesichert wurde. Die Grenzzone verblieb bis zum Ende der römischen Herrschaft gänzlich ein Teil der Provinz *Caesariensis* und sogar darüber hinaus, zumal die provinzielle Zeitschreibung weit ins 6. und sogar ins 7. Jahrhundert auf Grabsteinen aus den Grenzsiedlungen in Gebrauch blieb. In Berichten von Oberflächenbegehungen aus der Kolonialzeit gibt es Hinweise auf mindestens eine mögliche kurze lineare Barriere bei Kef Irhoud, an der Südflanke des Ouarsenis und mit Hilfe von Satellitenfernerkundung könnten vielleicht weitere Beispiele von Anlagen ähnlich denen in Tripolitania aufgezeigt werden.

Die ersten Truppenstationierungen in *Africa Proconsularis*, die wir mit einer gewissen Genauigkeit nachverfolgen können, beziehen sich auf die augusteische Basis der *Legio III Augusta* in *Ammaedara* (Haidra) und den Bau einer Straße im Jahr 14, welche diesen Stützpunkt mit der Oase *Capsa* (Gafsa) und dem Küstenort *Tacapae* (Gabes) verband. Diese Straße verlief quer durch die Gebiete der Musulami und anderer Völker der Steppe bzw. der Vorwüste (die kollektiv als *Gaetuli* bezeichnet wurden), was eine größere Revolte in den Jahren 17–24 hervorrief. Die Festung in *Ammaedara*, sofern sie direkt unter dem Zentrum der späteren Stadt lag, kann kein richtiges Legionslager gewesen sein, was die Vermutung nahelegt, dass die Legion zu diesem Zeitpunkt in mehrere *vexillationes* unterteilt war. Es ist durchaus möglich, dass weitere größere Detachements in dieser Periode in *Capsa* und *Tacapae* stationierten, topographischen Schlüsselstellen für die Kontrolle von Oasengruppen und nomadisierenden Völkern in den Räumen dazwischen. Im späten 1. Jahrhundert

ceux-ci vers la steppe. La zone frontalière est restée une partie intégrante de la province de *Caesariensis* jusqu'à la fin de l'ère romaine voire plus tardivement, l'ère de datation de la province se poursuivant au 6ème et 7ème siècles sur des épitaphes des établissements frontaliers.

Les relevés de l'époque coloniale moderne suggèrent l'existence potentielle d'au moins une courte barrière linéaire à Kef Irhoud, sur les contreforts sud de l'Ouarsenis et la télédétection pourrait révéler d'autres exemples similaires aux ouvrages trouvés en Tripolitaine.

En *Africa Proconsularis*, les premiers dispositifs que nous soyons à même de retracer en détail se rapportent au quartier général augustéen de la *Legio III Augusta* à *Ammaedara* (Haidra) et à la construction d'une route en l'an 14 reliant ce site à l'oasis de *Capsa* (Gafsa) ainsi qu'au site côtier de *Tacapae* (Gabès). Cet axe traversait le territoire des *Musulami* ainsi que d'autres peuplades des steppes ou des zones pré-sahariennes (collectivement appelés *Gaetuli*), déclenchant une révolte majeure de 17 à 24. La forteresse d'*Ammaedara*, si toutefois elle se trouve directement sous le centre de la ville plus tardive, n'a pas pu être une base pour une légion entière, ce qui fait penser que la légion était scindée vraisemblablement en plusieurs vexillations à cette date. Il est tout à fait probable que d'autres détachements importants aient été stationnés à *Capsa* et à *Tacapae*, qui constituaient des emplacements clés pour le contrôle des oasis ainsi que des transhumances dans les espaces intermédiaires. Vers la fin du 1er siècle, la garnison s'est déployée plus à l'ouest, la légion étant sans doute réunie désormais à *Theveste* (Tebessa) avec des avant-postes au-delà dans le massif de l'Aurès.

Sous Trajan et Hadrien, le système frontalier a connu de nouvelles transformations. Il fut désormais articulé autour de la nouvelle forteresse de la légion à *Lambaesis*, dans l'Aurès, et d'un écran de forts avancés jusqu'aux abords du désert. À compter du règne d'Hadrien, ce dispositif était sans doute renforcé par des barrières linéaires de grande longueur ponctuées de portes et de tours (le *fossatum Africae*), bien que la présence des ces éléments linéaires dès le 2ème siècle ne soit pas incontestée. Il est certain que leur construction et leur réaménagement se sont poursuivis jusqu'au Bas-Empire,

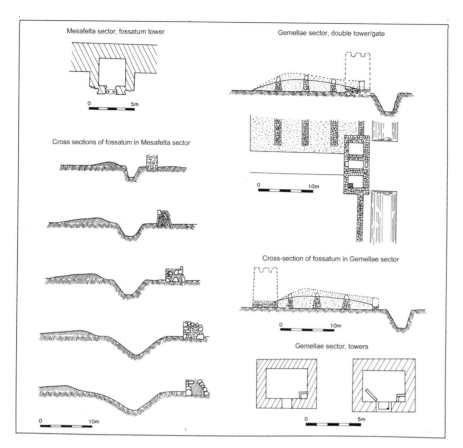

101. Features of the *fossatum Africae* (Algeria)

Anlagen des *fossatum Africae* (Algerien)

Eléments du *fossatum Africae* (Algérie)

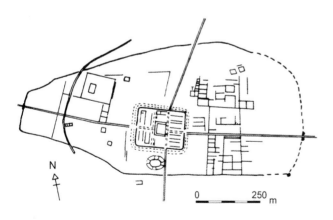

102. The fort at *Gemellae* and its garrison settlement (Algeria)

Das Kastell bei *Gemellae* mit seiner Garnisonssiedlung (Algerien)

Le fort de *Gemellae* et la ville de garnison (Algérie)

a screen of forts pushed out to the desert edge. From the time of Hadrian this was probably accompanied by some lengthy linear barriers and associated gates and towers (the *fossatum Africae*), though the 2nd-century origin of these linear elements is not incontrovertible. They certainly continued to be built or modified into Late Roman times, but the initial conception is similar to Hadrianic artificial frontiers elsewhere. The example of *Gemellae* is instructive, with a Hadrianic fort dominating an oasis that lay a few km north of a 60-km sector of east-west running ditch and embankment, with numerous gates and towers attached to it. The gates (effectively double towers) seem to have been fairly regularly provided along the *fossatum*, though not with the absolute regularity one finds on Hadrian's Wall. The relative over-provision of gates clearly indicates that the linear barriers were more about control than defence.

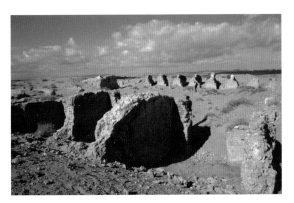

103. The headquarters building at *Gemellae* (Algeria)
Das Hauptquartier von *Gemellae* (Algerien)
Le quartier général de *Gemellae* (Algérie)

104. Double gate tower on the *fossatum Africae* near *Mesarfelta* (Algeria)
Turm mit Doppeltor am *fossatum Africae* unweit *Mesarfelta* (Algerien)
Tour d'une porte à double passage du *fossatum Africae* près de *Mesarfelta* (Algérie)

verlagerte sich die Stationierung der Garnisonen weiter nach Westen, wobei die Legion nunmehr vermutlich in *Theveste* (Tebessa) vereint war und kleinere Kastelle in die weiter gelegenen Aures-Berge gelegt wurden. Unter Trajan und Hadrian wurden weitere Veränderungen in Richtung eines organisierten Grenzsystems vorgenommen, das um den Drehpunkt der neuen Legionsfestung *Lambaesis* in den Aures-Bergen operierte, mit einem Schirm aus Kastellen, die an den Wüstenrand vorgeschoben waren. Beginnend mit der Regierungszeit Hadrians bestand zusätzlich noch eine befestigte lineare Grenzbarriere mit Toren und Türmen (das *fossatum Africae*), auch wenn die Datierung dieser linearen Elemente ins 2. Jahrhundert nicht ganz unumstritten ist. Sicherlich wurden sie bis in die spätrömische Zeit weiter gebaut oder modifiziert, aber das ursprüngliche Konzept entspricht den künstlichen Grenzen Hadrians anderswo. Lehrreich ist das Beispiel von *Gemellae* mit seinem hadrianischen Kastell, das eine Oase sichert, die einige Kilometer nördlich eines 60 km langen, auf einer Ost-West Achse verlaufenden Grenzabschnitts mit Wall und Graben, sowie zahlreichen angebundenen Toren und Türmen liegt. Die Tore (im Grunde Doppeltürme) scheinen durchaus regelmäßig entlang des *fossatum* entstanden zu sein, wenn auch nicht mit der absoluten Präzision wie am Hadrianswall. Die relative Übermenge an Toren zeigt deutlich, dass die linearen Grenzsperren eher der Kontrolle denn der Abwehr dienten.

mais la conception d'origine est apparentée à celle d'autres frontières artificielles dressées ailleurs sous Hadrien. L'exemple de *Gemellae* est parlant ; il s'agit d'un camp de l'époque d'Hadrien dominant une oasis, quelques kilomètres au nord d'un tronçon de fossé et de talus aligné est-ouest sur 60 km, pourvus de nombreuses portes et tours. Les portes (en fait des tours doubles) semblent avoir été espacées à intervalles assez réguliers sur le *fossatum*, même si on ne retrouve pas la régularité absolue de la configuration de la muraille d'Hadrien en Grande Bretagne. L'abondance de ces portes indique clairement que les barrières linéaires étaient destinées plus au contrôle qu'à la défense. Dans un autre secteur bien cartographié du *fossatum*, près du défilé d'al-Kantara qui conduit aux riches terres agricoles et aux pâturages de la plaine de l'Aurès, on discerne la relation étroite entre la barrière linéaire avec ses tours et ses portes et la voie frontalière et les postes de garnison en soutien à l'arrière. Seba Mgata (« fort parallélogramme ») semble être un fort romain tardif, mais les traces au sol indiquent qu'il occupe l'emplacement d'un poste plus ancien. Parmi les autres éléments fascinants de ce paysage sont les importants systèmes agraires ainsi qu'un oppidum indigène voisin à el-Krozbet.
Dès le début du 3ème siècle, d'autres développements de ce dispositif frontalier sont intervenus, dans le cadre de l'inauguration de la province de

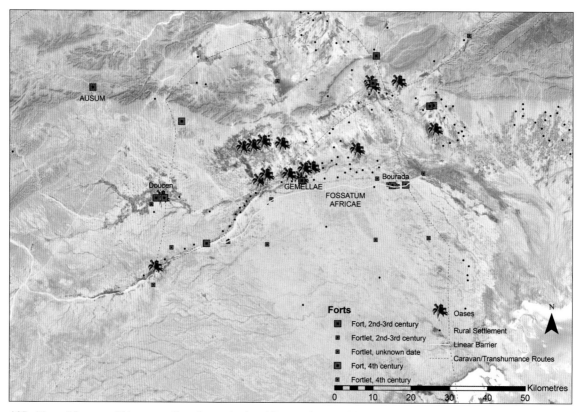

105. Map of *fossatum Africae* near *Gemellae* and related Roman forts and fortlets

Karte des *fossatum Africae* nahe *Gemellae* und damit verbundene römische Kastelle und Kleinkastelle

Carte du *fossatum Africae* près de *Gemellae* avec les forts et fortins romains

106. Double gate tower on the *fossatum Africae* near *Gemellae* (Algeria)

Turm mit Doppeltor am *fossatum Africae* unweit *Gemellae* (Algerien)

Tour d'une porte à double passage du *fossatum Africae* près de *Gemellae* (Algérie)

In another well-mapped sector of the *fossatum*, close to the al-Kantara pass that leads up onto the rich farmland and pastures of the Aures plain, it is possible to make out the close relationship between the linear barrier with its towers and gates and the frontier road with the supporting garrison posts to the rear. Seba Mgata ('fort parallelogram') appears to be a Late Roman fort, but there are visible traces on the ground that it overlies an earlier fort platform. Other intriguing elements of this frontier landscape include the substantial field systems and a nearby native hillfort of el-Krozbet.

In the early 3rd century there were further extensions to the frontier, corresponding with the inauguration of the province of *Numidia*. The most extraordinary of these were two lines of forts extending south-west of *Gemellae* into the Saharan Atlas. The explanation for these outpost forts must be that there were substantial communities who lived beyond the frontier

An einem anderen gut kartierten Abschnitt des *fossatum*, nahe dem al-Kantara Pass, der in das reiche Farm- und Weideland der Aures Ebene führt, lässt sich die enge Beziehung zwischen der linearen Grenzmauer mit ihren Türmen und Toren sowie der Grenzstrasse mit den unterstützenden Garnisonsposten im Hintergrund ausmachen. Seba Mgata (Befestigung in Form eines Parallelogramms) scheint ein spätrömisches Kastell gewesen zu sein, es gibt aber sichtbare Spuren auf dem Boden die davon zeugen, dass es auf der Plattform eines früheren Lagers liegt. Weitere bemerkenswerte Elemente dieser Grenzlandschaft umfassen großräumige, systematisch angelegte Feldstrukturen und die nahe autochthone Hügelbefestigung el-Krozbet.

Im frühen 3. Jahrhundert kam es zu weiteren Ausdehnungen der Grenze, die mit der Gründung der Provinz *Numidia* im Einklang standen. Der außergewöhnlichste Zusatz darunter waren zwei Linien von Kastellen, die sich von *Gemellae* aus nach Südwesten in die Sahara-Alpen erstreckten. Auslöser für diese befestigten Außenposten müssen wichtige Völkerschaften gewesen sein, die jenseits der Grenze lebten, die Rom besser kontrollieren wollte. Bei einigen handelte es sich wohl um nichtsesshafte Völker, es gab aber auch substantielle landwirtschaftliche Gemeinschaften in den Oasen. Oasen waren potentiell große Bevölkerungsreserven in der Wüste. Kastelle wie *Gemellae* hatten also vermutlich mehrere Funktionen in der Kontrolle der Grenze, darunter die Aufsicht über sowohl

la Numidie. Les éléments les plus remarquables étaient deux rangées de forts qui s'étendaient au sud-ouest de *Gemellae* jusque dans l'Atlas saharien. La seule explication possible pour ces avant-postes était que Rome visait à exercer un contrôle resserré sur les populations puissantes vivant au delà de la frontière. Certaines de ces populations pratiquaient sans doute la transhumance, mais il y avait également d'importantes communautés de cultivateurs dans les oasis. En effet, dans le désert, les oasis représentaient des bassins de peuplement significatifs. Des forts comme celui de *Gemellae* jouaient sans doute de multiples rôles dans le contrôle des frontières, y compris la supervision des

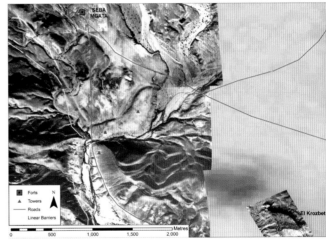

107. Map of *fossatum Africae* near Seba Mgata (*Mesarfelta* sector), Algeria

Karte des *fossatum Africae* nahe Seba Mgata (Abschnitt *Mesarfelta*), Algerien

Carte du *fossatum Africae* près de Seba Mgata (secteur de *Mesarfelta*), Algérie

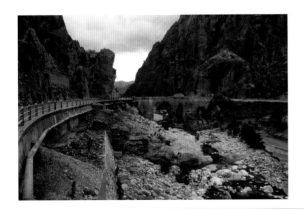

108. Roman bridge in the al-Kantara pass, connecting the Aures High Plains near *Lambaesis* with the pre-desert zone (Algeria)

Eine römische Brücke im al-Kantara Pass, welche das Hochplateau von Aures nahe *Lambaesis* mit der Vorwüstenzone verbindet (Algerien)

Pont romain dans le défilé d'al-Kantara, reliant les hauts-plateaux de l'Aurès près de Lambèse à la zone pré-saharienne (Algérie)

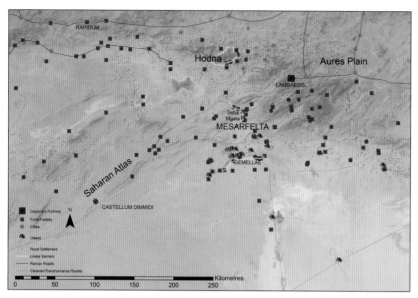

109. Map of garrison pattern and linear barriers in *Numidia*

Karte der Truppenverteilung und der linearen Grenzsperren in *Numidia*

Carte de la disposition des garnisons et des barrières linéaires en Numidie

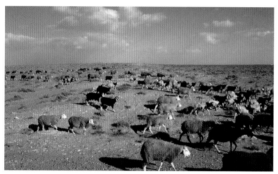

110. Transhumant flocks still cross the line of the *fossatum Africae* (Algeria)

Viehherden nicht sesshafter Hirten kreuzen weiterhin die Linie des *fossatum Africae* (Algerien)

Aujourd'hui encore des troupeaux transhumants franchissent la ligne du *fossatum Africae* (Algérie)

111. Tunisian policeman at the Roman customs gate in the Tebaga linear barrier

Tunesischer Polizist am römischen Zolltor der linearen Grenzmauer von Tebaga

Policier tunisien à la porte de la douane romaine sur la barrière linéaire du Tebaga

and that Rome sought to exercise greater control over them. Some were probably transhumant peoples, but there were also substantial oasis farming communities. Oases were potential large population reservoirs in the desert. Forts like *Gemellae* thus likely had multiple roles in frontier control including supervision of both fixed (oasis cultivators) and mobile (transhumant and trading) groups. The Numidian frontier sector also provides numerous examples of the *quadriburgus*, the classic Late Roman style of fort with projecting towers, mostly of 4th-century date.

Further east, the frontier centred on control of further major groups of oases on either side of a series of seasonal salt lakes (chotts): the Jerid and the Nefzaoua. The latter oasis group marked the start of the region (and later province) of **Tripolitana**, where there was a thin distribution of forts and fortlets at key oases and water points in the predominantly desert landscapes. These forts were supported by short earthworks and walls constructed in major passes and natural corridors. Passage through these linear barriers was again regulated and controlled by towers and gates. The most famous of these short barriers is Bir Oum Ali in southern Tunisia, where the wall still stands to about 4 m in height. The Roman date is assured by the ashlar masonry of its gatehouse and associated Roman pottery, though none of the surface finds is closely

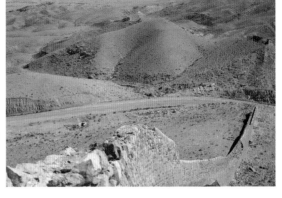

112. Stone wall blocking the pass of Bir Oum Ali in southern Tunisia

Ein Steinwall, der den Pass Bir Oum Ali in Südtunesien blockiert

Muraille de pierre barrant le col de Bir Oum Ali dans le sud tunisien

sesshafte (Oasenbauern) wie auch nicht sesshafte, Handel betreibende Gruppen. Der numidische Grenzabschnitt besaß auch eine Vielzahl von *quadriburgi*, den klassischen spätrömischen Kastellen mit vorkragenden Türmen, zumeist aus dem 4. Jahrhundert.

Weiter im Osten kontrollierte die Grenze weitere große Oasengruppen zu beiden Seiten einer Reihe von saisonalen Salzseen (chotts): Jerid und Nefzaoua. Letztere Gruppe markiert den Beginn der Region (und späteren Provinz) **Tripolitana**, in der es eine nur dünne Verteilung von Kastellen und Kleinkastellen an Schlüsseloasen und bei Wasserstellen in vorwiegend aus Wüste bestehender Landschaft gab. Diese Kastelle wurden durch kurze Erdbauten und Wälle verstärkt, die in wichtigen Pässen und natürlichen Geländekorridoren errichtet waren. Der Durchlass durch diese linearen Grenzbarrieren wurde abermals durch Türme und Tore reguliert und kontrolliert. Die bekannteste dieser kurzen Barrieren ist Bir Oum Ali in Südtunesien, wo der Wall immer noch eine Höhe von gut 4 m hat. Die römerzeitliche Chronologie wird durch das Quadermauerwerk am Torhaus und vergesellschaftete römische Keramik bestätigt, obwohl keines der Fundstücke von der Oberfläche präzise zu datieren ist. Sowohl das *fossatum* wie auch die kürzeren linearen Grenzbarrieren scheinen die Bewegungen durch die Grenzzone gebündelt zu haben, wodurch die Kontrolle über Migrationen zwischen Wüste und Stadt erleichtert wurde. Der Wall bei Bir Oum Ali etwa liegt in der Bergkette des Chareb an der Trennlinie zwischen dem Gebiet von *Capsa* und der Oase *Turris Tamalleni* (Telmine), der Hauptstadt des Volks der *Nybgenii*, welches wohl Oasenbauern wie auch nichtsesshafte Hirten umfasste.

peuplades sédentaires (cultivateurs des oasis) et nomades (transhumance et commerce). Le secteur frontalier numide contient aussi de nombreux exemples de *quadriburgi*, le style classique de fort du Bas-Empire avec des tours en surplomb, dont la plupart datent du 4ème siècle.

Plus à l'est, la frontière visait le contrôle d'autres grands groupes d'oasis de part et d'autre d'une série des lacs salés saisonniers (chotts), le Jerid et le Nefzaoua. Ce dernier groupe d'oasis signalait le début de la région (plus tard la province) de la **Tripolitaine**, où il y avait un semis de forts et de fortins installés à proximité des oasis et des points d'eau clés dans ces territoires essentiellement désertiques. Ces forts étaient adossés à des tronçons courts de terrassements et de murailles aménagés dans les principaux défilés et couloirs naturels. Le passage de ces barrières linéaires était surveillé au moyen de tours et de portes. La plus célèbre de ces courtes barrières se situe à Bir Oum Ali dans le sud tunisien, où se dresse encore une muraille d'environ 4 m de haut. La datation à l'époque romaine repose sur la maçonnerie en pierre de taille de son corps de garde et des poteries romaines qui y sont associées, bien qu'aucun des objets découverts en surface ne puisse être daté avec précision. Tant le *fossatum* que les barrières linéaires semblent avoir canalisé les déplacements dans la zone frontière, facilitant le contrôle des mouvements entre le désert et les terres ensemencées. Par exemple, la muraille à Bir Oum Ali, est dans le massif du Chareb, à la limite entre le territoire de *Capsa* et l'oasis de *Turris Tamalleni* (Telmine), capitale du peuple *Nybgenii*, composé, semble-t-il de populations de cultivateurs d'oasis et d'éleveurs transhumants.

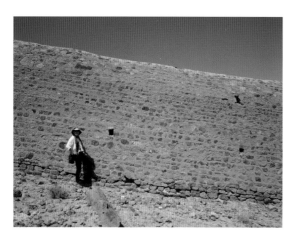

113. Detail of Bir Oum Ali wall (Tunisia)

Detailansicht der Mauer von Bir Oum Ali (Tunesien)

Détail de la muraille à Bir Oum Ali (Tunisie)

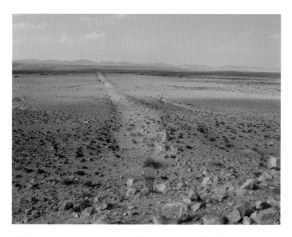

114. Linear barrier in the Tebaga plain (Tunisia)

Lineare Grenzbarriere in der Ebene von Tebaga (Tunesien)

Barrière linéaire dans la plaine du Tebaga (Tunisie)

dateable. Both the *fossatum* and the shorter linear barriers seem to have channelled movement across the frontier zone, thereby facilitating control of the movement between the desert and the sown. The wall at Bir Oum Ali, for instance, lies in the Chareb mountain range on the boundary between the territory of *Capsa* and the oasis of *Turris Tamalleni* (Telmine), capital of the *Nybgenii* people, who seem to have combined both oasis cultivators and transhumant pastoralists.

There is evidence of a dense occupation of the fertile plain to the north, focused on large villages established around fortified enclosures, which may have begun as Roman forts or fortlets. Here as elsewhere along the African frontier the linear barriers marked lines of rapid transition from desert terrain to cultivated landscape. Seasonal movements of people with their flocks have a long history in the Maghreb, and these transhumant groups have often provided a pool of seasonal harvesters and a source of animal manure that the sedentary farmers rely on. The Roman frontier measures can also be linked to the levying of taxation on migratory groups and customs dues on Trans-Saharan trade. The 17-km wide Jebel Tebaga corridor was traversed by the longest of the linear barriers in Tripolitania. It had several watchtowers along its length and a gate on a low hillock towards its south end. Once again, the barrier was constructed close to the boundary between the lands of the *Nybgenii* and the coastal town of *Tacapae*. There are now more than 20 of these short linear barriers known in Tripolitania and it is likely that still further examples remain to be discovered.

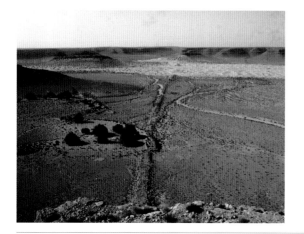

115. Linear barrier controlling the Skiffa pass in southern Tunisia

Lineare Grenzbarriere, die den Skiffa-Pass in Südtunesien kontrolliert

Barrière linéaire contrôlant l'oued Skiffa dans le sud tunisien

Es gibt Hinweise auf eine starke Bevölkerungsdichte in der fruchtbaren Ebene im Norden, die geballt in großen Dörfern um befestigte Stützpunkte herum entstanden, bei denen es sich anfangs um römische Kastelle oder Kleinkastelle gehandelt haben mag. Hier, wie auch anderswo entlang der afrikanischen Grenze, markierten die linearen Grenzbarrieren Abschnitte eines schnellen Übergangs von Wüstenumgebungen in kultivierte Landschaften. Die saisonalen Migrationen von Gemeinschaften mit ihren Herden haben eine lange Geschichte im Maghreb, und diese Nomaden-Gruppen stellten vielfach eine Reserve von Saisonarbeitern und eine Quelle für tierischen Dünger dar, auf welche sich die sesshaften Landwirte verlassen konnten. Die Grenzmaßnahmen der Römer sahen auch die Besteuerung von Migrationsgruppen und Wegezölle auf den Trans-Sahara Handel vor. Der 17 km breite Jebel Tebaga Korridor wurde von der längsten aller linearen Grenzsperren in Tripolitania geschnitten. Sie besaß mehrere Wachtürme auf ihrer Gesamtstrecke und ein Tor auf einem niedrigen Hügel am Südende. Erneut befand sich die Barriere nahe an der Grenze zwischen den Ländern der *Nybgenii* und der Küstenstadt *Tacapae*. Man kennt nunmehr über 20 dieser kurzen linearen Grenzsperren in Tripolitania und vermutlich wird man noch weitere Beispiele entdecken. Die Grenze in *Tripolitana* wurde auch unter Septimius Severus ausgebaut. Die Kastelle bei *Myd...* (Gheriat al-Gharbia) und *Gholaia* (Bu Njem) gehören zu den markantesten Fundstellen in Nordafrika. In Gheriat wurde das Innere des Kastells

Il y a des preuves d'une forte occupation de la plaine fertile au nord, focalisée sur d'importants villages établis autour d'enclos fortifiés, qui étaient peut-être initialement des forts ou fortins romains. Ici comme ailleurs sur la frontière africaine, les barrières linéaires démarquaient des lignes de transition rapide entre le désert et les zones cultivées. Ces mouvements saisonniers de populations humaines et de leurs troupeaux ont une longue histoire au Maghreb et ces groupes en transhumance ont souvent constitué une main d'œuvre saisonnière ainsi qu'une source de fumier animal dont dépendent les cultivateurs sédentaires. Le dispositif frontalier romain peut être associé également à l'imposition des groupes migratoires et aux droits de douane sur les échanges trans-sahariéen. Le couloir du Jebel Tebaga, large de 17 km, était coupé par l'une des plus longues barrières linéaires de la Tripolitaine. Elle comportait plusieurs tours de guet ainsi qu'une porte surmontant une monticule vers son extrémité sud. Encore une fois, la barrière se dressait à proximité de la limite entre le territoire des *Nybgenii* et la ville côtière de *Tacapae*. On connaît désormais une vingtaine des ces barrières linéaires dans la Tripolitaine et d'autres restent sans doute à découvrir. La frontière dans la Tripolitaine a également connu des améliorations sous le règne de Septime Sévère. Les forts de *Myd...* (Gheriat al-Gharbia) et de *Gholaia* (Bu Njem) comptent parmi les sites les plus évocateurs de l'Afrique du Nord. À Gheriat, l'intérieur du fort a été largement oblitérée par un village médiéval berbère, mais les murs et les tours de 9 m

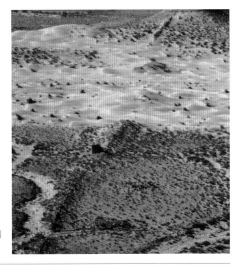

116. Detail of control a gate in the linear barrier in the Skiffa pass (Tunisia)

Detailansicht des Kontrolltores an der linearen Grenzsperre des Skiffa-Passes (Tunesien)

Détail d'une porte de la barrière linéaire de l'oued Skiffa (Tunisie)

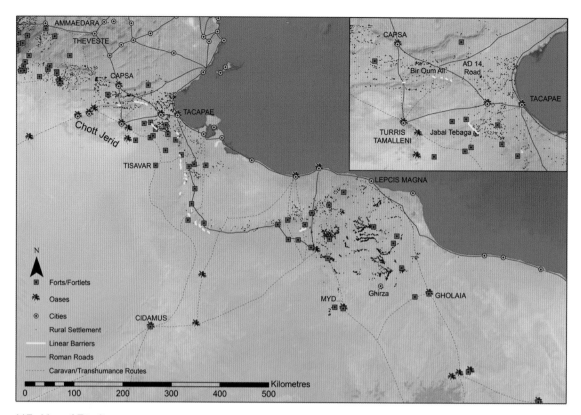

117. Map of *Tripolitana*

Karte von *Tripolitana*

Carte de la Tripolitiaine

118. Tombstone of soldier of *Legio III Augusta* from Gheriat al-Gharbia (Libya)

Grabstein eines Soldaten der *Legio III Augusta* aus Gheriat al-Gharbia (Libyen)

Pierre tombale d'un soldat de la légion III Auguste de Gheriat al-Gharbia (Libye)

There were also advances to the frontier in *Tripolitana* under Septimius Severus. The forts of *Myd...* (Gheriat al-Gharbia) and *Gholaia* (Bu Njem) are among the most evocative sites in North Africa. At Gheriat the interior of the fort has been largely obliterated by a medieval Berber village, but the walls and 9-m high towers of the fort are impressively preserved, with the central arch of the main gate intact until 1983. The sequence of occupation at Gheriat has been shown by Mackensen to have been complex, with a first period running from around 201 to 280 and reoccupation of the fort between the mid-4th to mid-5th century, at a time when it was previously thought that much of this frontier zone had been abandoned. There was further reoccupation of the abandoned fort in the 5th to 6th centuries, possibly by a Libyan chieftain.

The overall map of the Numidian and Tripolitanian *limites* can be combined with the impressive evidence of other settlements in the frontier zone, revealing a strong correlation of the linear barriers with the limits of intensive sedentary farming and emphasising the existence of numerous oases in the desert beyond.

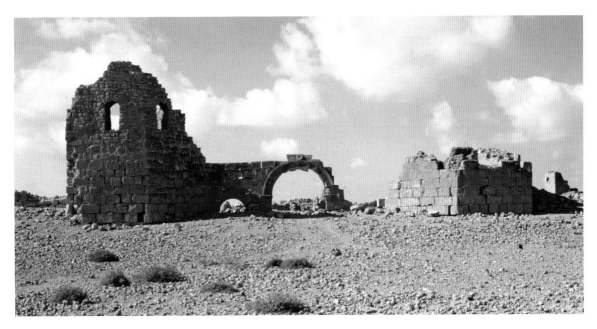

119. The north-east gate of the fort at Gheriat al-Gharbia (Libya)
Das Nordwesttor des Kastells Gheriat al-Gharbia (Libyen)
La porte nord-est du fort à Gheriat al-Gharbia (Libye)

größtenteils durch ein mittelalterliches Berberdorf zerstört, aber die Festungsmauern und 9 m hohen Türme der Befestigung sind in imposantem Maß erhalten, der zentrale Bogen des Haupttors war noch bis 1983 sichtbar. Die Belegungssequenz in Gheriat war, wie M. Mackensen zeigte, komplex, mit einer ersten Periode in den Jahren 201–280 und einer Wiederbelebung des Kastells von der Mitte des 4. bis zur Mitte des 5. Jahrhunderts, also zu einer Zeit, als diese Grenzzone bisher als verlassen gegolten hatte. Es gab eine weitere Nutzungsphase des aufgegebenen Kastells im 5. bis 6. Jahrhundert, möglicherweise durch einen libyschen Stammesfürsten.

Die Gesamtkarte der numidischen und tripolitanischen *limites* lässt sich mit den beachtlichen Befunden aus anderen Siedlungen in der Grenzzone zusammenstellen, wodurch die starke Korrelation der linearen Grenzbarrieren mit der Ausdehnung intensiver sesshafter Landwirtschaft und die Existenz zahlreicher Oasen in der jenseitigen Wüste deutlich werden. Die Grenzentwicklung in **Cyrenaica** ist kaum bekannt, in der frühen Kaiserzeit scheinen dort aber nie mehr als eine oder zwei Auxiliareinheiten stationiert gewesen zu sein. Diese waren auf kleine

de haut présentent un état de préservation impressionnant, et la porte principale a préservé son arche centrale jusqu'en 1983. La série d'occupations à Gheriat était complexe, comme l'a démontré M. Mackensen, une première période s'étendant approximativement de 201 à 280 suivie d'un réinvestissement du fort entre le milieu du 4ème et le milieu du 5ème siècles, à une époque où l'on pensait qu'une grande partie de la zone frontalière avait été abandonnée. Par la suite, le fort abandonné a été occupé de nouveau du 5ème au 6ème siècles, peut-être par un chef libyen.

La carte générale des *limites* numides et tripolitaines peut être associée aux preuves impressionnantes d'autres établissements dans la zone frontalière, ce qui montre la forte corrélation qui existait entre les barrières linéaires et les limites de l'agriculture sédentaire intensive et met en évidence la présence de nombreuses oasis dans le désert.

Le dispositif frontalier en **Cyrénaïque** est peu connu, mais ne semble pas avoir comporté plus d'une ou deux unités auxiliaires pendant le Haut-Empire. Celles-ci étaient réparties entre de petites installations sur les axes principaux autour du golfe

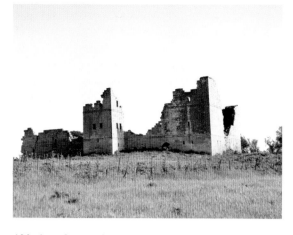

120. Late Roman fort at *Qasr Beni Gdem* (Libya)

Spätrömisches Kastell bei *Qasr Beni Gdem* (Libyen)

Fort romain tardif à Qasr Beni Gdem (Libye)

The frontier deployment in **Cyrenaica** is poorly known, but never seems to have amounted to more than one or two auxiliary units during the early empire. These were split between small installations along the main roads round the Syrtic gulf and in the desert margins where control of water-points along the key routes was crucial. In the Late Roman period, there is evidence of a growing threat from the oasis communities of *Marmarica* to the south-east and *Syrtica* to the south-west. A substantial force was installed under a *dux* and some new forts, built in the typical Late Roman style, are known. As the size and efficiency of official military units declined (amply attested by Synesius), there was an increased emphasis on urban defences and self-reliance, with many rural communities erecting castle-like buildings (*qsur*). Nevertheless a regular garrison remained up to the Arab conquest. Around 500 an Edict of Anastasius mentions five regiments of regular *comitatenses* stationed in the cities as well as frontier troops (*castensiani*).

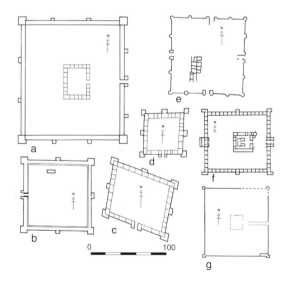

a. Zebaret et Tir
b. Centenarium Aquae Vivae
c. Fort Parallelogram (Seba Mgata)
d. Aquae Herculis
e. Tamuda
f. Bourada
g. Doucen

0 100

121. Comparative plans of Late Roman forts on the African frontiers

Vergleichende Pläne von spätrömischen Lagern

Plans comparés de forts romains tardifs sur les frontières africaines

Befestigungen entlang der Hauptstraßen um den Syrtischen Golf herum und an den Wüstenrändern verteilt, wo die Kontrolle von Wasserstellen an den wichtigsten Wegen notwendig war. In spätrömischer Zeit gibt es Hinweise auf eine wachsende Bedrohung von den Oasengemeinschaften von *Marmarica* im Südosten und *Syrtica* im Südwesten aus. Eine größere Streitkraft wurde einem *dux* unterstellt und einige neue Kastelle, gebaut im typisch spätrömischen Stil, sind bekannt. Zumal die Größe und Effizienz der offiziellen Garnisonseinheiten schrumpfte (wovon Synesius erschöpfend berichtet), wurde zunehmend auf Stadtbefestigungen und Selbstverteidigung Wert gelegt, in deren Zuge viele landwirtschaftliche Gemeinschaften burgenähnliche Bauten (*qsur*) errichteten. Dennoch verblieb hier eine reguläre Garnison bis zur Eroberung durch die Araber. Um das Jahr 500 nennt ein Edikt von Anastasius fünf Regimenter regulärer *comitatenses,* die in den Städten stationierten, wie auch Grenztruppen (*castensiani*).

de Syrte et sur les marges du désert où le contrôle des points d'eau sur les itinéraires clés était crucial. Vers la fin du Bas-Empire apparaissent des signes d'une menace grandissante des communautés des oasis de la Marmarique au sud-est et de la Syrtique au sud-ouest. Une force importante était installée sous le commandement d'un *dux* et certains forts nouveaux, construits selon un style romain tardif caractéristique sont connus. Au fur et à mesure que les effectifs et l'efficacité des unités de garnison officielles déclinaient (un phénomène largement attesté par Synesius), l'accent était mis davantage sur les défenses urbaines et l'autarcie, de nombreuses communautés rurales construisant des bâtiments de type château fort (*qsur*). Néanmoins, une garnison régulière est restée jusqu'à la conquête arabe. Vers l'an 500, un édit d'Anastase fait état de cinq régiments de *comitatenses* réguliers postés dans les métropoles ainsi que des troupes de frontière (*castensiani*).

122. The reverse of this coin of the Emperor Hadrian reflects his travels to all frontiers of the empire

Diese Münze des Kaisers Hadrian gedenkt seiner Reisen an alle Grenzen des Imperiums

Monnaie de l'empereur Hadrien représentant ses voyages sur toutes les frontières de l'empire

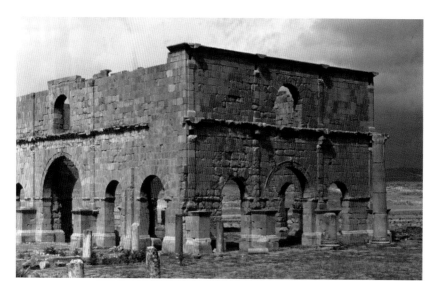

123. Detail of the arch that formed the forehall of the headquarters building at *Lambaesis* (Algeria)

Detailansicht des Torbogens, der die Eingangshalle zum Hauptquartier von *Lambaesis* bildete (Algerien)

Détail de l'arche qui constituait le porche d'entrée du quartier général à Lambèse (Algérie)

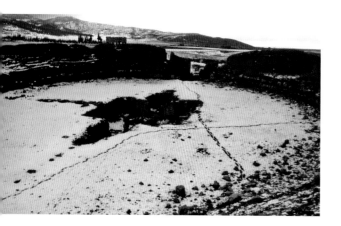

124. The legionary amphitheatre at *Lambaesis* (Algeria) under snow

Das schneebedeckte Amphitheater der Legion in *Lambaesis* (Algerien)

L'amphithéâtre de la légion à Lambèse (Algérie) sous la neige

Life on the Frontier: Hadrian at *Lambaesis*

In AD 128 Hadrian visited *Africa* and inspected the army at *Lambaesis*, as was no doubt routine in such imperial tours. Uniquely, though, the speech he delivered to the troops has survived inscribed on a monument erected on the very parade ground where he observed the troops. This *adlocutio* provides one of the most vivid insights into life and training on the Roman frontiers.

He highlighted aspects of the performance of the different troops he had reviewed, rather negatively commenting on some and praising others:

"Open order tactics [of *Cohors II Hispanorum*] I do not approve of ... a trooper should ride out from cover and be more cautious in pursuit ... You [cavalry of *legio III Augusta*] performed the most difficult task, throwing the javelin in full armour ... I also approve your spirit."

He also described an exercise in fortification building, perhaps a prelude to the commencement of work on linear frontier barriers:

"What others would take several days to finish, you completed in one day. You have built a wall, a lengthy construction ... with large, heavy and irregular stones. You have cut a ditch in a straight line through hard and rough gravel and have levelled it smooth..."

125. Legionary barracks and forehall arch of the headquarters building at *Lambaesis* (Algeria)

Legionskasernen und Torbogen der Eingangshalle zum Hauptquartier von *Lambaesis* (Algerien)

Caserne de la légion et arche du porche d'entrée du quartier général à Lambèse (Algérie)

Das Leben an der Grenze: Hadrian in *Lambaesis*

Im Jahr 128 besuchte Hadrian *Africa* und inspizierte die Armee in *Lambaesis*, was sicherlich Routine bei solchen imperialen Rundreisen war. Einzigartig ist jedoch der Umstand, dass seine Ansprache vor den Truppen als Inschrift auf einem Monument überdauerte, das auf dem Exerzierplatz aufgestellt wurde, wo er die Überprüfung vorgenommen hatte. Diese *adlocutio* gibt uns einen der lebendigsten Einblicke in das Leben und Training an den römischen Grenzen. Der Kaiser hob Aspekte in den Leistungen der verschiedenen Truppen hervor, die er inspiziert hatte, wobei er einige eher negativ kommentierte und andere lobte:

„Die Taktik einer offenen Ordnung [der *cohors II Hispanorum*] gefällt mir nicht ... ein Soldat sollte aus der Deckung hervorreiten und vorsichtiger bei der Verfolgung sein ... Ihr [die Kavallerie der *legio III Augusta*] habt die schwierigste Aufgabe gemeistert, als ihr Speere in voller Rüstung schleudertet ... Auch euer Kampfgeist sagt mir zu."

Er beschrieb auch eine Übung im Festungsbau, möglicherweise eine Vorstufe zur Aufnahme von Arbeiten an linearen Grenzbarrieren:

„Wofür andere mehrere Tage gebraucht hätten, habt ihr an einem Tag fertiggestellt. Ihr habt eine Mauer errichtet, ein langes Bauwerk... aus großen, schweren und unbehauenen Steinen. Ihr habt einen Graben in gerader Linie durch harten und groben Kiesboden gegraben und ihn sauber geebnet..."

La vie sur la frontière : Hadrien à Lambèse

En 128 ap. J.-C., Hadrien a visité l'*Africa* et procédé à une revue de l'armée à Lambèse, ce qui était sans doute la procédure normale lors des tournées impériales. Fait unique, cependant, son allocution aux soldats a survécu, inscrite sur un monument dressé sur le même terrain de parade où il a observé les troupes. Cette *adlocutio* nous offre un aperçu très immédiat de la vie et de l'entraînement sur les frontières romaines.

L'Empereur souligne certains aspects des performances des différentes troupes qu'il avait passées en revue, critiquant les uns et louant les autres :

« Je désapprouve la tactique d'ordre non groupé [de la *Cohors II Hispanorum*] [...]. Un cavalier doit surgir d'une position à couvert et se montrer plus prudent lors de la poursuite [...] Vous (la cavalerie de la Légion III Auguste) avez réalisé la tâche la plus difficile, lancer le javelot tout en portant une armure intégrale [...]. J'approuve également votre esprit de corps».

Il décrit aussi un exercice de construction de fortifications, peut-être un préliminaire au commencement des travaux sur les barrières linéaires de la frontière : « les fortifications que d'autres auraient mis plusieurs jours à faire, vous les avez élevées en un seul. Vous avez bâti un mur solide [...] vous n'aviez sous la main que des pierres énormes, pesantes et inégales, [...]. Vous avez établi un fossé selon les règles, en creusant le gravier dur et rugueux, puis vous l'avez aplani en le ratissant ».

126. The north gate of the Roman fort at *Gholaia* (Bu Njem) as recorded by the British explorer Lyon about 1820 (Libya)

Das Nordtor des römischen Kastells *Gholaia* (Bu Njem), wie es der britische Entdecker Lyon um 1820 festhielt (Libyen)

La porte nord du fort romain à *Gholaia* (Bu Njem) dessiné par l'explorateur britannique Lyon vers 1820 (Libye)

Life on the Frontier: Documents from Bu Njem

The fort of *Gholaia* (Bu Njem) in Libya controlled a small oasis on the desert route south from *Lepcis Magna* towards the land of the *Garamantes*. It is currently the most extensively excavated frontier site, its significance enhanced by remarkable epigraphic records. The fort was established by a detachment (*vexillatio*) of the *legio III Augusta* commanded by a legionary centurion in 201. The legionaries were complemented by auxiliary components at various points (*numerus collatus and cohors VIII Fida*). The presence of some cavalry is likely to have been the norm at such an isolated site. After 238, *legio III Augusta* was disbanded following its part in the suppression of the Gordian revolt, though it seems likely that the Bu Njem garrison was simply rebranded as a *vexillatio golensis*. In the 240s there was a new command structure, with the appearance of a *praepositus limitis Tripolitanae* – a precursor of the Late Roman frontier arrangements of multiple regional *limites* detailed in the *Notitia Dignitatum*. From the last phase of the fort's occupation 253–59 come a remarkable series of documents written in ink on pot sherds (*ostraca*). The last document from the site dates to 259 and final withdrawal seems to have occurred by 263, though some activity in the fort and associated settlement is attested into the 4th century.

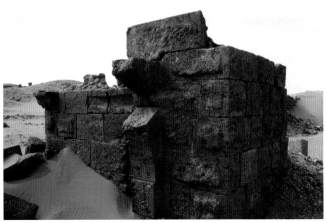

127. Detail of surviving masonry of the north gate at *Gholaia* (Libya)

Detailansicht des erhaltenen Mauerwerks am Nordtor von *Gholaia* (Libyen)

Détail de la maçonnerie de la porte nord à *Gholaia* (Libye)

Das Leben an der Grenze: Die Dokumente aus Bu Njem

Das Kastell *Gholaia* (Bu Njem) in Libyen kontrollierte eine kleine Oase an der Wüstenstraße südlich von *Lepcis Magna* in Richtung des Landes der *Garamantes*. Es ist gegenwärtig die am umfangreichsten ausgegrabene Fundstelle der Grenze, deren Bedeutung durch bemerkenswerte epigraphische Dokumente noch erhöht wird. Das Kastell wurde von einem Detachement (*vexillatio*) der *legio III Augusta* unter dem Befehl eines Zenturios der Legion im Jahr 201 gebaut. Die Legionäre wurden zu verschiedenen Zeiten durch Auxiliarkräfte vervollständigt (*numerus collatus und cohors VIII Fida*). Die Anwesenheit von Kavallerieeinheiten scheint an einer derart isolierten Stelle die Norm gewesen zu sein. Nach 238 wurde die *legio III Augusta* aufgelöst, als Folge ihrer Rolle in der Unterdrückung der Revolte Gordians, obwohl es wahrscheinlich ist, dass die Garnison von Bu Njem einfach in *vexillatio golensis* umbenannt wurde. In den 240er Jahren entstand eine neue Kommandostruktur, in der ein *praepositus limitis Tripolitanae* auftauchte – ein Vorläufer der spätrömischen Grenzanlagen von mehreren regionalen *limites* wie sie in der *Notitia Dignitatum* beschrieben werden. Aus der letzten Belegungszeit der Kastells in den Jahren 253-59 stammt eine Reihe bemerkenswerter Dokumente, die in Tinte auf Gefäßscherben (*ostraca*) geschrieben wurden. Das letzte Dokument dieser Fundstelle stammt aus dem Jahr 259 und der endgültige Rückzug scheint bis 263 erfolgt zu sein, obwohl eine gewisse Aktivität im Kastell und der verbundenen Siedlung bis ins 4. Jahrhundert attestiert ist.

La vie sur la frontière : les documents provenant de Bu Njem

Le fort de *Gholaia* (Bu Njem) en Libye contrôlait une petite oasis sur l'itinéraire à travers le désert au sud de *Lepcis Magna* vers le pays des *Garamantes*. Il s'agit du site frontalier le mieux fouillé à présent, et sa signification est enrichie par des document épigraphiques remarquables. Le fort a été établi par un détachement (*vexillatio*) de la *legio III Augusta* sous le commandement d'un centurion légionnaire en 201. Les légionnaires ont été renforcés par des éléments auxiliaires à certains moments (*numerus collatus* et *cohors VIII Fida*). La présence d'effectifs de cavalerie était vraisemblablement la norme sur des sites aussi isolés. Après 238, la légion III Auguste a été dissoute comme suite à sa participation à la suppression de la révolte gordienne, encore qu'il soit probable que la garnison de Bu Njem ait simplement changé de nom pour devenir une *vexillatio golensis*. Dans les années 240, une nouvelle structure de commandement est instaurée avec l'avènement d'un *praepositus limitis Tripolitanae*, précurseur des dispositifs frontaliers de la fin de l'ère romaine qui consistaient en de multiples *limites* régionaux dont la liste détaillée est fournie par la *Notitia Dignitatum*. La dernière phase d'occupation du fort de 253 à 259 a livré une série remarquable de documents écrits à l'encre sur des tessons (*ostraca*). Le dernier document connu du site remonte à l'an 259 et le retrait définitif semble s'être opéré dès 263, bien qu'une certaine activité au fort et dans l'agglomération voisine soit attestée jusqu'au 4ème siècle.

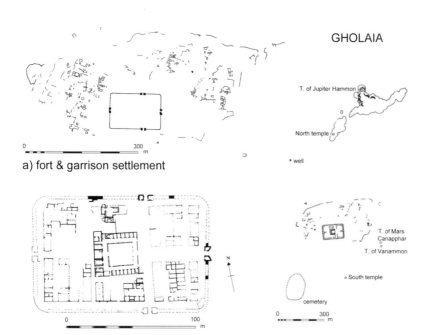

a) fort & garrison settlement

b) detail plan of fort c) Religious landscape around fort

128. *Gholaia*: a) plan of the fort and garrison settlement; b) fort; c) the religious landscape around the fort (Libya)

Gholaia: a) Plan des Kastells und der Garnisonssiedlung; b) Kastell; c) Die religiösen Einrichtungen um das Kastell herum (Libyen)

Gholaia : a) plan du fort et de la ville de garnison ; b) le fort; c) l'environnement religieux du fort (Libye)

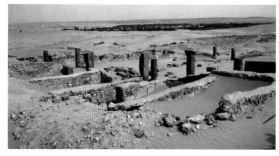

129. The headquarters building at *Gholaia* (Libya)

Das Hauptquartier von *Gholaia* (Libyen)

Le quartier général à *Gholaia* (Libye)

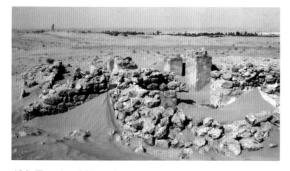

130. Temple of *Mars Canapphar* at *Gholaia* (Libya)

Tempel des *Mars Canapphar* in *Gholaia* (Libyen)

Le Temple de *Mars Canapphar* à *Gholaia* (Libye)

The layout of the 1.28 ha fort is plainly visible beneath the engulfing sand dunes. The main excavated buildings are spread across the central range: the headquarters complex, the commanding officer's house, two store buildings and the baths. The barrack accommodation is sufficient for about 480 legionaries and perhaps 64–128 cavalry at maximum.

The *ostraca* open a remarkable window on garrison life. There were day lists of the tasks to which parts of the garrison were assigned, reports from outposts of movements along the desert tracks (small groups of *Garamantes* with donkey and mule trains), supply documents that give details of the payments made to local farmers for the delivery of specified quantities of foodstuffs to the garrison, details of the recruitment of spies and the dispatch of someone on a mission to the Garamantian heartlands. The impression is of a Roman garrison going about the orderly business of surveillance, supervision and diplomatic control of a wide network of desert routeways, extending up to 500 km to the south.

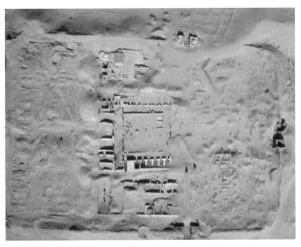

132. Camel caravan on the desert tracks as depicted on a Roman tomb at the Libyan pre-desert site of Ghirza

Kamelkarawane auf einer Wüstentrasse, dargestellt auf einem römischen Grab aus Ghizra in der libyschen Vorwüste

Caravane de dromadaires sur les pistes du désert : représentation sur une sépulture romaine du site pré-saharien de Ghirza (Libye)

131. Aerial photograph of fort at *Gholaia*, with north to the top (Libya)

Luftbild des Kastells *Gholaia*, in Nordrichtung (Libyen)

Vue aérienne du fort de *Gholaia*, le nord vers le haut (Libye)

Der Bauplan des 1,28 ha großen Kastells ist gut unter den bedeckenden Sanddünen ersichtlich. Die vorrangig ausgegrabenen Gebäude erstrecken sich über den Mittelteil: das Hauptquartier, das Haus des Lagerkommandanten, zwei Vorratsgebäude und die Bäder. Die Kasernen hatten Platz für etwa 480 Legionäre und vielleicht 64–128 Kavalleristen im Auslastungsmaximum.

Die *ostraca* öffnen ein bemerkenswertes Zeitfenster in das Leben der Garnison. Es gab tägliche Listen der Aufgaben, die Teilen der Garnison auferlegt wurden, Berichte von Außenposten über Bewegungen auf den Wüstenwegen (kleine Gruppen von *Garamantes* mit Esel- und Maultierzügen), Nachschubdokumente mit genauen Angaben der Zahlungen an lokale Bauern für die Lieferung von bestimmten Mengen an Nahrungsmitteln für die Garnison, Details zur Rekrutierung von Spionen und der Entsendung einer Person auf eine Mission ins Kernland der *Garamantes*. Es entsteht der Eindruck einer römischen Garnison mit dem geregelten Ablauf von Überwachung, Beaufsichtigung und diplomatischer Kontrolle über ein weites Netzwerk von Trassen durch die Wüste, die bis zu 500 km nach Süden reichen.

La disposition du fort de 1,28 ha est clairement visible sous les dunes de sable qui l'ont enseveli. Les principaux bâtiments fouillés s'étendent sur une zone centrale : le quartier-général, la maison du commandant, deux entrepôts et les thermes. La caserne pouvait loger environ 480 légionnaires et peut-être de 64 à 128 cavaliers au maximum.

Les *ostraca* offrent une vision remarquable de la vie de la garnison. On y trouve des listes des tâches quotidiennes auxquelles les éléments de la garnison étaient affectées, des rapports en provenance des avant-postes de déplacements sur les pistes dans le désert (petits groupes de *Garamantes* avec des trains de baudets et de mulets), des documents d'approvisionnement donnant le détail de paiements aux cultivateurs locaux pour la livraison à la garnison de quantités stipulées de denrées alimentaires, le détail du recrutement d'espions et l'envoi d'une personne en mission au cœur du territoire garamante. Tout donne l'impression d'une garnison romaine procédant méthodiquement à la surveillance, à la supervision et au contrôle diplomatique d'un large réseau de pistes dans le désert, s'étendant jusqu'à 500 km au sud.

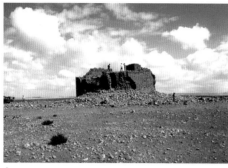

a

The Rise of the Fortified Farm

A final theme of the African frontier that is echoed across most of the frontier zones described above is that of the fortified farm. At one time seen as official outposts of the frontier army, there are simply too many of these and some are undeniably associated with civilians and farming activity for this to be an acceptable explanation of the phenomenon. Some of these structures were striking in the way they imitated military architecture or evoked quasi-official powers. They are not necessarily an indication of endemic insecurity, but they do seem to increase in number at a time when regular frontier troops appear to have been thinned out and there are some indications of increasing military threats from desert peoples. The transformation of the Roman frontier zone from one where the main fortifications were those of the army, to one where the landscape was studded with private defensive works is a striking one. Interestingly, similar fortified farming settlements were also a feature of Garamantian oasis communities well outside the frontier at this time.

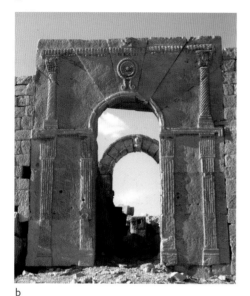

b

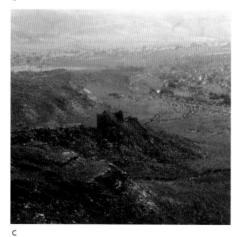

c

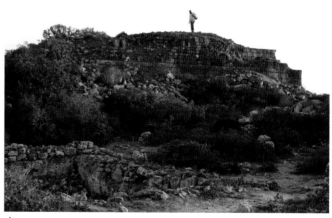

d

133. Montage of military outposts and fortified farms of frontier zone: a) military outpost; b) and c) Tripolitanian fortified farms; d) Cyrenaican fortified farm

Zusammenstellung von militärischen Aussenposten und befestigten Bauernhöfen der Grenzzone: a) militärischer Außenposten; b) und c) befestigte Bauernhöfe Tripolitaniens; d) befestigte Bauernhöfe von Cyrenaica

Montage d'avant-postes et d'une ferme fortifiée de la zone frontalière : a) avant-poste militaire ; b) et c) fermes fortifiées de la Tripolitaine ; d) ferme fortifiée en Cyrénaïque

Die Entstehung von befestigten Bauernhöfen

Ein letztes Thema der afrikanischen Grenze, das an den meisten oben beschriebenen Abschnitten anzutreffen ist, sind die befestigten Bauernhöfe. Sie wurden einst als offizielle Außenposten der Grenzarmee angesehen, aber es gab einfach zu viele davon und einige sind eindeutig mit Zivilisten und Farmaktivitäten in Verbindung zu bringen, so dass dies keine akzeptable Erklärung für das Phänomen sein kann. Einige der Strukturen waren insofern auffallend, weil sie die Militärarchitektur nachahmten oder eine quasi-offizielle Macht andeuteten. Es handelt sich nicht unbedingt um einen Hinweis auf eine endemische Bedrohung, aber ihre Zahl schien anzusteigen, als die regulären Grenztruppen stark geschwunden waren; es gibt auch einige Anzeichen für eine zunehmende militärische Gefahr von Seiten der Wüstenvölker. Die Transformation der römischen Grenzzone von einem Gebiet in dem die wichtigsten Fortifikationen zur Armee gehörten in eines, in dem die Landschaft von privaten Befestigungsanlagen übersät war, ist erstaunlich. Interessanterweise waren ähnliche befestigte Farmsiedlungen auch ein Charakteristikum der Wüstengemeinschaften der *Garamantes,* weit jenseits der damaligen Grenze.

L'essor de la ferme fortifiée

Un dernier élément se rapportant à la frontière africaine est celui qui se retrouve dans la plupart des zones frontalières décrite plus haut, à savoir la ferme fortifiée. Considérées autrefois comme des avant-postes officiels de l'armée des frontières, ces établissements sont tout simplement trop nombreux pour que cette explication soit valable et certains sont sans aucun doute associés à des civils et à une activité agricole. Certaines de ces structures sont frappantes par leur imitation de l'architecture militaire, par leur évocation de pouvoirs quasi-officiels. Elles ne sont pas forcément le signe d'une insécurité endémique, mais elles semblent être plus nombreuses à mesure que les troupes régulières le sont moins et, de fait, il existe des indices d'une menace accrue de la part des peuplades du désert. L'évolution de la zone frontalière romaine d'un espace où les principales fortifications étaient celles de l'armée en un espace ponctué d'ouvrages défensifs privés est frappante. Il est intéressant de constater que des établissements agricoles fortifiés étaient également une caractéristique des communautés garamantes des oasis bien au-delà des frontières à cette époque.

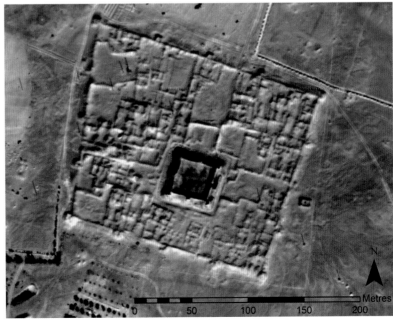

134. A fortified Garamantian village in southern Libya

Ein befestigtes garamantisches Dorf im Süden Libyens

Un village fortifié garamante dans le sud de la Libye

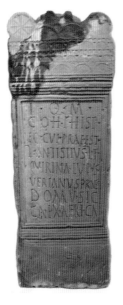
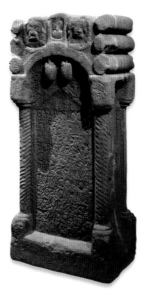

The Frontiers of North Africa

The frontiers of North Africa are unique, yet they fall within the general framework of all Roman frontiers. They offer an insight into how the Romans protected their lands south of the Mediterranean, in rugged and challenging terrain, and through study of their methods we can learn about the significance of patterns of protection elsewhere. In this way, we can understand better the flexible approaches adopted by the Romans on their many frontiers. North Africa offers a particular contribution to Roman frontier studies in the excellence of the documentary evidence, the inscriptions and *ostraca*, which reveal not only the actions of the emperor but the day-to-day activities of the soldiers manning the frontier posts.

135. Africans served in the Roman army. The 2 officers on these altars commanded the regiment at Maryport (UK) on the north-west frontier of the empire, L. Antistius Lupus Verianus from *Sicca* (left) and C. Cornelius Peregrinus from *Saldae* in *Mauretania Caesariensis* (right).

Afrikaner dienten in der römischen Armee. Diese beiden Offiziere befehligten das Regiment in Maryport (UK) an der nordwestlichen Grenze des Imperiums, L. Antistius Lupus Verianus aus *Sicca* (links) und C. Cornelius Peregrinus aus *Saldae* in *Mauretania Caesariensis* (rechts)

Des Africains servirent dans l'armée romaine. Ces deux officiers commandaient le régiment à Maryport (GB) sur la frontière nord-ouest de l'empire. L. Antistius Lupus Verianus de *Sicca* (à gauche) et C. Cornelius Peregrinus de *Saldae* en Maurétanie Césarienne (à droite)

The sites to visit

Morocco: *Thamusida* (Sidi Ali ben Ahmed), *Volubilis* (Moulay Idriss Zerhoun), *Banasa* (Gharb-Chrarda Beni Hassen), *Sala* (Rabat)
Algeria: *Rapidum* (Sour Djouab), *Lambaesis* (Lambese), Theveste (Tebessa), *Gemellae, Fossatum Africae* (*Gemellae* and el-Kantara sections)
Tunisia: *Tisavar* (Qasr Rhilane), *Ammaedara* (Haidra), Jabal Tebaga, Bir Oum Ali
Libya: *Cidamus* (Ghadames), *Myd...* (Gheriat al-Garbia), Gheriat ash-Shargia, *Gholaia* (Bu Njem), Ghirza, *Garama* (Jarma)
Cyrenaica: *Ptolemais* (Tolmeita), Qasr Beni Gdem.

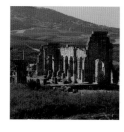

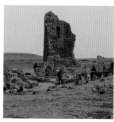

Die Grenzen in Nordafrika

Die Grenzen in Nordafrika sind einmalig, aber dennoch Teil des großen Rahmens aller römischen Grenzen. Sie geben einen Einblick, wie die Römer ihre Gebiete südlich des Mittelmeers schützten, in einem rauen und strapaziösen Gelände und durch ein Studium ihrer Methoden können wir mehr über die Bedeutung und die Schemata der Verteidigung anderswo erfahren. So können wir besser das flexible Vorgehen der Römer an ihren vielen Grenzen verstehen. Nordafrika bietet einen besonderen Beitrag zu den Studien der Militärgrenzen Roms, welcher aus der Qualität der dokumentierten Befunde, der Inschriften und Ostraka resultiert, welche nicht nur die Handlungen des Kaisers aber auch die tagtäglichen Aktivitäten der an den Grenzstützpunkten stationierten Soldaten enthüllen.

Les frontières de l'Afrique du Nord

Si les frontières de l'Afrique du Nord sont uniques elles s'inscrivent néanmoins dans le cadre d'ensemble des frontières romaines. Leur étude nous renseigne sur les moyens mis en œuvre par les Romains pour protéger leurs terres de la rive sud de la Méditerranée, dans des milieux accidentés et difficiles, et nous éclaire sur les modes de protection mobilisés ailleurs. Ainsi, nous comprenons mieux la grande souplesse des modalités adoptées par les Romains sur leurs nombreuses frontières. L'Afrique du Nord constitue un apport particulier à l'étude des frontières romaines de par la qualité des traces documentaires, des inscriptions et des *ostraca* qui révèlent, certes, les actions de l'empereur mais aussi le quotidien des soldats affectés aux postes frontières.

Sehenswürdigkeiten:

Marokko: *Thamusida* (Sidi Ali ben Ahmed), *Volubilis* (Moulay Idriss Zerhoun), *Banasa* (Gharb-Chrarda Beni Hassen), *Sala* (Rabat)
Algerien: *Rapidum* (Sour Djouab), *Lambaesis* (Lambese), Theveste (Tebessa), *Gemellae*, *Fossatum Africae* (*Gemellae* und el-Kantara Abschnitte)
Tunesien: *Tisavar* (Qasr Rhilane), *Ammaedara* (Haidra), Jabal Tebaga, Bir Oum Ali
Lybien: *Cidamus* (Ghadames), *Myd...* (Gheriat al-Garbia), Gheriat ash-Shargia, *Gholaia* (Bu Njem), Ghirza, *Garama* (Jarma)
Cyrenaica: *Ptolemais* (Tolmeita), Qasr Beni Gdem.

Sites à voir :

Maroc : *Thamusida* (Sidi Ali ben Ahmed), *Volubilis* (Moulay Idriss Zerhoun), *Banasa* (Gharb-Chrarda Beni Hssen), *Sala* (Rabat)
Algérie : *Rapidum* (Sour Djouab), *Lambaesis* (Lambèse), Theveste (Tébessa), *Gemellae*, *Fossatum Africae* (sections de *Gemellae* et el-Kantara)
Tunisie : *Tisavar* (Qasr Rhilane), *Ammaedara* (Haïdra), Jabal Tebaga, Bir Oum Ali
Libye : *Cidamus* (Ghadamès), *Myd...* (Gheriat al-Garbia), Gheriat ash-Shargia, *Gholaia* (Bu Njem), Ghirza, *Garama* (Jarma)
Cyrénaïque : *Ptolemais* (Tolmeita), Qasr Beni Gdem.

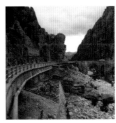

Bibliography for African frontier/Bibliographie zur afrikanischen Grenze/Bibliographie

Adams, J.N., 'Latin and Punic in contact? The case of the Bu Njem', *Journal of Roman Studies* 84 (1994) 87–112

Adams, J.N., 'The poets of Bu Njem: language, culture and the centurionate', *Journal of Roman Studies* 89 (1999) 109–34

Africa romana 15, Ai Confini dell'impero: contatti, scambi, conflitti, Sassari 2004

Akerraz, A. & Papi, E. (eds.), *Sidi Alli Ben Ahmed –Thamusida 1*, Rome 2008

Baradez, J., *Vue aérienne de l'organisation romaine dans le sud Algérienne. Fossatum Africae*, Paris 1949

Baradez, J., Compléments inédits au 'Fossatum Africae', *Studien zu den Militargrenzen Roms: Vortrage des 6. Internationalen Limes Kongress in Süd-deutschland*, Cologne 1967, 200–210

Barker, G., Gilbertson, D., Jones, B. and Mattingly, D. (eds), 1996a/b. *Farming the Desert: The UNESCO Libyan Valleys Archaeological Survey, Vol. 1: Synthesis* and *Vol. 2: Gazetteer and Pottery*, UNESCO/Society for Libyan Studies, Paris/London 1996

Benseddik, N., *Les troupes auxiliaires de l'armée romaine en Maurétanie Césarienne sous le Haut empire*, Alger 1982

Benseddik, N., ' "Limes" – Mauretania Caesariensis', in de Ruggiero, E. (ed.), *Dizionario Epigrafico di Antichita Romana* IV, fasc 43. 2–3 (1376) (1986) 47–67

Brogan, O. and Smith, D.J., *Ghirza: a Romano-Libyan Settlement in Tripolitania*, Libyan Antiquities Series 1, Tripoli 1985

Camps, G., *Berbères. Aux marges de l'histoire*, Toulouse 1980

Camps, G., 'Rex gentium Maurorum et Romanorum: Recherches sur le royaumes de Maurétanie des VIe et VIIe siècles', *Antiquités Africaines* 20 (1984) 183–218

Daniels, C.M., 'Africa', in Wacher, J. (ed.), *The Roman World* vol 1, London 1987, 223–65

Desanges, J., 'Pline l'Ancien', *Histoire Naturelle, Livre V, 1–46 (L'Afrique du Nord)*, Paris 1980

Desanges, J., Duval, N., Lepellay, C. and Saint-Amans, S., *et al.*, *Carte des routes et des cités de l'est de l'Africa à la fin de l'antiquité*, Bibl. Antiquité Tardive 17, 2010

Euzennat, M., *Le limes de Tingitane, la frontière méridionale*, Paris 1989

Fentress, E.W.B., *Numidia and the Roman army. Social, military and economic aspects of the frontier zone*, BAR IS 53, Oxford 1979

Fentress, E.W.B., ' "Limes" – Africa', in de Ruggiero, E. (ed.), *Dizionario Epigrafico di Antichita Romana* IV, fasc 43. 2–3 (1376) (1985) 21–47

Gliozzo, E., Memmi, I.T., Akerraz, A. & Papi, E. (eds.), *Sidi Alli ben Ahmed - Thamusida 2*, Rome 2009

Goodchild, R.G., *Libyan Studies: Selected papers of the late R. G. Goodchild* (ed. Reynolds, J.M.), London 1976

Gsell, S. *Atlas Archéologique de l'Algérie*, Paris/Algiers 1911

Laporte, J.-P., *Rapidum. Le camp de la cohorte des Sardes en Maurétanie Césarienne*, Sassari 1989

Laporte, J.-P. and Dupuis, X., 'De Nigrenses Maiores à Négrine', *Antiquités Africaines* 45 (2009) 51–102

Laronde, A., 'L'armée romaine en Cyrenaique', in Groslambert, A. (ed.), *Urbanisme et urbanisation en Numidie militaire*, Paris 2009, 15–20

Lawless, R.I., 'The lost Berber villages of Eastern Morocco and Western Algeria', *Man* 7 (1972) 114–121

Le Bohec, Y., *La IIIe Légion Auguste*, Paris 1989

Le Bohec, Y., *Les unites auxiliares de l'armée romaine dans les provinces d'Afrique Proconsulaire et de Numidie*, Paris 1989

Lepelley, C. and Dupuis, X. (eds.), *Frontières et limites géographiques de l'Afrique du nord antique. Hommage à Pierre Salama*, Paris 1999

Leveau, P., 'Recherches historiques sur une région montagneuse de Maurétanie Césarienne : Des Tigava Castra à la mer', *Mélanges d'Archéologie et d'Histoire de l'Ecole Française de Rome, Antiquité* 89.1 (1977) 257–311

Leveau, P., *Caesarea de Maurétanie : Une ville romaine et ses campagnes*, Collections de l'Ecole Française de Rome 70, Rome/Paris 1984

Mackensen, M., 'Mannschaftsunterkünfte und Organisation einer severischen Legionsvexillation im tripolitanischen Kastell *Gholaia*/Bu Njem (Libyen)', *Germania* 86 (2008) 271–322

Mackensen, M., 'Römische und spätantike Kleinfunde aus Simitthus/Chemtou (Nordwesttunesien)', *Mitteilungen des Deutschen Archäologischen Instituts Römische Abteilung = Bullettino dell'Instituto Archeologico Germanico Sezione Romana* 114 (2008) 339–5

Mackensen, M., 'Das Commoduszeitliche Kleinkastell *Tisavar*/Ksar Rhilane am Südtunesischen *Limes Tripolitanus*', *Kölner Jahrbuch* 43 (2010) 461–8

Mackensen, M., 'Das severische Vexillationskastell Myd (---)/Gheriat el-Garbia am *limes Tripolitanus* (Libyen). Bericht über die Kampagne 2009', *Mitteilungen des Deutschen Archäologischen Instituts Römische Abteilung = Bullettino dell'Instituto Archeologico Germanico Sezione Romana* 116 (2010) 363–458

Mackensen, M., 'Das severische Vexillationskastell Myd (---) und die spätantike Besiedlung in Gheriat el-Garbia (Libyen). Bericht über die Kampagne im Frühjahr 2010', *Mitteilungen des Deutschen Archäoligischen Instituts Römische Abteilung = Bullettino dell'Instituto Archeologico Germanico Sezione Romana* 117 (2011) 247–375

Mackensen, M., 'New fieldwork at the Severan fort of Myd(---)/Gheriat el-Garbia on the limes Tripolitanus', *Journal of Libyan Studies* 43 (2012) 41–60

Marichal, R., *Les Ostraca de Bu Njem*, Libya Antiqua Supplement 9, Tripoli 1992

Mattingly, D.J., 'War and peace in Roman Africa. Some observations and models of State/Tribe interaction', in Ferguson, B. and Whitehead, N. (eds.), *War in the Tribal Zone. Expanding States and Indigenous Warfare*, Santa Fe 1992, 31–60

Mattingly, D.J., Tripolitania, London 1995

Mattingly, D.J. (ed.) = Mattingly, D.J., Daniels, C.M., Dore, J.N., Edwards, D. and Hawthorne, J., *The Archaeology of Fazzān. Volume 1, Synthesis; Volume 2, Site Gazetteer, Pottery and other Survey Finds; Volume 3, Excavations carried out by C. M. Daniels.* Society for Libyan Studies, Department of Antiquities, London 2003/2007/2010

Mattingly, D.J., *Imperialism, Power and Identity. Experiencing the Roman Empire*, Princeton 2011

Pringle, R.D., *The Defence of Byzantine Africa from Justinian to the Arab Conquest*, BAR IS 99, 2 vols, Oxford 1981

Rebuffat, R. 1982. 'Au-delà des camps romains d'Afrique mineure, renseignement, contrôle, pénétration', in Temporini, H. (ed.), *Aufstieg und Niedergang der römischen Welt*, 10.2, Berlin/New York 1982, 474–513

Rebuffat, R., 'Le camp romain de Gholaia (Bu Njem)', *Journal of Libyan Studies* 20 (1989) 155–67

Rushworth, A., 'North African deserts and mountains: comparisons and insights', in Kennedy, D. (ed.), *The Roman Army in the East*, Journal of Roman Archaeology Supplement 18, 1996, 297–316

Rushworth, A., 'From Arzuges to Rustamids: State formation and regional identity in the Pre-Saharan Zone', in Merrills, A.H. (ed.), *Vandals, Romans and Berbers. New Perspectives on Late Antique North Africa*, Aldershot 2004, 77–98

Salama, P., 'Nouveaux témoignages de l'oeuvre des Sévères dans la Maurétanie Césarienne', *Libyca* I (1953) 231–261 & 3 (1955) 329–365

Salama, P., 'Occupation de la Maurétanie Césarienne occidentale sous le Bas-Empire romain', in R. Chevallier, R. (ed.), *Mélanges d'archéologie et d'histoire offerts à Andre Piganiol*, III (1966) 1291–1311

Salama, P., 'Un point d'eau du limes maurétanien', in *Maghreb et Sahara: Etudes géographiques offertes à Jean Despois*, Paris 1973, 339–349

Salama, P., 'Les déplacements successifs du limes en Maurétanie Césarienne (Essai de synthèse)', in Fitz, J. (ed.), *Limes: Akten des XI Internationalen Limeskongresses*, Budapest 1977, 577–595

Spaul, J., 'The Roman "Frontier" in Morocco', *University College London, Institute of Archaeology Bulletin* 30 (1994), 105–19

Trousset, P., *Recherches sur le limes Tripolitanus du chott el-Djerid à la frontière tuniso-libyenne*, Paris 1974

Trousset, P., 'Note sur un type d'ouvrage linéaire du 'limes' d'Afrique', *BCTH* ns 17B (1984) 383–98

Trousset, P., 'Nouvelles barrières de contrôle dans l'extrême sud tunisien', *BCTH Af du Nord* 24 (1997) 155–63

Trousset, P., 'Pénétration romaine et organisation de la zone frontière dans le prédesert tunisien', *L'Africa romana* 15 (2004) 59–88

General books on frontiers/Allgemeine Bücher zu den Grenzen/Ouvrages généraux sur les frontières

Austin, N. J. E. and Rankov, B., *Exploratio: Military and Political Intelligence in the Roman World*, London 1995

Breeze, D. and Jilek, S. (eds.), *Frontiers of the Roman Empire. The European Dimension of a World Heritage Site*, Edinburgh 2008

Breeze, D. J., *The Frontiers of Imperial Rome*, London 2011

Dyson, S., *The Creation of the Roman Frontier*, Princeton 1985

Elton, H., *Frontiers of the Roman Empire*, London 1996

Ferrill, A., *Roman Imperial Grand Strategy*, New York 1991

Graichen, G. (ed.), *Limes, Roms Grenzwall gegen die Barbaren*, Frankfurt am Main 2009

Green, D. and Perlman, S. (eds.), *The Archaeology of Frontiers and Boundaries*, London 1985

Hanson, W. S., *The Army and Frontiers of Rome*, Portsmouth, RI 2009

Isaac, B., *The Limits of Empire. The Roman Army in the East*, Oxford 1992

Klee, M., *Grenzen des Imperiums. Leben am römischen Limes*, Mainz 2006

Luttwak, E., *The Grand Strategy of the Roman Empire*, New York 1976

Mattern, S. P., *Rome and the Enemy: Imperial strategy in the Principate*, Berkley/Los Angeles/London 1999

Parker, P., *The Empire Stops Here*, London 2009

Whittaker, C. R., *Frontiers of the Roman Empire: a Social and Economic Study*, Baltimore/New York 1994

Woolliscroft, D. J., *Roman Military Signalling*, London 2003

o.A., *Grenzen des römischen Imperiums*, Mainz 2006

Illustration acknowledgements (* indicates figure adapted from)/Bildnachweis (* bedeutet Abbildung angepasst nach):/Illustrations (* indique une adaptation)

1 FRE project; 2 Markus Gschwind, München/D; 3 Granada Media Group, London/UK; 4 Richard Avent, Raglan/UK; 5, 8 David Graf, Miami/USA; 6, 19, 29, 31, 34, 35, 37, 38, 41, 43, 84, 86 David J Breeze, Edinburgh/UK; 9, 70 Michael Mackensen, München/D; 10, 61 Aquincum Museum, Budapest/H; 11, 122 Tyne and Wear Archives and Museums, Newcastle/UK; 12, 13 Steven Sidebotham, Newark/USA; 14, 42 St. Boedecker, J. Kunow, H.J. Lauffer/LVR-Amt für Bodendenkmalpflege im Rheinland/D; 15 Andreas Schmidt-Colinet, Wien/A; 16 Museum Udine, Udine/I; 17 National Museum of Denmark, Kopenhagen/DK; 18, 25 Jan Rajtár, Nitra/SK; 20, 25, 39, 50, 61 Sonja Jilek, Wien/A; 21, 24, 33, 55 Andreas Thiel, Esslingen/D; 22 Rijksmuseum Leiden, Leiden/NL; 23, 27 Hunterian Museum and Art Gallery, University of Glasgow, Glasgow/UK; 28 Paul Tontur, Wien/A; 30 Utrecht/NL; 32 Denise Allen, London/UK; 36 Archäologisches Institut Belgrad/SR; 40 George Gerstein; 44 Historic Scotland, Edinburgh/UK; 45 Museum Augst/CH; 46 Museum Intercisa, Dunaujvaros/H; 48 Janusz Recław, Warszawa/PL; 49 Lorraine Kerr/UK; 51 Vindolanda Trust/UK; 52, 53 Valerie Maxfield, Mons Porphyrites Project/Egypt; 54 Zsolt Visy, Pécs/H; 56 RGK des DAI, Frankfurt/D; 57 Maté Szabó, Pécs/H; 58 Stadtarchäologie Wien, Wien/A; 59 TimeScape, Newcastle upon Tyne/UK; 60 Stuart Laidlaw and Portable Antiquities Scheme/UK; 62 Igor Vukmanić, Osijek/HR; 63, 64, 72, 85, 90, 105, 107*, 109, 117, 134 Martin Sterry, University of Leicester, Leicester/UK; 65a, 87 Emmanuele Papi, Siena/IT; 65b, 78, 79 Niccolo Mugnai, Leicester/UK; 65c, d, e, f, g, h, 68, 71, 73, 76, 80, 81, 91, 92, 98, 100, 102, 103, 104, 106, 108, 110, 111, 112, 113, 114, 115, 116, 118, 119, 123, 124, 125, 127, 129, 130, 132, 133 a, b, c David Mattingly, University of Leicester, Leicester/UK; 66 Lisa Fentress, Rome/IT; 67, 128* Rene Rebuffat, Paris/F; 69*, 107* Jean Baradez (deceased); 74 Toby Savage, Leicester/UK; 75 Andrew Wilson, Oxford/UK; 77* Phillippe Leveau, Aix/F; 80, J. Mazard; 82 The Bodleian Libraries, University of Oxford (MS. Canon. 378. fol. 156r), Oxford/UK; 83 René Cagnat (deceased); 88, 89, Alan Rushworth, Archaeological Practice, Newcastle/UK; 93, 96, 97 Jean-Pierre Laporte, Paris/F; 94, 95*, 101*, 121* Charles Daniels (deceased); 126 Frederick Lyon (deceased); 131 Barri Jones,(deceased); 120, 133d Ahmad Emrage, Leicester/UK; 135 left Senhouse Roman Museum, Maryport/UK; 135 right, The British Museum, London; 136 Antike-Museum Staatliche Museen Preussicher Kulturbesitz, Berlin.

136. The Emperor Septimius Severus and his family: the face of his younger son was erased after his murder by his elder brother

Der Kaiser Septimius Severus und seine Familie: das Gesicht seines jüngeren Sohn wurde unkenntlich gemacht, nachdem ihn sein älterer Bruder ermordet hatte

L'empereur Septime Sévère et sa famille : le visage de son fils cadet fut effacé suite à son assassinat par son frère ainé